The Magic of Instant Photography

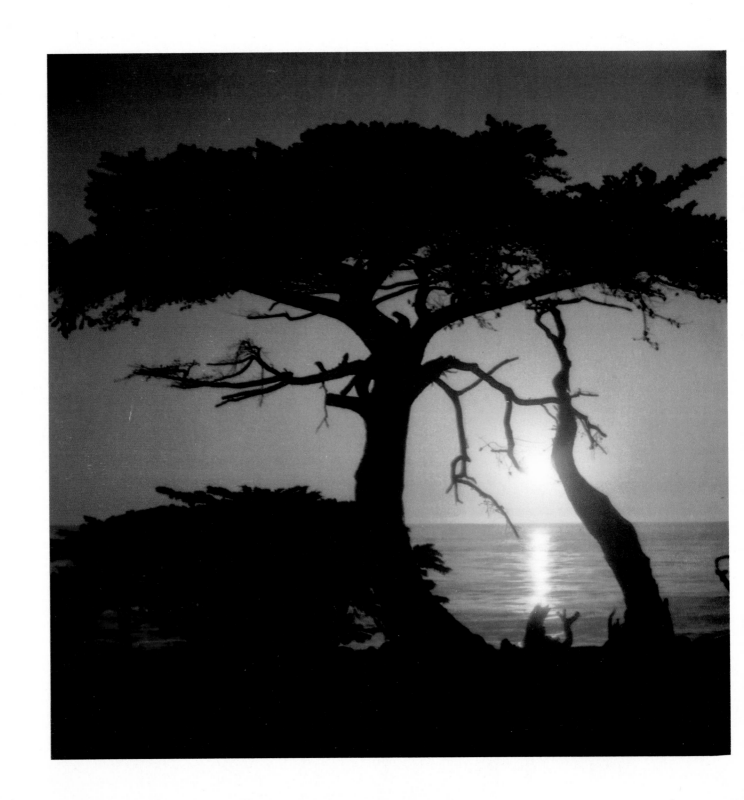

Instant Photography

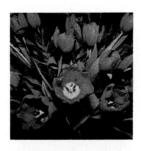
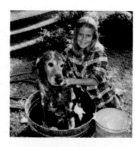

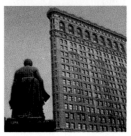

PEGGY SEALFON

CBI Publishing Company, Inc.
51 Sleeper Street
Boston, Massachusetts 02210

Production Direction / Becky Handler
Editorial Production / Sally Lifland et al., Bookmakers
Book Design / Ann Schroeder
Composition / Arabesque Composition
Illustration / Phil Carver & Friends
Printing / Federated Lithographers and Printers
Binding / The Book Press

Library of Congress Cataloging in Publication Data

Sealfon, Peggy.
 The magic of instant photography.

 Bibliography: p.
 Includes index.
 1. Instant photography—Handbooks, manuals, etc.
I. Title.
TR269.S43 1983 770 82-17739
ISBN 0-8436-0137-X
ISBN 0-8436-0138-8 (pbk.)

Printed in the United States of America

Printing *(last digit):* 9 8 7 6 5 4 3 2 1

To My Mother
Belle H. Sealfon, 1915–1981
for all her support, advice, intelligence, integrity, and love

Contents

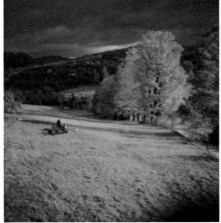

CONTENTS

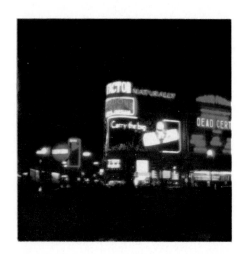

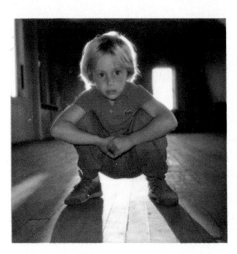

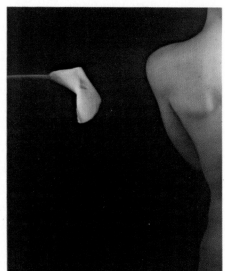

THE USES 170

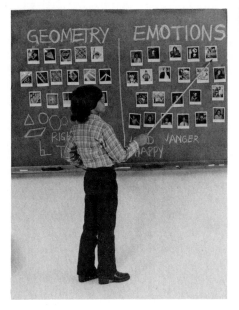

THE DISPLAY 192

THE GUIDE 202

Photo Credits

All photographs not credited were taken by the author.

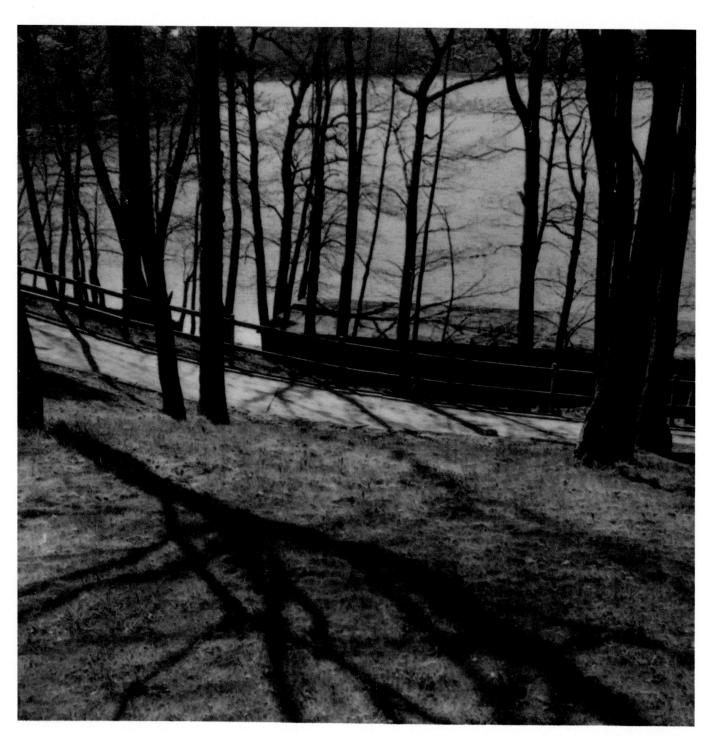

Walden Pond, 1981

Preface

Like many others of the post–World War II "baby-boom" generation, I was born very near the time of instant photography's birth. And like many families since that time, ours owned a Polaroid camera. I remember the funny machine with great vividness. It would be pointed at our smiling little faces and then, in a feat like some magician's sleight-of-hand, it would deliver a rectangular piece of paper that was peeled apart to reveal to us a picture of ourselves. It was a kid's delight. It still is.

As a young adult I had another positive encounter with instant photography. While working for a small tabloid in New York City, I was summoned by the editor to take an urgently needed picture of Macy's department store. By a lucky stroke of fate, I was dispatched with an old Polaroid camera, one bearing a remarkable resemblance to the family camera of my childhood. At the time I had no idea how to use a conventional camera, and so the instant experience was a tremendous turn-on. I felt a great sense of pride about fulfilling the assignment satisfactorily—something I never could have done without the confidence and instant feedback provided by the instant camera.

The simplicity of operation of instant cameras makes them exciting tools for anyone to use. The sheer joy of taking a picture and seeing it fully develop in seconds is incomparable. It is a magical mystery tour for the eyes.

With this book, I am thrilled to be able to share some of the wonderful discoveries of instant photography. In preparing the book, I became very aware of two distinct kinds of instant users—those who enjoy taking occasional pictures, mostly of family events, travel, and friends, and those who take pictures all the time to satisfy artistic or more passionate photographic inclinations. This book is meant to appeal to both groups. The casual user will be guided through the basics and shown easy ways to improve pictures. The serious instant photographer will find more advanced techniques and sophisticated applications.

Though I feel no justification is necessary for getting involved in taking instant pictures, I want to address the concern some people have voiced over the fact that instant film is considerably more costly than conventional film. While this is obviously true, I want to point out a few evident savings. The immediate gratification of taking a picture and seeing it almost simultaneously is in itself a film economizer. The very knowledge that the moment has been duly captured eliminates the need for further photographs. How many horror stories have you heard about people who have taken pictures on an exotic vacation with a conventional camera and returned home to discover, weeks later after the pictures were processed, that the camera wasn't working, and so they have no pictures to record the unique moments of a once-in-a-lifetime trip! With instant photography, after-the-fact tragedies are avoided.

Second, the instant process is educational. The chance to compare the picture with the reality of the scene photographed can prove an invaluable teaching aid. In fact, many photo schools rely on instant cameras for teaching students composition and helping to sensitize their seeing.

A third, and perhaps the most important, advantage of instants is the opportunity they provide for sharing pictures immediately. While an event or gathering is still in progress, instant pictures can be circulated and enjoyed by all. Sometimes, in fact, taking instant pictures can create the event, motivating people to do the unexpected.

The Magic of Instant Photography has been written as a vehicle for passing along ideas, techniques, and pictures to whet your appetite and generate enthusiasm for getting more involved in the fascinating rewards of instant picture taking.

ACKNOWLEDGMENTS

Many people contributed to making this book possible, and I would like to extend my heartfelt appreciation. My thanks:

To Eelco Wolf, Pam Wright, Larry Mach, and Sherrie Lassiter of the Polaroid Corporation, who opened many doors, allowing me to delve into Polaroid's vast picture files, especially at the Clarence Kennedy Gallery, and who spent endless hours supplying information, resource materials, and products or checking my original manuscript for technical accuracy; and—most important—providing moral support.

PREFACE

To many others at Polaroid who helped in various facets of the book's preparation, including Manfred Heiting, Roy Hughes, Connie Sullivan, Wilma Woollard, Barbara Hitchcock, Carol Kennedy, Linda Reisman, and Joan Poster. Special thanks to Sam Yanes, whose encouragement of the idea of a book on instant photography helped initiate the project.

To Michael Sullivan and Michael More of the Eastman Kodak Company, for keeping me abreast of the latest Kodak materials and for giving me technical data and products to use. I am especially grateful for the input and cooperation of Hugh Reinhard and Polly Hansen, whose wonderful ideas for instant applications were incorporated into "The Uses" section.

To all the photographers who contributed bits of themselves in the form of their photographs and whose images are really what this book is about. Special gratitude to R. R. Twarog and his assistant, Jerrold Connor, for setting up pictures in his studio, and to Sam Liggero for allowing me into his home to make picture selections from personal albums.

To Christine Marotta for her clerical assistance in preparing the manuscript.

To those at CBI Publishing who orchestrated this enormous project, especially Mike Tucker, who had the foresight to undertake a book on instant photography; to former editor Tom Hession for his capable diplomacy; to editor Becky Handler for the amazing abilities she demonstrated in ushering the book through all the treacherous stages of editing, typesetting, designing, and printing; and to Sheryl Avruch for her production skills.

To Ann Schroeder for solving some extremely difficult design problems.

To Sally Lifland of Lifland et al., Bookmakers, for her swift, professional organization, fine editing, extraordinary attention to detail, and much-valued participation, which contributed to getting—and keeping—the book on track and on time.

To my family and close friends, without whom I would have short-circuited very early in this project. I am especially thankful to Mary Mugele Sealfon for her design expertise; to Andy Sealfon for his enthusiasm and valuable technical perceptions; to Stuart and Cele Sealfon for reading and reacting to many chapters; to Charles Sawyer for his excellent advice and corrections on "The Vision" section; to Linda Benedict-Jones for her photographs, photocopying, and helpful conversations introducing me to other photographers; to Donald Kleban for his legal counsel and friendly advice; to my father Robert Sealfon, my sister Hazel Kandall, my nephew Larry Kandall, my nieces Marlene Kandall and Carolyn Sealfon; to my closest friend Joan Rogers; and to my newfound little friends Kim and Tina Ilowite, who were patient, cooperative models and endured many impromptu and planned photo sessions.

Finally, and most important, to Gerry Ilowite, who painstakingly reviewed each page of manuscript, every photograph, and every layout at all stages of production. His laborious attention, his constant criticism which engendered constructive battles of disagreement, his innate understanding of my intent, and his advice, guidance, and caring gave me invaluable support and confidence to carry on. When necessary, he not only posed for pictures, but took many. His technical capabilities, his talent for seeing and appreciating images, and his acute sense of design are part of every page of this book.

The Magic of Instant Photography

THE STORY OF INSTANT PHOTOGRAPHY

The birth and evolution of instant photography is a story about one scientist's dream and its realization: about inspiration, scientific creativity, personal perseverance, and corporate integrity threading through more than three decades. It is the story of Edwin H. Land: his founding of the Polaroid Corporation, his revolutionary discovery of an instant picture-making process and its global impact.

With Land's invention, photography was forever changed...and with it the world. The phenomenal ability to share visual experiences instantly in pictures was a staggering notion and one rapidly propelled into virtually every home, into artists' studios and scientists' laboratories. Instant pictures became widely used for family albums, insurance reports, artistic expression, scientific documents, and industrial communications. Dr. Land was to surpass his own goal of developing one-step photography in which "all that should be necessary to get a good picture is to take a good picture."

Instant cameras as we know them today are a long way from their more primitive beginnings. Today's autofocusing, self-ejecting cameras and self-contained films were preceded by larger machines with bellows to extend, shutters to cock, lenses to focus, and film to pull or peel manually from the back of the cameras. Still, the miracle of having a finished picture within minutes after releasing the shutter button was awesome.

A youthful and enthusiastic Edwin H. Land at the first public demonstration of his one-step photography process in 1947.

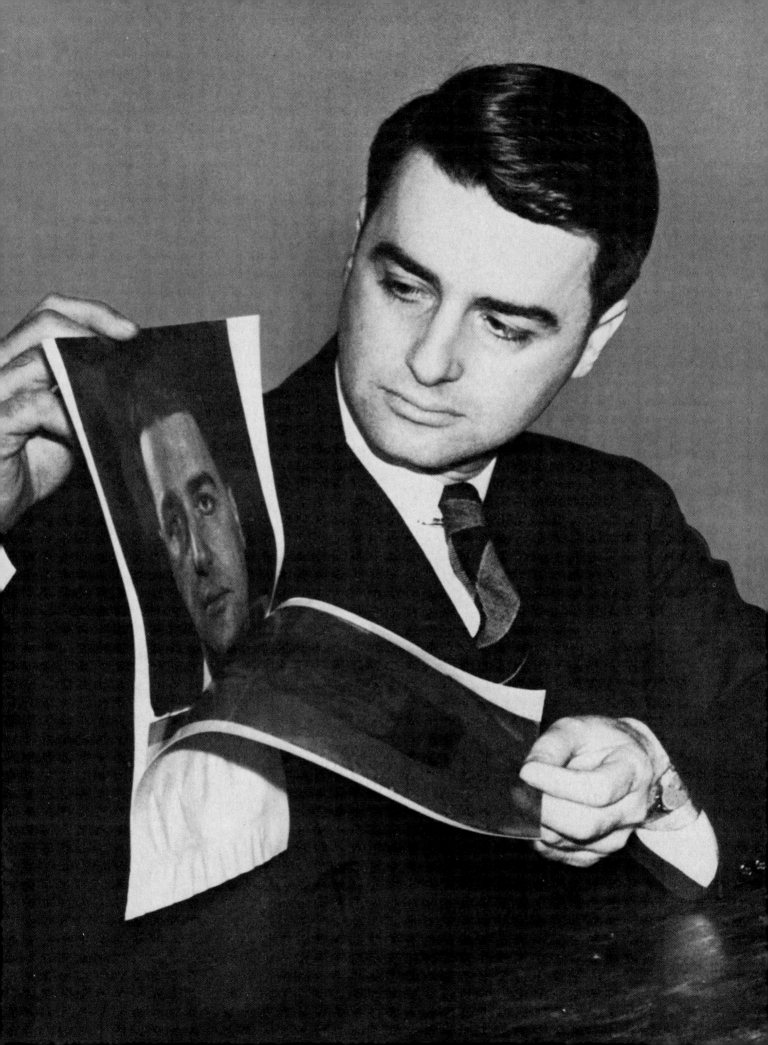

Polaroid Corporation: Beginnings

The heart of the instant story began in 1943 in Santa Fe, New Mexico, when, vacationing with his wife and their three-year-old daughter Jennifer, Land took his daughter's picture with a conventional 35mm camera. When she impatiently asked why she couldn't see the picture immediately, the thirty-seven-year-old Land started thinking. Why couldn't there be a one-step process that eliminated the barrier between the photographer and the process, one that provided an opportunity to view the subject and the resulting picture simultaneously? Land's scientific curiosity, his refusal to accept something that on the surface might seem impossible, is key to his nature. He once claimed, "If you can think of it, you can do it."

Within five years, the first Polaroid Land camera and film went on sale at a department store in Boston. Of course, the steps leading to the momentous first sale date back long before even that critical day in Santa Fe.

As a freshman at Harvard University in 1926, Land took the opportunity to visit New York City during a semester break. While strolling down Broadway one night, the seventeen-year-old student was suddenly struck by the dazzle of lights glaring out from marquees, streetlights, and car headlights. His interest in optics made him realize that if certain optical shields were placed in front of car beams and integrated into windshields, the glare would be reduced and night drivers would not be blinded by oncoming cars.

So consumed was Land with his inspiration that he took a leave of absence from college, moved to New York, rented a small room on 55th Street off Broadway, set up an optical laboratory, and began experimenting. The concept of polarization was not a new one. In fact, as early as the 1880s it had been proven that crystals could react to light in a polarizing way. But it was not until 1926 that the concept was given a practical application by Edwin Land. Within two years, Land obtained a patent on polarizing sheet plastic. But as timing would have it, four other inventors had patents pending for antiglare carlight devices and the U.S. Patent Office was undecided as to which patent to accept. In 1929, Land returned to Cambridge and to Harvard, marrying Helen "Terre" Maislen, who had assisted him on developing the polarizer.

Fortunately the academic world was

already recognizing Land's achievements. Harvard University provided him with an optical laboratory in which he could continue his research. Progress was so encouraging that Land—at the age of twenty-three—left Harvard, only a semester short of graduation, and teamed up with a Harvard physics lecturer, George W. Wheelwright III, to establish Land-Wheelwright Laboratories. Its purpose was twofold: the scientific goal was to further optical research, and the commercial aim was to produce the polarizing sheet plastic called "Polaroid." Land never returned to Harvard to complete his undergraduate studies, but was later awarded an honorary degree in 1957.

The first contract of the fledgling company was to make Polascreens, photographic light filters, for Eastman Kodak. The second major commitment was with the American Optical Company for the manufacture of Polaroid sunglasses, a contract which provided a healthy financial start for the company and proved to be a substantial source of income for many years.

In 1937, the rapidly growing enterprise evolved into the Polaroid Corporation, with Wall Street financiers showing increased interest in Land and his expanding ventures. Soon Land was being introduced to men of prominent financial stature, including W. Averell Harriman, Lewis Strauss, and James P. Warburg, associated with the major investment houses of Kuhn, Loeb and Company and Schroder–Rockefeller.

Inventor, engineer, scientist, and semi-recluse, Land was concerned by business strategizing only to the extent necessary to build a company in which he could function scientifically and still apply his inventions. His interests remained predominantly scientific, aesthetic, and humanitarian, aimed at furthering his research and applying his discoveries to benefit mankind.

One of his earliest discoveries was Vectography, a three-dimensional system based on light polarization. (Later, in the fifties, the process was applied to Hollywood filmmaking and for a short while special 3-D plastic glasses were the rage of millions of moviegoers.)

Still, the major commercial thrust of Polaroid's early endeavors was to convince the Detroit car industry to incorporate

polarizing filters into every car's windshield and headlights as a safety factor. Land still viewed this area as having enormous potential for his ever-growing company—he thought it would provide a way of satisfying Wall Street concerns about the financial aspects of the business. Unhappily, the polarizing material never did become accepted as part of the headlight system; however, in 1947 a decision was finally made to use polarized screens in car windshields.

A replica of the 1946 sepia photograph used to illustrate the first article written by Edwin Land on one-step photography.

The Instant Discovery

In the meantime, ever since his daughter's question in Santa Fe, Land had been quietly researching and developing a one-step photographic process—a system he had envisioned almost intuitively within hours but which took several years to bring to life. As Land related to a *Life* Magazine reporter in 1972: "All that we at Polaroid had learned about making polarizers and plastics, and the properties of viscous liquids and the preparation of microscopic crystals smaller than the wavelengths of light was preparation for that day in which I suddenly knew how to make a one-step photographic process."

With a team headed by William C. McCune, Jr.—who had joined Polaroid just two years after it was formed—Land achieved his objective. On February 21, 1947, at a meeting of the Optical Society of America at the Hotel Pennsylvania in New York, Edwin H. Land demonstrated the system, described by the Society's published program as "a new kind of photography as revolutionary as the transition from wet plates to daylight-loading film."

Reports on the sixty-second picture-making process began rolling off the presses. The *New York Times* described the camera's single-step accomplishment as: "all the processing operations of ordinary photography. The turn of a knob produces a positive print in permanent form. The camera contains no tanks; the picture comes out dry and requires no further processing. Thus snapshots can be seen at once, while technical pictures could be put to immediate use." The *Herald Tribune* carried a front-page story; *Newsweek* titled its coverage "Snap and See"; *Business Week* called the device "a photographer's dream come true"; and *Scientific American* went so far as to glimpse the future—with uncanny accuracy—in predicting: "A whole new photographic industry.... Sharp increase in 'snapshooting' as a result of new convenience and simplicity.... Application of revolutionary principle to movies, industrial photography, X-ray work." *Time* sounded a bit cautious in its coverage, noting: "A special camera is needed to take Land pictures.... Polaroid says that one is being designed for mass production, but does not promise how soon it will hit the market." It hit the market less than nineteen months later. The Model 95 Polaroid Land camera

and Type 40 roll film went on sale at the Jordan Marsh Company in Boston on November 26, 1948. The camera produced sepia-toned pictures measuring 3-1/4×4-1/4 inches (8.3×10.8 cm). The Model 95 camera had a semiautomatic exposure system relying on a very precise shutter with a series of fixed apertures. It was designed so that the picture developed inside the camera. The camera back was then opened and the print peeled apart from its negative sixty seconds after the shutter was clicked.

The instant film was the result of much experimentation in transfer processes to find the most efficient and stable method of combining negative and positive development into one step. The film was a sandwich of two sheets, with a viscous reagent which was spread after exposure to activate a chemical exchange from the negative to the image-receiving sheet. The reagent included a silver halide solvent and a developing agent all in one so that the unexposed grains of silver halide in the exposed emulsion layer could be transferred as soluble salts to the receiving layer and undergo a reduction to metallic silver, thus forming the positive image.

The public was enthusiastic and demanding. Within the first five years, one-half million cameras were sold. Perhaps the public was buying Polaroid's promotional messages that sold the idea of the ordinary amateur photographer becoming an aesthetic experimenter. But more likely, the public was buying instant gratification. After all, it was the age when fast foods, fast cars, and fast travel were becoming more and more desirable. The thrill of seeing one's photograph fully developed in a matter of seconds was both titillating and addictive (and still is!). The acquisitional satisfaction of "taking" and "getting" a picture simultaneously had tremendous appeal. No longer did picture-takers have to wait a week for local drugstore processing, and no longer did they have to be concerned about the film's contents passing under the scrutiny of the druggist's eye. Instant pictures of lovers and spouses became quite common.

Opposite: **These are examples of early image transfer processes.**

Top left: Dye image formed by transfer through a negative layer hardened in negative image areas (1944). *Top right:* Silver transfer image deposited in gelatin (1944). *Bottom left:* Silver transfer image deposited in a cellulose blotting paper (1944). *Bottom right:* Silver transfer image deposited in a layer formed of cross-linked polymeric reagent (1945).

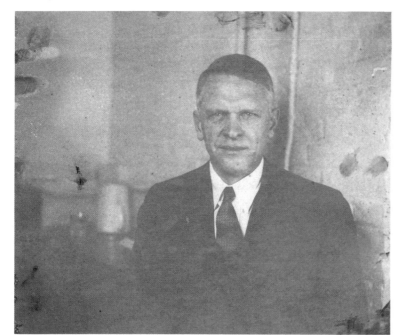

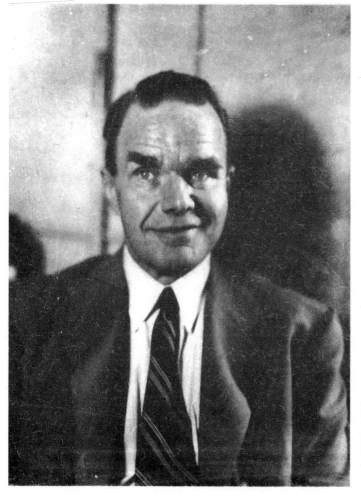

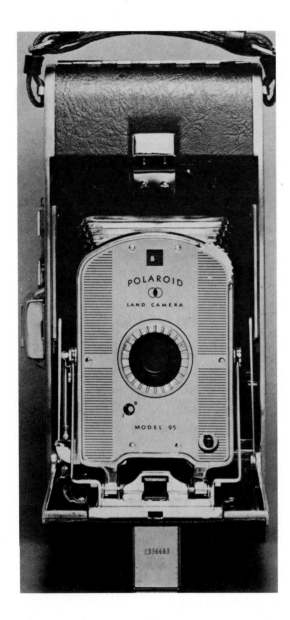

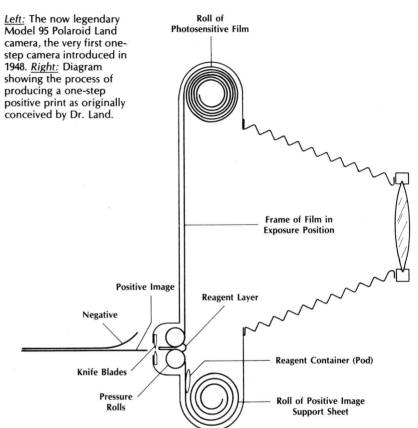

Left: The now legendary Model 95 Polaroid Land camera, the very first one-step camera introduced in 1948. *Right:* Diagram showing the process of producing a one-step positive print as originally conceived by Dr. Land.

Roll of Photosensitive Film

Frame of Film in Exposure Position

Positive Image

Negative

Reagent Layer

Knife Blades

Pressure Rolls

Reagent Container (Pod)

Roll of Positive Image Support Sheet

An early sepia photograph made in 1948 with Type 40 instant film.

The Growth

During the ensuing years, Land continued researching, perfecting the instant materials and producing new products. In 1950, the first black-and-white instant print film (Type 41) was marketed. In 1952, a camera designed for professional use was announced. And the public kept buying. The one millionth instant camera was sold on the last day of December, 1956, at a camera shop in South Orange, New Jersey. (It was a Model 95A Speedliner.) Soon pack film was introduced. While roll film pictures were processed inside the camera back, pack film permitted development to be completed outside the camera.

From the earliest days of instant photography, Dr. Land sought experts in the photographic profession whose opinions could help improve both technical and aesthetic aspects of Polaroid products. His aim was rooted in scientific discovery and quality. One long-time friend and associate has been celebrated photographer Ansel Adams, renowned for his panoramic landscapes of the American West as well as his precise system for control of film exposure and development. Land also surrounded himself with dedicated researchers like Meroe Morse, who headed the black-and-white film research team, and Howard Rogers, who took on the development of color instant film.

New improved cameras and films continued to surface. In 1961, a very fine-grained black-and-white film was introduced, providing a finished print and a permanent negative usable for making enlargements. Type 55 Positive/Negative film quickly became a much relied-upon tool for artists and commercial photographers. Polaroid's expanding scope of materials extended into industrial and scientific areas as well. A special ultra-high-speed film was incorporated into industrial and medical fields, and a special industrial view camera, being developed, would become a reliable instrument for use in hospitals, universities, research laboratories, and industrial plants.

By the 1960s, Polaroid was firmly established as a blue-chip company and Dr. Land's indefatigible interests in research and development were all-pervasive. At the company's 1960 shareholder's meeting—a platform Land characteristically used for sharing not only financial reports but product

An example of one of the early experimental color instant prints. This is a three-color dye developer print made from a continuous multilayer negative in 1957.

evolution accounts—Dr. Land made an enthusiastic "progress demonstration" of a Polaroid color film he had been developing with Rogers's color research team. By 1963, the new film, Polacolor, had been refined and was ready for market. And it was resoundingly successful. Briefly, the developing process works as follows. As the film is pressed through developer rollers, a chemical pod breaks, spreading an alkaline reagent between the positive and negative and beginning the development process. Each of the film's emulsion layers responds to only blue, green, or red light, and the corresponding layer of dye developer responds to the complementary color. All the dyes then move to a self-washing receiving sheet, and the positive is formed and stabilized. The processing takes sixty seconds, and when the negative and positive sheets are peeled apart, the Polacolor print is finished to a hard glossy surface. Interestingly it was Eastman Kodak that supplied Polaroid's color negative material up until 1972, when the next major step in instant evolution occurred.

In November, 1972, Dr. Land—the reserved, low-key inventor incapable of resting on his laurels—boggled the minds of the

The Growth

public once again with a revolutionary approach to instant photography, the SX–70 Land System, a self-contained, garbage-free, self-developing film and a completely automated folding single-lens-reflex camera with superb optical and mechanical features. It was, as Land described, "Absolute One-Step Photography," designed to remove barriers between photographer and subject.

The development of the SX–70 System required teams working in many specialized areas of optics, chemistry, electronics, and mechanical design, and it was an extremely involved undertaking. Many U.S. companies were contracted with to supply components, including Texas Instruments, which designed the electronic module, and Corning Glass, which made the lenses. The basic manufacturing and assembly were done at Polaroid.

The first SX–70 camera, folding to a compact 7×4×1-inch (2.2×1.2 m×2 cm) size, was a handsome affair encased in top-grain cowhide and trimmed with brushed chrome for an elegant look. When opened, it took on a triangular shape, exposing a single lens, a bright red shutter button, and a pair of control knobs (one for exposure regulation labeled "lighten/darken" and one for focusing). The top cap turned into a smaller repetition of the strange triangular shape and became the camera's viewfinder. To operate the camera, all the user had to do was sharpen the image seen in the viewfinder, depress the shutter button, and watch. The electric eye automatically set the exposure, the mirror flipped up, the shutter clicked, a motor softly buzzed, and a piece of plastic was mysteriously disgorged from the front of the machine. After thirty seconds, the plastic—actually the photograph—began to show an image through the Mylar-protected sea-green chemicals. Within two minutes the image was recognizable, and roughly ten to fifteen minutes later the color was stabilized.

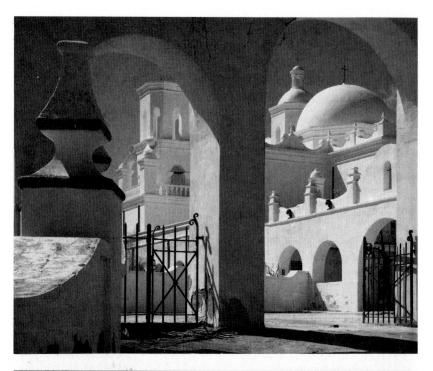

From the very early days of instant photography, Dr. Land relied on advice from artists and photographers for ways of improving Polaroid products. These two images—a positive and negative—represent work done in 1956 on Polaroid's Positive/Negative film by noted photographer Ansel Adams who has been a continual Polaroid consultant and a personal friend of Land's.

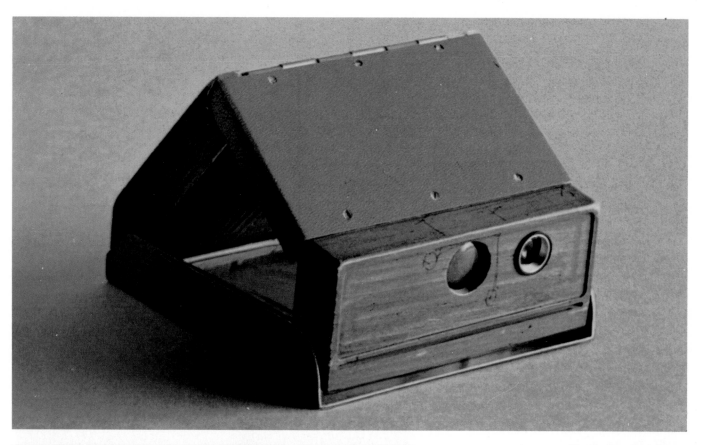

The SX–70 camera began to be conceptualized in 1965. This shows an early prototype design.

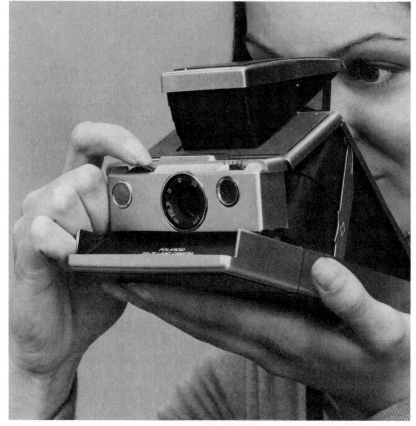

The first SX–70 camera—a collapsible, single-lens-reflex using self-processing, integral film—revolutionized instant picture-taking in 1972. The technological achievements in electronics, optics, and mechanical functions of the SX–70 make it the most advanced instant camera of its kind.

The Competition

In Kodak's eyes, the new system and film meant that the older Polacolor film would become obsolete. Kodak immediately terminated its contract to supply color negative material. As it turned out, Polaroid did not cease production of Polacolor—which has, in fact, become a staple of many commercial and industrial users—and instead began manufacturing the materials itself at a handsome profit. At the same time, Kodak was paying close attention to the instant photography market as a potential avenue for expanding its own interests. In fact, as early as 1974, Kodak's annual report carried a notation making their intent clear: "Productive work has made feasible a film that will yield dry prints of high quality without waste, to be used in equipment priced for a wide spectrum of consumers."

Another company had jumped onto the instant bandwagon in the interim. In 1972, Berkey Photo Inc.'s Keystone Division introduced the 60-Second Everflash, an instant camera accepting three types of Polaroid peel-apart film. But Berkey was not to stay in the instant arena for very long. With the introduction of their Wizard XF 1000, designed for SX–70 film, Berkey was doomed. Polaroid filed suit for patent infringements, and in 1978 Berkey made an out-of-court settlement and discontinued manufacture.

Polaroid could not eliminate competition for much longer, however. In 1975, at a gala presentation to the international press at New York City's Pierre Hotel, the Eastman Kodak Company entered the field of instant photography with the introduction of two instant camera models called the EK–4 and the EK–6, accepting a newly designed Kodak integral instant print film called PR–10.

Kodak's entry had been accomplished with premeditated speed. Rather than spend a great deal of time researching individual areas of film chemistry, then film, then a camera to accept the film, Kodak orchestrated simultaneous development of the project by its chemists, designers, engineers, and technicians. In fact, Kodak was so confident of the positive results of its efforts that manufacturing facilities were built even before the camera and film designs had been finalized.

The nonfolding cameras appeared bulky and awkward compared to Polaroid's sleek, folding SX–70 design. Both Kodak models ejected the film from the bottom and had separate viewing and taking lenses. The Model EK–4 used a simple hand crank to expel the print, while the slightly more advanced EK–6 was motorized. The film was designed to satisfy average taste and average applications. Based on Kodak research showing a public preference for a rectangular format, the PR–10 print became 2-3/4 × 3-1/2 inches (67 × 90 mm) with a pebbled Satinluxe surface making it less susceptible to finger smudges and less likely to reveal minor internal film flaws. Compared to Polaroid's warm-toned film, the Kodak film seems cool. Its off-center image area is bordered by a white continuation of the Satinluxe surface,

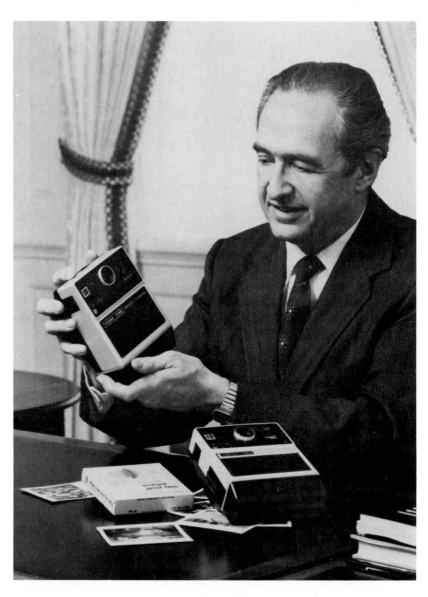

Kodak's former president, Walter A. Fallon, is shown with the first of Kodak's instant cameras and self-developing color film. Fallon is holding the EK–6 instant camera, the EK–4 is resting on the table.

while Polaroid's square image is framed by a paper mat. Many photo industry critics were disappointed by the Kodak system, and yet the public was receptive. About one million cameras were sold in the first year alone, asserting Kodak's commitment to instant photography and the fact that Kodak was in the business to stay.

While Kodak's stand was clear, its presence in the instant field took on a much different aspect from Polaroid's. Kodak's promotions were aimed solely at the masses— the average amateur who enjoys snapshooting—while Polaroid's aim was to encourage a higher involvement in the picture-taking experience and to appeal to a more sophisti-

cated audience of commercial and artistic photographers as well as the masses. The Polaroid-Kodak rapport fast became a rivalry, bringing discord to the industry. Polaroid filed suit against Kodak for ten patent infringements. (The conflict had yet to be settled at the time of this writing.)

In the meantime, Kodak pursued a vigorous marketing program of its instant products and continued developing new ones. In 1977, Kodak introduced an easy-to-use instant camera called the Handle. Soon other manufacturers began producing cameras accepting Kodak's instant film, such as the New Jersey-based Continental Company with its instant camera called the Colorshot 2000.

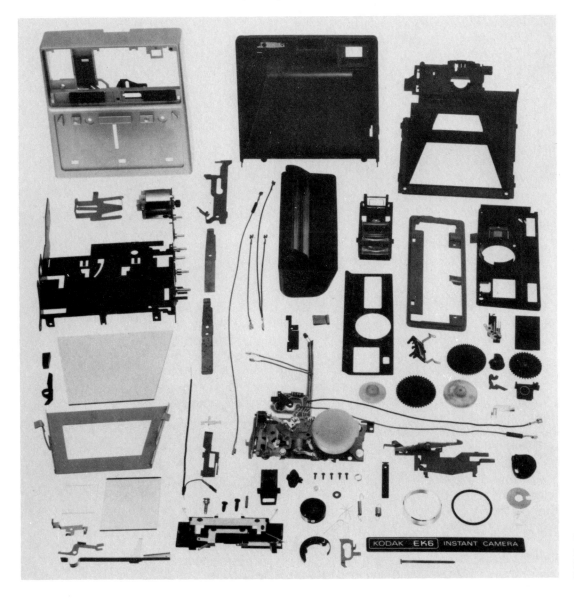

While the camera is simple to operate, Kodak's EK–6 instant camera was made with more than 200 parts.

The Competition

Undaunted and still the established giant in the instant industry, Polaroid continued to introduce new improvements—faster develping SX-70 films and new camera models. The Polaroid One-Step/Model 1000, directly competitive in price and simplicity with Kodak's instant models, became an international bestseller and helped to hold Kodak at bay. Polaroid was asserting its role by satisfying mass consumer needs and still continung to upgrade its more sophisticated line of products and improve quality. A new SX-70 camera model was introduced with a special sonar autofocusing feature that emits ultrasonic sound waves to determine subject distance and automatically sets the lens accordingly. A new professional camera system for pack-format films, Model 600 SE, was announced, and a new 8×10 Polacolor system was marketed. According to one industry account, sixty million instant Polaroid Land cameras had been sold by 1977. And in 1978, instant camera sales comprised forty-two percent of all camera sales.

Unfortunately, by that time a sagging economy had begun chipping away at the Polaroid empire. The saturation of the market for instant cameras created further financial setbacks for the thirty-one-year-old company. Production had to be slowed and manufacturing sites trimmed. Still, guided by the charismatic Dr. Land, Polaroid continued its significant investments in research and design. And in 1979, Land furthered his long-standing quest—for a way to deliver a one-step instant image in practically zero time—with the development of Polaroid Time-Zero Supercolor SX-70 Land film, which processes almost as soon as it issues forth from the camera.

When he succeeded Dr. Land as Chief Executive Officer at the 1980 company meeting, William J. McCune, Jr. asserted: "We intend to remain at the forefront of this field, maintaining the high level of appeal of our systems by constant attention to their cost, versatility, reliability, and the quality of the pictures they produce." True to McCune's words, in May of 1981 Polaroid once again took a quantum leap by introducing yet another new concept in instant photography, the Polaroid 600 System initially consisting of two camera models, the autofocusing 660 and the fixed-focus 640, both using Polaroid

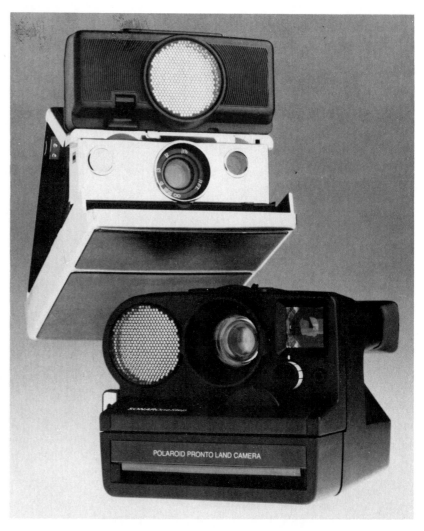

600 High Speed Land film, a new high-speed integral color print film. The cameras slightly resemble the nonfolding Pronto! camera, with an additional hinged flip-up front which protects the lens and electronic sensing elements. When this is opened, a special electronic strobe is revealed. Dubbed the Sun Cameras, these machines were designed to blend ambient light and strobe light for perfectly balanced pictures in varied indoor and outdoor lighting conditions. Like other recent new additions, the 600 line became an enhancement of Polaroid products; it was not a replacement and did not make an earlier system obsolete. The SX-70 System and pack camera systems have not diminished in availability. ✳

Polaroid also began broadening its base even more by placing emphasis on its industrial product line. Larger-format cameras including the 20×24 and the Camera Camera,

Improvements on the Polaroid SX-70 and Pronto! cameras did not detract from their sleek design and greatly enhanced their performance. The circular grid-like device visible on the front of each unit is the sonar autofocusing feature delivering accurate, automatic focus in milliseconds.

✳ in 1983 production of all folding (SLR) SX-70 cameras (except the Model 680) was stopped!

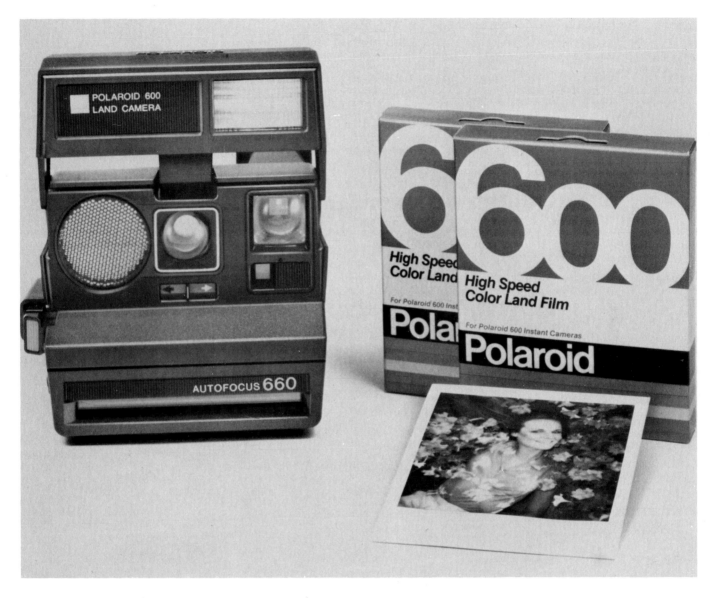

used for life-size reproductions of museum masterpieces, were developed. Better films such as Polacolor 3/ER were produced, and other applications of its existing technology are being investigated. Nonphotographic uses for the unique Polapulse battery have been pursued, for instance, and the auto-focusing sonar device is being considered for use in the aircraft industry as a landing aid.

In contrast, Eastman Kodak's goals remain fixed on the amateur photographic market. The only exception has been the manufacture of a 4×5 instant back (for view cameras) using the small-format Kodak instant film. To keep the Kodak instant audience satisfied, the research lab has been steadily developing camera improvements. The Colorburst

cameras were clear advancements over the earlier EK cameras. The Colorburst 250 and 350 models include built-in flash to facilitate picture-taking in all situations. The 350 even features an additional closeup lens so that focus is possible at from two to four feet (56 cm to 1.2 m). Attention devoted to Kodak's instant film has led to the develop-ment of the Ektaflex System, a very simplified color printing process for making color en-largements in minutes, designed for amateur darkroom users.

Even more recently, Kodak expanded and improved its instant lineup further with the introduction of the Kodamatic cameras and film, aimed to be directly competitive with Polaroid's Sun Camera line. Announced

Another new concept in instant photography occurred in 1981 with the arrival of the Polaroid 600 system, featuring two cameras with special light-mixing capabilities to take beautiful pictures in practically any lighting condition and a new high-speed 600 film similar in size and appearance to SX-70 but incompatible with SX-70 cameras.

The Competition

early in 1982, the Kodamatics original U.S. line consisted of three folding cameras and one rigid-body camera (resembling the Colorburst 50) and are expected to replace the Colorburst models eventually. The Kodamatic Instant Color film is an improved version of the Kodak Instant film with a faster speed of 320 ASA. Kodak's essential aim is to achieve "improved picture-taking results" so that the amateur can point and shoot without picture error. All the folding models feature a built-in flash which fires every time a picture is taken, resulting in evenly lighted pictures indoors or out. The top-of-the-line model, the 980L, offers an autofocus-type lens as well; the middle of the line, the 970L, has a closeup lens for focusing within the two- to four-foot range (56 cm to 1.2 m); the 960 has a fixed focus lens. By offering three-year warranties on the lower-end cameras and five-year warranties on the 980L and 970L, Eastman Kodak Company has made an obvious move to position itself firmly in the instant marketplace with its new products.

Fuji Photo Film has also joined the instant bandwagon with its 1981 introduction in Japan of two instant cameras, the F–10 featuring a separate flash and the F–50S with built-in electronic flash. The Fuji Instant Picture F1–10 film is similar in format to Kodak's and can be used in Kodak cameras. And rumors have been circulating that other manufacturers are researching instant camera and film possibilities.

Kodak's expanded lineup consists of four Kodamatic cameras and the new Kodamatic Instant Color film.

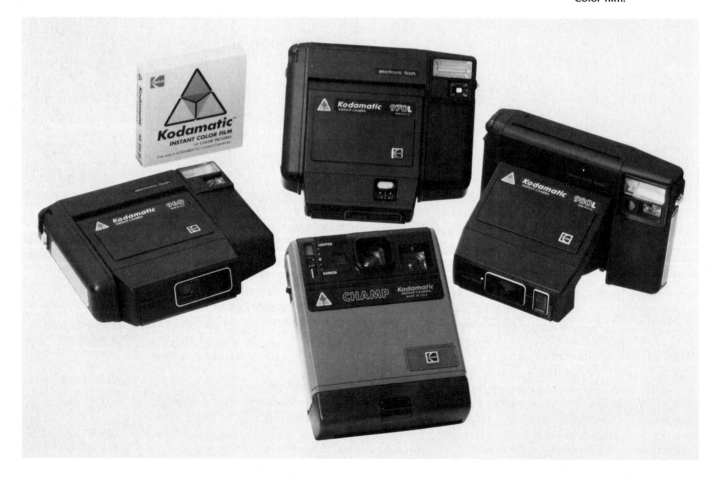

The Future

Though the future is unpredictable, it seems clear that instant photography's technology will continue to advance. According to one report in *Fortune* magazine, Polaroid has already applied for a patent for an instant camera equipped with reusable videotape that allows the photographer to take a series of pictures, view them on a small screen on the camera's back, and then decide which ones to print. "Among the wonders inherent in the gadget is simply its use of videotape—the first concrete indication that Polaroid has launched itself on that tack." Clearly the 1980s will witness far more use of instant photography not only in our daily lives, but also in more elaborate applications such as recording transmissions from space to NASA Control Centers, medical X-rays, scientific documentations, industrial imaging by computer graphics, and commercial photography.

Instant photography has come a long way since 1947, when Edwin Land introduced the first sepia-toned roll film producing instant prints. Over the years, Land's enthusiasm, excitement, and undiminished perseverance has heralded innovation atop innovation and dramatically affected more than three decades of image-making. Scientists have always pursued the notion of standing on the shoulders of our forebears to see just a little further. With Dr. Land's contributions and achievements, we are given a legacy enabling us to see a little further in both directions—in front of us and behind us through our accumulated pictures.

Perhaps imagemaking of tomorrow will be a symbiosis of instant photography and electronic imaging systems.

THE VISION

The question is not what you look at, but what you see.

—Henry David Thoreau
The Writings of Henry David Thoreau

A moment is seen, miraculously suspended, and then displayed within minutes; a slice of reality has been preserved. The instant-picture experience is dazzling; its immediacy is seductive. Anyone who can press a button can feel this allure. But too frequently, people never advance beyond the point-and-shoot method of taking pictures, thus missing out on the deeper joys of discovering and sharing a personal vision.

The following section offers an easy guide to improving your pictures by developing your personal vision. Whether you take instant pictures to record your family's activities, document your business, or satisfy your creative impulse, you can learn quickly to make more effective and expressive photographs. The very fact that instant cameras provide feedback instantly accelerates the learning process and makes a wide range of possibilities more accessible. The first step is to understand how to use your eye, to coordinate the mind and the camera.

Learning to See

Imagine that you're looking at a magnificent seaside sunset. The sun is melting into crystalline waters; the sky blazes with fiery colors. You compose, focus, and snap. Presto, an instant picture. You are sure that you have captured a modern masterpiece. But the developed image only remotely resembles what you witnessed. The ocean is brownish, the sky green, and the flaming sunstreaks seem dull. How can you reconcile the evidence of your senses with the results from the camera?

Such disappointment is a common experience for beginning photographers, since our senses easily mislead our expectations of photographic success. We forget that the camera does not feel the cool sand or breathe the fresh sea air; nor can it record the wide vista of shoreline which heightened our experience of the moment. Remember—the camera can provide only a two-dimensional reduction of the scene. It translates visual elements into flat, graphic representations. Therefore, to learn to see photographically, you must learn a new visual vocabulary.

The famous German philosopher Arthur Schopenhauer once noted: "Every man takes the limits of his own field of vision for the limits of the world." He probably did not have photography in mind, but his remark is all too apt. Yet the visual rut can be overcome easily. The best place to start expanding your vision is by working on your powers of observation.

Begin with the following simple visual exercise. Devote an entire day to looking at the visual properties of everyday things around you. You don't need to take any pictures, just be aware of the way things look. Notice the breakfast table and how morning light casts long, lean shadows. Look for architectural shapes at your workplace. Watch people talking and note their body language. Isolate patterns; compare colors for warmth and coolness. Everything is fair play—the cracks in the cement, a child's face, the quiet landscape down the road. Seeing something ordinary in a new way is stimulating, and sharing the observation through a photograph is exhilarating.

Try another visual exercise, only this time use the camera and one pack of film. Choose a single subject and look for ways to create a variety of photographs. Try changing the angle you shoot from, altering the exposure, varying the distance, shooting with and with-

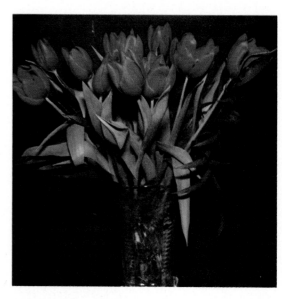

A single subject can be transformed when photographed from different angles, from different distances, and in varying light conditions. The ultimate choices depend on what the photographer wishes to convey about the subject. This series of pictures of a vase of tulips demonstrates a few of the possible variations in approach.

out flash—experiment. Since the goal is to make each picture different from the one before, you will be forced to explore the situation thoroughly. You will surely be staggered by the varied photographic effects you can achieve even though you are concentrating on the same subject. The unique advantage of instant photography is the speed with which you can try such exercises. Just minutes after visualizing the picture, framing it in the viewfinder, and pushing the button, you can actually see results.

As you continue taking pictures, particular subjects and themes will begin to occupy your attention. You might be intrigued by the way objects occupy a landscape or by the interplay of colors and shapes. When a subject compels you to examine it, then you are on your way to creating strong, communicative pictures. "A good photograph," comments photographic historian Beaumont Newhall in *The History of Photography*, "says something so well that it cannot be said better in any other way. It can be factual or poetic; but always it will be so true that from it we can learn of life."

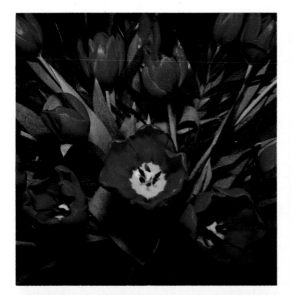

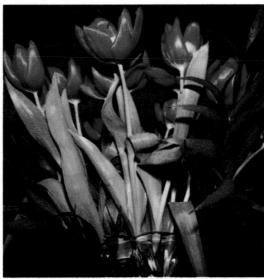

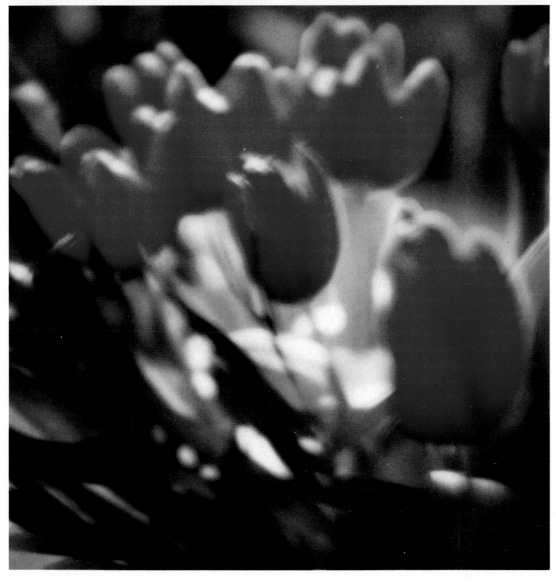

Opposite: This is a fairly conventional and straightforward approach to the subject. *Far left:* This photo was taken from a close vantage point, looking down on the floral arrangement. Notice that the vase is no longer visible. A slight disorientation results, yet the picture possesses vividness and vitality. *Left:* This photo was made from a very low vantage point, giving the tulips a very tall and grand appearance. *Bottom:* This photo was made with natural windowlight emanating from behind the flowers. Since the light was quite low, the camera had to be steadied for a long exposure. Slight camera movement caused the blurred, impressionistic effect which enhances the subject's soft, gentle quality.

Selection

The impact of a photograph depends on the particular aspects of reality that are isolated on the film. Thus, selection is the key to taking good photographs. The camera's viewfinder provides a frame that outlines the picture area and reveals what is being included. Think of the edges as a container and the photograph as the contents, and ask yourself, "Does everything included here belong? Is everything that belongs included here?" In other words, look carefully and scrutinize all the edges. Be sure all details contribute harmoniously to the overall feeling and message of the picture.

Simplicity is as important as harmony. Guard against distractions that may dilute the main focus of the picture. As the architect Mies Van der Rohe said, "Less is more." Unwanted elements can be eliminated by a change in perspective. Move closer to the subject or step to one side or the other; raise or lower your viewpoint and even lie on the ground if a bothersome detail can be eliminated. The important thing is to experiment. You must risk different approaches to framing a scene if you are to discover the best alternative. The attitude conveyed by placing the camera at a high angle is wholly different from the attitude suggested by looking from a low, inferior, upward-looking angle.

Some subjects demand one and only one perspective. For instance, a plowed landscape seen from a tall structure (or better still, an airplane) may possess intricate patterns and a rich sense of terrain. Yet photographed from ground level it may be only a mundane, thin strip of earth. By contrast, a skyscraper retains its thrusting verticality only when photographed from below.

Selective focus can be used as another valuable aid to the selection process. If you focus on a subject at very close range, distant objects will be blurred. The subject will be distinct against a patchwork of colors, and thus attention will be concentrated on the in-focus foreground subject. Conversely, if you focus on a distant subject, close foreground objects tend to blur and the viewer's attention is directed toward the background. To visualize the effect, extend one finger about five inches in front of your nose. Focus your eyes on your finger, a close-range subject, and notice how distant objects appear blurred. Now shift your focus to the back-

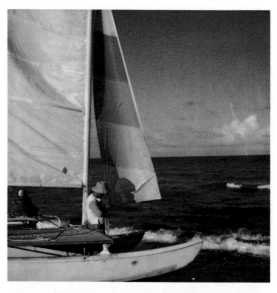

The distance the camera is positioned from the subject can affect the purpose of a picture drastically.

This is an establishing shot much like those used in filmmaking to set the scene. It works nicely as a scenic but would never be acceptable as a portrait of Joe, who is busily taking down the sails.

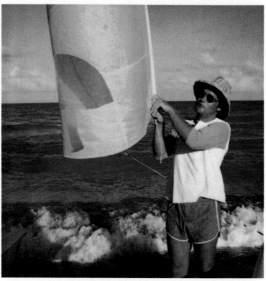

This is a medium shot which better conveys Joe's activity and yet still includes enough of the surrounding scene to suggest the location.

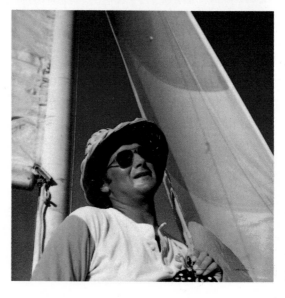

This closeup is shot at an excellent portrait distance for capturing Joe, framed between the colorful sails.

Selective focus can be used to eliminate unwanted elements and direct attention to the main subject. By focusing the camera so that the distant background becomes a blurred backdrop, the photographer directs the viewer's eye to the important feature in this composition.

ground and see how your finger is blurred and the background appears in focus.

Unfortunately, not all instant cameras can be controlled easily for selective focusing, and many do not provide a readily visible representation of the effect in the viewfinder. The folding single-lens-reflex instant camera does, and is the easiest to use for this purpose. Viewing is done through the camera's lens, permitting you to see exactly what is in focus and to change the focus if you desire. Still, you can experiment with any camera's focusing variables to achieve some selective focusing effects. Essentially this technique is used to concentrate attention on a subject by keeping it in focus while throwing unwanted elements out of focus.

Intuition/Perception

The American painter James MacNeil Whistler once testified in court on the value of his effort in painting a picture. "How long did it take you to paint that picture, Mr. Whistler?" he was asked under oath. "Thirty years," was his reply. "How long did it take you to make that photograph?" a famous American photographer was asked nearly a hundred years later. "About 1/30th of a second," he replied. Both replies point to the importance of intuition in art. The photographer's reply suggests that intuition may be even more important in photography than it is in painting. Because the act of pressing the shutter is so decisive in making photographs, the photographer's intuition about the intended results is paramount. The legendary French photographer Henri Cartier-Bresson has called pressing the shutter "seizing the decisive moment." The eye and the mind must work together.

Consider sports photography, where intuition reigns supreme. The sports photographer must capture the height of action, the precise instant when the ball is kicked or the moment of take-off when a skier leaves the ski jump. These professionals must know their equipment so well that photographing becomes as instinctive as shifting gears in a car. Further, they must have a keen familiarity with the game to anticipate the critical moment of action.

While other situations might not be quite as demanding as sports photography, every photographer must be able to sense what will happen in a situation and be ready to trap it. Cartier-Bresson commented in *The Decisive Moment*: "Photography is the simultaneous recognition, in a fraction of a second, of the significance of an event as well as of a precise organization of forms which give that event its proper expression." With experience, an ease of seeing and shooting develops and becomes automatic and instinctive. It is important to take a lot of pictures. Relax and let intuition take over.

Awareness of the moment is one part of "seeing"; perception is another. Remember that the sunset picture did not seem to do justice to the reality. Perception is odd. Sometimes you think you are seeing something as it is, so when the camera provides contradictory evidence, you are understandably surprised and even exasperated. Film registers only varying light intensities, while humans have an array of senses that combine to form the totality of an experience or event. Compared to a person's capacity to "take in" a scene, the camera's capacity seems severely limited.

On the other hand, whereas psychological and perceptual factors may mislead people into seeing subjects falsely, the camera can show us things we failed to see. It consistently reads the world "faithfully." For example, you might remember an orange sun splashing into aquamarine waters, but the film shows ruddy-colored water. The reason for the clash between memory and photographic results is simple. Your mind is unprepared to see the reality of the color in the early evening light because of previously learned associations. You remember an aquamarine sea because you expect one—after all, isn't seawater usually greenish-blue? But at sunset, the darkened orange sky reflects reddish hues. Similarly, when looking up at a building, you don't see lines converging in the same way as the camera lens shows them from that perspective. Buildings, of course, have parallel sides. Therefore you are rather shocked at how they appear in the resulting photograph.

Depth is another perception which escapes the camera. If Aunt Pauline is posed in front of a landscaped garden, a picture of her might well reveal a tree branch emanating from one ear. Your depth perception clearly informs you that the tree is in the distance, but the camera is not so discerning. The depth of the scene is flattened so that the tree branch and the main subject appear to be in the same plane. The result is a portrait that may make Aunt Pauline look quite silly.

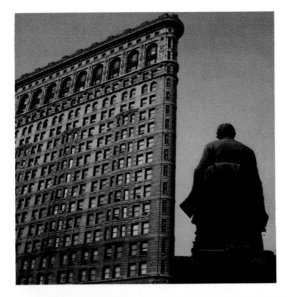

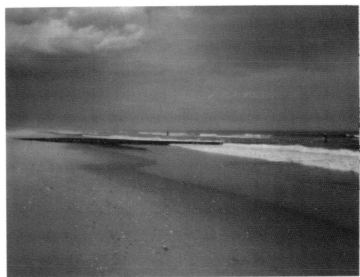

Top left: The camera's lack of depth perception can sometimes be put to use, as shown by this picture of a statue posed next to New York City's Flatiron building. In reality the statue is situated quite a distance from the building, but the camera "sees" the objects practically on the same plane, making for an unusual image.

Top right: The contrast between the colors of the sky, water, and sand is extremely subtle in this seascape, which is just the type of scene that can be extremely misleading for a photographer. Usually sand and water have distinctly different tonalities. To recognize that the colors here would result in a muted, monochromatic palette, a photographer must notice the highly reflective quality of the subjects and the strangely lighted, overcast sky.

Bottom: The striking skyline was taken from a low angle to exaggerate the upward thrust of the skyscrapers. Notice the converging lines of the buildings. When viewed with the naked eye, the lines do not appear to converge because you know building lines are parallel. Your mind compensates; the camera does not.

Composition

Fundamentally, composition is the arrangement of line, form, and shape within the photographic frame. The interplay of these elements may determine the impact of a photograph, usually making the difference between a photo that merely records the subject and one that holds the viewer's interest, pleases the eye, and even touches the soul. Some principles of composition should not be viewed as hard-and-fast rules, but are useful as guidelines.

SIMPLICITY

A well-composed picture is easy to read and uses the whole frame. Generally, it should have a strong center of interest—a main subject—which should be clearly defined. The background should not be cluttered, or it may detract considerably from the main purpose.

SUBJECT PLACEMENT

Most beginners place their main subject right in the geometric center of the frame. This may result in an adequate record, but usually produces a lifeless picture. A more interesting composition can be created by placing the subject somewhere else in the frame other than in the exact center. The traditional rule of thirds often is helpful here. To use this rule, mentally divide the frame—as seen through the viewfinder—into thirds horizontally and again into thirds vertically. The imaginary lines marking off these subdivisions intersect at four points. Placing the main subject at one of these junctions usually results in a more lively, dynamic photograph. Natural lines in the scene you are photographing, such as the horizon or a flagpole, rarely should be placed in the middle of the frame.

FRAMING

When your camera has a rectangular format, as opposed to the square format of some Polaroid films, you must decide whether your subject calls for a horizontal or a vertical frame. This choice is forgotten all too easily because out of habit you hold the camera the same way. As a general rule, use the orientation most harmonious with the nature of the

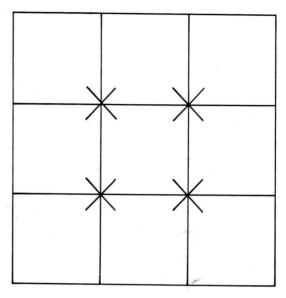

The rule of thirds can be used as a guideline for composing effective pictures. After you mentally divide the picture into thirds horizontally and vertically, place the subject(s) at one of the four intersecting points as marked by the Xs.

subject: a stretch of seascape has a definite horizontality, while a rising hot air balloon suggests verticality.

SPACE

Unless space is used effectively for emphasis, it can destroy a picture. A photograph of a farmer diminished by a wide expanse of field may convey a message about the loneliness of his work and his lifestyle. However, the same composition used to make a portrait of a friend hardly would be satisfactory. In other words, if an expansive foreground helps focus the viewer's attention in a useful way, then keep it; otherwise eliminate it by moving closer to the main subject.

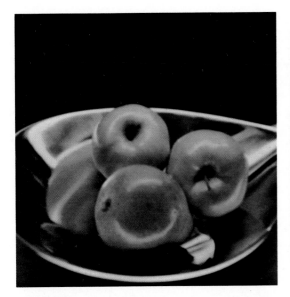

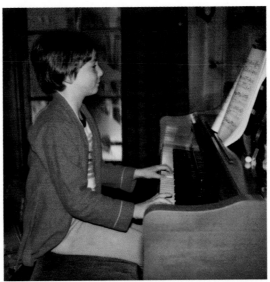

The still life composition and the portrait of the young piano player show the rule of thirds at work. In each, the subject is placed at one of the suggested intersections and the picture is balanced nicely.

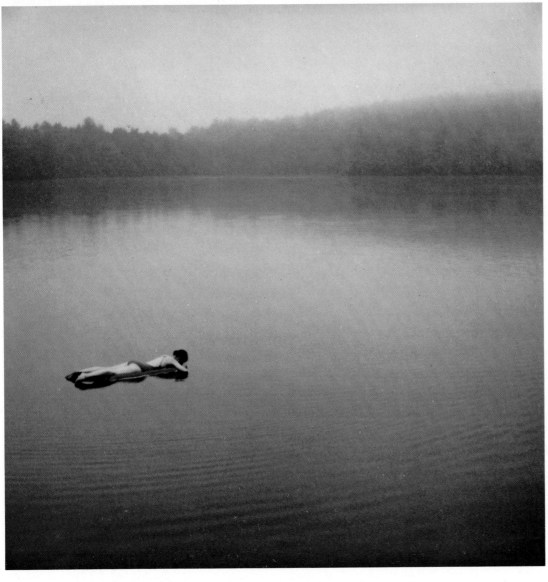

Space, when used properly, can enhance the purpose of a photograph. As shown in this composition, space serves to emphasize the isolation of the tiny floating figure. Note that the rule of thirds is also at play.

Lines

Lines have many uses in a composition. They can serve to connect objects or to isolate them. Most important, you should be aware of how lines lead the viewer's attention around the composition. Horizontal lines suggest calmness and tranquility, whereas vertical lines give a sense of strength, dignity. A prairie's horizontality is peaceful compared to a skyscraper's dramatic vertical lines. Diagonal lines lend movement and zip to an image, while curves can give a feeling of serenity or romance. Sometimes lines are present physically on surfaces being photographed, as evident in the picture of the beach jetty that forms a strong vertical line. Or lines can be subtly suggested, as in the psychological lines in the portrait of three bearded men. Lines lead the eye and can directly tug toward or away from a subject. The main thing is to use lines effectively. Be sure to keep the horizontal and vertical lines of subjects parallel to the edges of your frame—particularly horizons, doorways, and ceilings.

Below left: The vertical line of the jetty pulls the eye back and forth to the top and bottom of the frame. Despite the turbulent ocean, the verticality of the jetty dominates. *Below right:* The horizontal, linear qualities of the weathered wood are peaceful and quiet, allowing the eye to rest. *Bottom right:* A powerful diagonal shadow formed by strong sidelighting on this pine branch transforms a tranquil subject into an agitated composition.

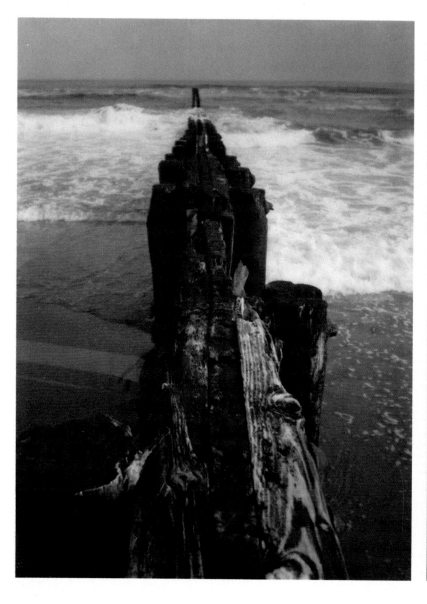

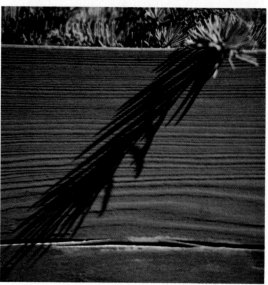

Psychological lines are a potent factor in the dynamics of this intriguing portrait. Each man's gaze creates a line of direction leading the viewer's eye outside the frame. The central figure looks downward while the others glance to each side, forming an elegant balance of lines. You also can perceive an implied line connecting the highlighted hands of each man, resulting in a very strong tension as the eye is buffeted back and forth.

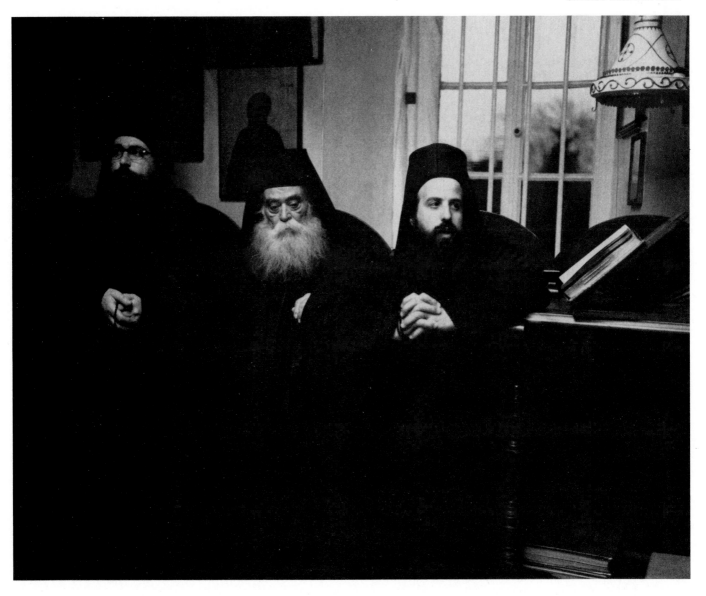

Depth

Lines can also express depth, as with converging railroad tracks, a road, or a trailing line that vanishes in the distance. But there are other ways to show depth, too. Henry David Thoreau once noted: "When the far mountains are invisible the near ones look the higher." The relative sizes of objects in a composition may create the illusion of depth, since foreground objects usually appear larger than distant ones. Objects that overlap in the field of view may also convey the three-dimensionality of space by appearing to recede into the distance. Framing a distant subject with objects in the foreground is a good way to use perspective to lend an impression of near and far. The sheer volume of space itself may be demonstrated when fine particles suspended in the air diffuse the light, producing a haze or fog. This effect is especially dramatic when a well-defined shaft of light cuts through the dust and moisture-laden air. Quite often this phenomenon, called atmospheric perspective, is visible in landscapes which appear to shroud distant objects in a mist.

Left: In this impressive picture, the lines—curving and vanishing into the distance—provide a perfect example of how lines can be used to express depth in a composition. The keen drama of the scene is further accentuated by the odd perspective. _Above:_ Lines that curve and disappear into the distance, as seen in this street scene by Brett Weston, are yet another way of guiding the viewer's eye around the composition and establishing a powerful spatial sensation. The overlap of the buildings' roofs also adds to the impact.

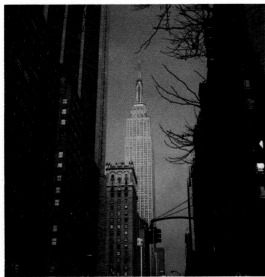

Top left: Converging lines also can suggest depth, as seen in this winter scene by Linda Benedict-Jones. The long directional sidewalk rapidly leads the eye from foreground to background. Further, repetition of the frozen trees receding into the distance, as well as the distinct color variation from foreground to background, also lends this exquisite photograph a good sense of depth. *Top right:* Depth can be evoked through the use of a foreground object to frame the subject. The skeletal tree branches reaching into the cyan sky on the right and the massive buildings on the left form a perfect frame to offset the Empire State Building. *Bottom:* Depth can also be suggested by overlapping subjects, as in this picture showing a row of band musicians marching in a parade.

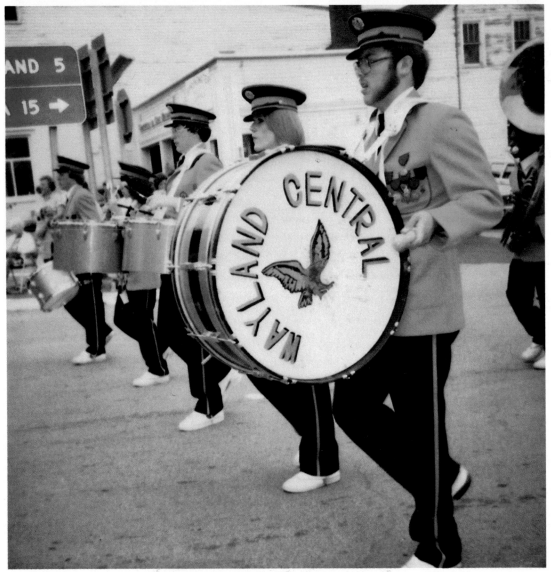

Balance

The placement of forms and shapes within the frame affects the visual balance of the image. If all objects were crowded at the top of a frame, the picture would be top-heavy; if all sat at the bottom, the result would be a bottom-heavy imbalance. By changing the position of objects, you can observe new balances and find the one arrangement that works to communicate the essentials of your subject. With still life subjects, you can physically move objects to make pleasing juxtapositions. With other subjects, you can change the position of the camera and frame the object differently. The important thing is to practice recognizing visual relationships between objects. When your analytical power to recognize such relationships increases, you can make it work to convey the impression you want.

Balance is an important element in making a photograph feel right and justified.

When the flowers are clustered at the top of the frame, the picture appears to be off-balance.

Ten-Point Shooting Checklist

✓ Decide what is important about the subject.

✓ Investigate the best vantage point for communicating the message.

✓ Use lines to direct attention.

✓ Use the foreground effectively.

✓ Arrange a balance of forms and shapes.

✓ Watch the interplay of colors.

✓ Be aware of light and notice how it falls on the subject.

✓ Keep the composition simple and check the edges of the viewfinder. Crop out unwanted elements.

✓ Keep the horizon line and any edges level.

✓ Relax, enjoy. Give your intuition a chance to operate.

When concentrated at the bottom, the clustered flowers still do not occupy the frame in a pleasing manner.

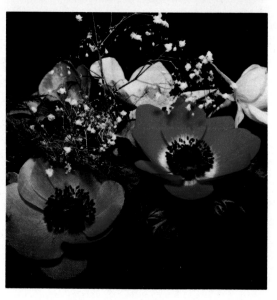

When the flowers are photographed from a different angle, the forms and shapes seem balanced more properly within the frame and the composition appears more satisfying to the eye.

Form, Shape, and Texture

Form is the three-dimensionality of an object contoured in a photograph by highlights and shadows which suggest bulk and weight. Shape refers to the overall configuration of an object, whether it is round or rectangular. The interplay of form and shape in a composition strongly influences the feelings evoked in a photograph. Sharp angular shapes, for instance, can give a picture jagged, vibrating sensations, whereas soft, rounded shapes are more peaceful and pleasant. Contrasting shapes, such as a round shape against a square one, will emphasize and exaggerate differences, while similar shapes, such as two round ones side by side, will echo one another and display symmetry.

Forms can be dense and weighty, such as the forms of boulders, or they may be graceful and light, as are the forms of ballet slippers. For effect, the forms of objects can sometimes be made to appear solid and heavy when, in fact, the objects themselves are light and delicate. Consider, for example, the picture of wine corks. The image suggests great bulk and the forms project a leaden quality, yet the objects weigh only a few ounces.

Texture is the tactile quality of surfaces. A bed of rocks, wind-eroded sand dunes, an orange rind, some wine corks, and cat fur all have different textures which appeal to the sense of touch in different ways. Light and its modulation of highlights and shadows can serve to accentuate the impression of texture or to downplay it. Soft, diffused light eliminates the tactile quality by making lines and details less distinct. Strong, direct lighting, sidelighting, and backlighting can enhance a subject's texture and result in richly exciting visuals.

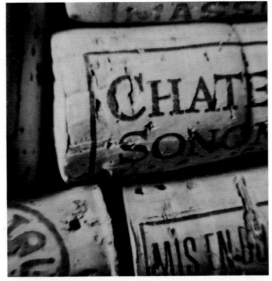

The outline of each of these wine corks represents its shape; its form lies in the sense of bulk. We all know that wine corks are light and delicate, yet this closeup perspective gives the subject a misleading feeling of tremendous size and weight. It underscores how unusual images can be created by varying perspectives. Notice, too, the subject's tactile surface, which gives it a marvelous textural quality.

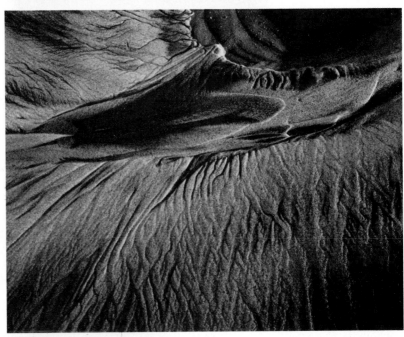

Strong lighting can enhance the texture of a surface, as seen in the exquisite photograph of a windswept, sandy terrain. The swirling shapes and moiré patterns intensify the picture's spectacular impression.

Light

It's the light that makes the picture. It's not just the moment.

—Marc PoKempner

Without light a photograph cannot be made. The word "photography" in the Greek language appropriately means lightwriting. Light visually defines objects, and the quality of light can alter the way you see reality. Bright, evenly distributed light results in upbeat, cheerful images. Dark, shadowy light creates mysterious, brooding, or even threatening visuals. Light can be used to highlight and call attention to a subject or can throw a subject into intriguing obscurity.

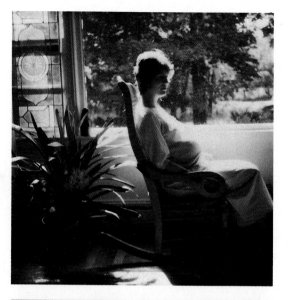

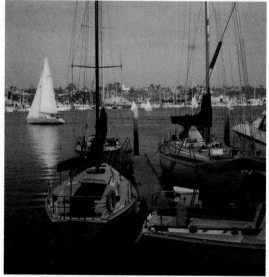

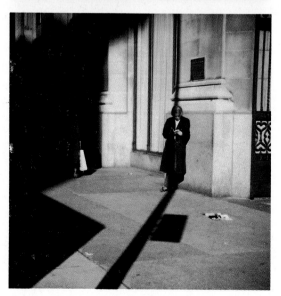

Light is an essential ingredient of and a crucial influence on the expressive powers of any composition.

Top: Diffused backlight can bathe a subject in a sentimental, romanticized glow, as in this portrait of a pregnant woman. Such indirect light softens the edges of objects, making them less distinct and conveying a serene, quiet mood. *Center:* A shaft of light streaking through a composition can add a highlight which focuses our attention, as in this seascape. The dimly lighted foreground objects are only a counterpoint to the bright highlight of the sailboat in the background which rivets the eye. *Bottom:* The interplay of light and shadow can create an intensely fascinating composition of mystery and intrigue. The linear shadow is used dramatically to draw the viewer's attention from the empty foreground to the single figure lurking in the distance. *Opposite page:* In this nude study by Minor White, light molds and defines the form. The highlights and shadows accent contours of the body: the muscular arms, the veined hands, the gentle curvature of the back. The picture's strength derives from the chiaroscuro, or the interplay of the light, as well as the captivating pose of the model.

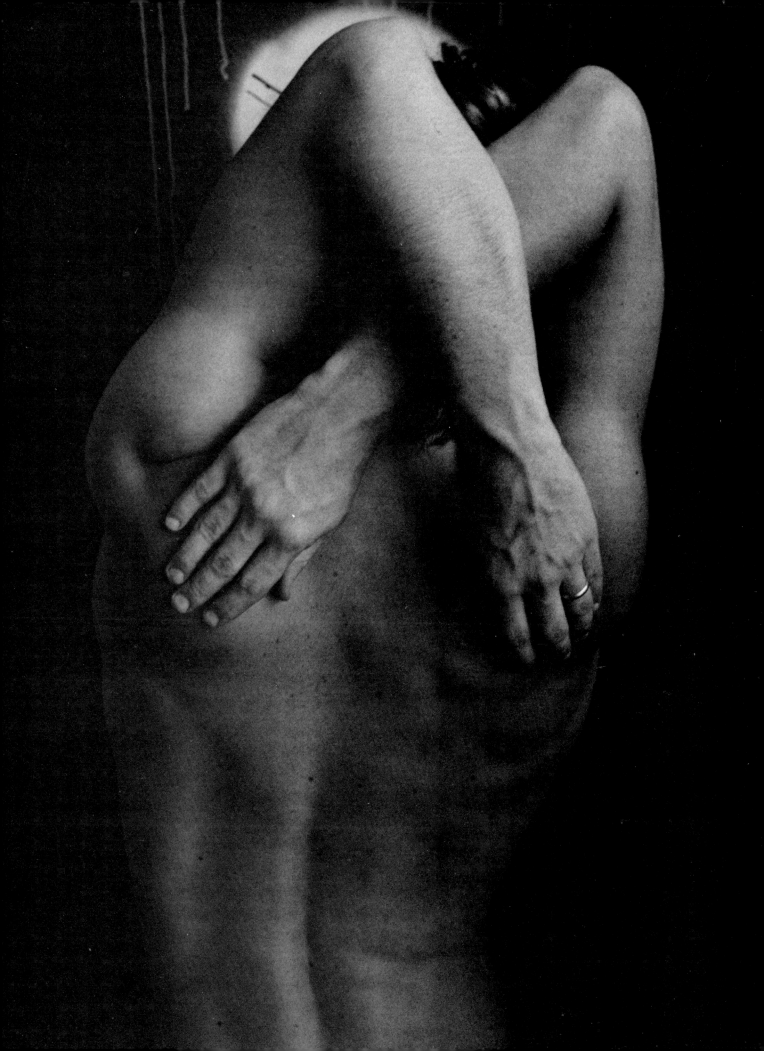

Light

The direction of light on a subject can have an enormous impact on the definition and mood of a picture. There are three kinds of basic lighting: frontlight, sidelight, and backlight.

Frontlight is achieved by using flash on camera or sunlight falling over the photographer's shoulder onto the subject. The illumination is even; however, the shadows fall behind the subject, making it appear very flat. Frontlight, therefore, works well for emphasizing two-dimensional shapes, but not for showing depth or texture.

Sidelight is achieved by positioning the source of light at one side of the subject. It is excellent for most subjects and offers much versatility. Sidelight from a high source provides a completely different effect than sidelight from a low-angled source. Sidelight can be used to accentuate a portion of the subject while throwing the rest into darkness. It can reveal the three-dimensionality of forms or bring out the intricate textures. It can show depth and volume or just create a mood.

Backlight is difficult to control, but for the right subject it can be very effective. In backlighting, the source of light is behind the subject so that the subject is wreathed in a ring of light but the front surface details remain in shadow. Silhouettes and partial silhouettes done with backlighting achieve stark, powerful effects.

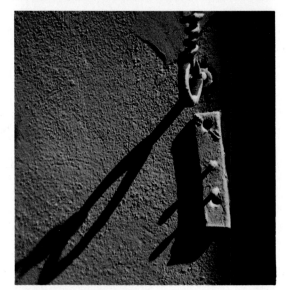

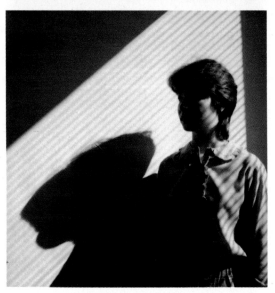

Top: Frontlighting produces an even, overall illumination which is excellent for colorful patterns, as you can see in the foreground of this picture taken with flash. However for three-dimensional subjects, frontlight is flat and shadowless and does not carve out texture or form. Notice that the fur of this black feline is hardly discernible. For the success of this image, however, texture and form are not so important as color and highlights; the floral pattern leads to the central feature, the penetrating eyes of the cat hanging like marbles within a dark face. _Center:_ Late-morning sun provided the sidelighting for this dynamic photograph, transforming a mundane subject into an extraordinary visual. The long shadow, the rounded three-dimensionality of the object, and the textures of the wall and the object exemplify the powerful effects of sidelighting. _Bottom:_ In another example of sidelighting, this natural windowlight portrait illustrates the use of lighting for effect rather than illumination. The subject is not so much the young woman as it is the light—a combination of stripes caused by Venetian blinds and a grotesque shadow adding intrigue. Notice, too, how the diagonals create tension.

This photograph by Harvey Stein was created with backlighting which silhouetted the subject to produce a most striking effect.

Light

Besides the direction of light, the variation from light to dark is an important consideration. On a sunny day, clear tones modulate off surfaces differently, giving images a great deal of contrast. From sunup to sunset, the quality of light constantly changes, as does the direction of light from the low horizon angle to overhead. Early morning light is saturated with orange hues, while midday light is bluish and harsh. More pros consider the most pleasing light to be during early and late hours when the sun hovers close to the horizon, casting long shadows, resplendent in glowing reddish-orange colors. On a cloudy day, the quality of light is entirely changed, and the colors from sunup to sundown are fairly monochromatic. The highly diffused light on such days diminishes contrast and enhances soft edges. The result is a moody, romanticized impression.

In extremes of lighting, you might consider toning down bright hot spots and bringing out more detail in the shadow areas. You can do so by using the lighten/darken control on your camera. To reduce highlights, you dial in one stop on the darken side. To expose more details in the shadow areas, move the exposure one or two marks to the lighten side.

6 A.M.

From sunrise to sunset and into the evening hours, the changing effects of light can be extreme. All six photographs were taken during one day from 6 A.M. to 9 P.M. Note the variations in the sun's color tonalities from 6 A.M. to noon. Note, too, the difference between the frontlighted clarity of 9 A.M. and the haunting backlight of 3 and 6 P.M. Then consider the total transformation of the nighttime skyline. The Polaroid SX-70 camera was used for all pictures. The lighten/darken control was at the normal setting in each case.

3 P.M.

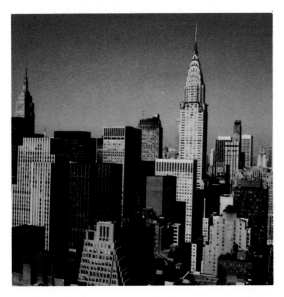

9 A.M.

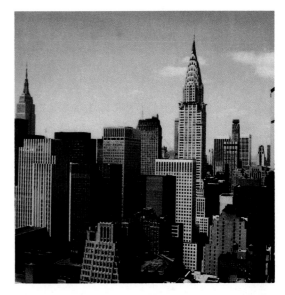

Noon

6 P.M.

9 P.M.

Light

Indoor light is no less varied than outdoor light. Sources range from sunlight shining in, to incandescent light from ordinary household bulbs, to fluorescent lights. Instant films are designed to respond to natural sunlight, which is rich in blue and deficient in red. Thus instant photos taken under red-rich, blue-deficient incandescent light produce warm, orange-hued images. Fluorescent light is different, lending a bluish-green cast to a photograph. Candlelight is copper-colored. Thus you should consider the kind of light available where you are shooting.

To overcome unacceptable lighting, such as fluorescents which give flesh tones a sickly, unflattering look, use a flashbar or strobe attachment. The light of the flash is balanced toward the blue end of the color spectrum and will supply the missing component needed to color balance the picture properly. Filters can also be used to compensate for lighting variations. (Refer to the filter section in "The Art.") Pay attention to light variations around you. Study the nature of light and how it falls on your subject. Time and experience will fine-tune your sense of light.

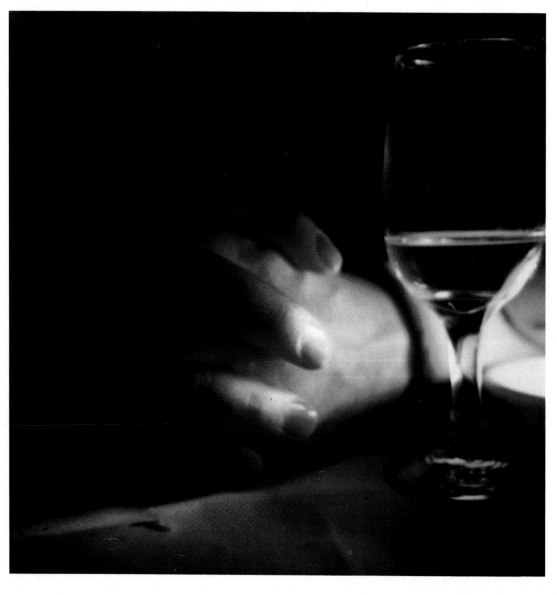

The flicker of candlelight with its rich orange hues lends this subtle image a charming, poetic quality. The camera was held very steadily—braced on a table—to keep the subject in focus during the long exposure. The candle was placed to one side to add to the dramatic lighting.

The natural sunlight of midday streams into this room and lends a bluish cast to the scene. The coolness of the colors is quiet and in harmony with the actual feeling of the moment.

Color

The visual world is made up of a spectrum of colors ranging from indigo to red. By their very nature, colors tend to dominate an image. Therefore, they demand crucial consideration in instant color photography. Look at the photograph of the red tomato and the large, dark-colored pot. If the photo were black and white, the form of the pot would engage the eye because of its very bulk. But clearly it does not in this color rendition. Instead you are attracted magnetically by the small red fruit. Why? The reason is simply that red—the color of blood, the color of anger—has a strong emotional impact. It is no accident that an idiom for being angry is "seeing red."

To use colors effectively, you must understand their impact. Colors are divided into two categories: assertive (hot) colors which are bold, boisterous, and eye-catching; and passive (cool) colors which are gentle, soft, and recessive. Red, yellow, and orange belong to the first class, whereas green, blue, and brown are passive and more restful.

Color can serve a multitude of purposes. Since it reveals far more about a subject than monochromatic black and white, it can be a powerful tool for providing precise information about a subject. Combinations of hot and cool tones can create a color dialogue. Conflict and tension can be depicted by two aggressive colors fighting for prominence; quiet and serenity can be evoked by cool, harmonious tones. Color also can be decorative. Patterns of vibrant, aggressive colors can be eye-riveting; light, delicate hues can be whimsical and poetic.

Colors also are associated with specific objects. Grass is green, sky is blue, apples are red. These built-in color associations accelerate recognition of objects. Sometimes by contradicting the norm—and using colors not typically expected for subjects—a photographer can create surreal, striking images. Filters can turn the sky red and the grass blue.

Color plays on perceptual and psychological conditioning and may evoke distinct responses. Research has shown that people are more agitated by red than they are by blue or green. In one study, the pulse rates of a group of people placed in a red room increased. When the same group was placed in a blue room, their autonomic systems slowed down their hearts and relaxed their breath-ing. Researchers concluded that red hues stimulate the system while blues and greens are more tranquilizing and peaceful.

The psychological implications of colors are even more fascinating. For instance, red calls to mind apprehension and passion; blue evokes a spiritual and contemplative frame of mind. By knowing the psychological associations of color, you can understand clearly how colors convey impressions and strike certain moods as elements of visual language. Color enhances communication and should be used to help convey the photographer's message.

COLOR ASSOCIATIONS

anger, danger, fire, love

sea, sky, things cold, subdued, spiritual, distant, contemplative, cool, tranquil

sun, cheerful, vital, joyful, optimistic

abundance, restful, calm, pleasant

rich earth, ground, security

dignity, splendor, reverence of mourning and mysticism, royalty, richness

lively, funny, exuberant

cool, youthful, spirited, purity, zest

Below: Combining dominant colors with quieter, passive ones emphasizes elements in a composition and creates a color dialogue of visual elements. Even though the tomato is the smallest element in this photograph, it rivets your attention because red is a bold, "hot" color. The sharp contrast between the tomato's red form and the large, dark-colored pot also contributes to the impact. Notice, too, the clean lines and balanced symmetry of this composition. *Below right:* Yellows and reds are both hot colors. When such assertive colors are grouped together, as in this seaside composition, the effect is rhythmic and vigorous. *Bottom right:* Passive colors such as blues and greens have a quieting effect. When combined as in this landscape by Harvey Stein, the result is peaceful and harmonious. Generally, related colors can help to unify a composition.

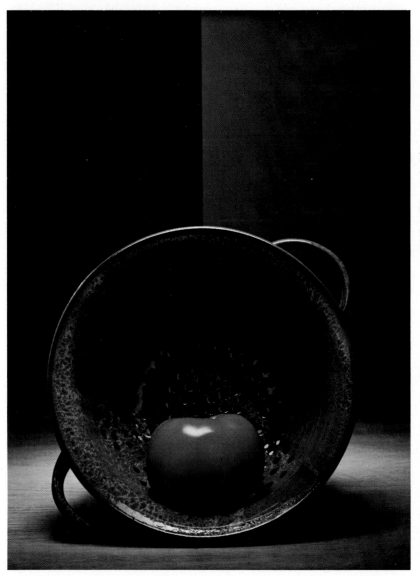

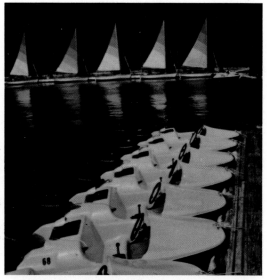

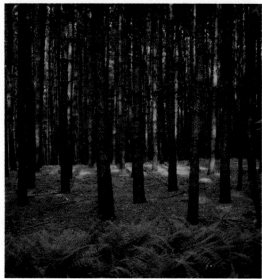

Equipment Variables

A final prerequisite in learning to see photographically is knowing how your equipment can affect the representation of a scene. Differences in instant camera models can be significant. The Polaroid SX–70 models are single-lens-reflex cameras which allow the user to see through the lens and observe exactly what will be exposed on the film. The obvious advantage is total control over composition. Other instant models—Kodak's Kodamatic or Polaroid's OneStep, for example—have a separate viewing lens which has a slightly different viewpoint from the one that actually exposes the picture. Therefore, with these cameras, you must be aware of the difference between how you see the subject and what you see in the lens and compensate when framing. You can easily analyze the difference by mounting your camera on a tripod (or setting it on a firm support), taking a picture, and then comparing the result with what you can recheck in the viewfinder.

Film differences are another consideration. Obviously black-and-white film has distinct properties making it unlike color film. Black-and-white film translates a subject into gradations of highlights and shadows called tonal values. Color film is generally more "faithful" to real life by representing a scene with a full spectrum of hues. With color film, however, hue variations occur from one film type to another and even from one film pack to another. For instance, Kodak's instant color film is slightly more cyan and cooler than Polaroid's Time-Zero film. The format sizes of these two films are also significantly different. The image area of Kodak film is rectangular, measuring approximately 3½ × 2¾ inches (90 × 67 mm), while Time-Zero film's is square, about 3⅛ × 3⅛ inches (79 × 79 mm). The resulting aesthetic variation is tremendous. The format influences the way forms and shapes interact within the frame and, with the Kodak rectangular format, the choice of a horizontal or vertical frame. Naturally, when working with larger formats such as 4 × 5 or 8 × 10 or 20 × 24, you must take compositional elements into account in a new way. Object sizes and form relationships work differently in the varied frame sizes.

Print surfaces also differ. The Kodak film has a matte surface which gives a generally flat, dulled impression. The Time-Zero film has a clear, glossy surface and, because of its

dye layering process, actually has a slight three-dimensional quality.

As you use your equipment, be aware of its special idiosyncrasies. These aspects can be used to advantage if you take them into consideration. If you don't, they can be the bane of your picture-taking existence.

Format can have a tremendous influence on the way forms relate within a frame. Imagine this beautifully composed, square-format picture in a rectangular format. The rocks would not fill the frame in a balanced and pleasing manner and the scene would have to be reframed.

Black-and-white is a far more interpretative medium than color. Objects are translated into tones of black, gray, and white according to their inherent colors and the intensity and direction of light. The extraordinary range of tonal values is readily seen in the stunning landscape by Stephen Gersh.

THE TOOLS

The camera need not be a cold mechanical device. Like the pen, it is as good as the man who uses it. It can be the extension of mind and heart.
—John Steinbeck

Any tool is only a means to an end. In instant photography, the tools consist of cameras and film, and the end is the pictures whose success varies according to the knowledge and experience of the user. This section is aimed at the photographer who wants a more comprehensive understanding of instant cameras and films with the ultimate goal of learning how to handle and control instant equipment and produce better pictures.

The chapter begins with an overview of basic cameras and some practical information about focusing, exposure, and using flash, followed by the use of basic films. (The Guide at the end of the book provides more detailed information and many illustrations on the inner workings of each basic camera type with step-by-step instructions for the use of specific camera models, a section on film technology, plus a roundup of accessories and a look at professional cameras and equipment.) A concise troubleshooting guide is then provided, and the chapter concludes with instructions for cleaning and maintaining your camera.

For novices entering the world of instants for the first time, the information should clarify and simplify; for veterans who may have left their cameras sitting on shelves a little too long, it should be a worthwhile memory refresher.

Basic Cameras

Essentially six types of instant cameras are presently available internationally. All, except pack cameras, use integral film—a self-contained film that is automatically ejected from the camera and develops outside, before the photographer's eyes. (A seventh type of instant camera, the roll-film camera, also exists. However it is not being included in this text because it is an old and rarely used model. But roll film is still being produced for use with these early units.) The six types of instant cameras are as follows:

- Folding cameras for Kodamatic Instant Color film
- Nonfolding cameras for Kodak Instant Color Print film
- Folding single-lens-reflex (SLR) cameras for Polaroid SX–70 Time-Zero film
- Nonfolding cameras for Polaroid SX–70 Time-Zero film
- Sun Cameras for Polaroid 600 film
- Polaroid pack film cameras for peel-apart film

In a sense, it seems ironic that the latest instant cameras are so simple to use and yet are based on sophisticated electronics and technology. The newer instant models have eliminated the need for pulling film tabs or coating prints, or for setting or focusing lenses. With these space-age marvels, the process of taking a picture has been reduced to pressing a button and watching the picture materialize in seconds. Visual gratification has been made virtually instantaneous. Breakthroughs and advancements in optics, film, and electronics have contributed to the increased facility of operation and the expanded capabilities (of certain models), especially in the hands of more advanced, experimental photographers.

For example, focusing features have come a long way since the early days. Vintage instant cameras had to be focused manually by setting a dial to adjust the correct distance from subject to camera. In many of today's instant models, focusing is done by the camera, not the photographer. Optical advances have made it possible to produce good quality fixed-focus lenses, as found on cameras like the Kodamatic 960 and Polaroid One-Step. With these cameras, subjects from a set minimum distance to infinity are rendered in sharp focus so the user is relieved of thinking about focusing and need only point, compose, and shoot.

Electronic advances have come into play in several other instant cameras, making a complex autofocusing system possible via a sonar transducer. When the shutter button is partially depressed in any of these autofocusing cameras like the SX–70, Pronto, and some Sun Cameras, the sonar emits a high-frequency 50 kHz ultrasonic signal which is transmitted to the subject. As soon as the echo is received by the camera's transducer, the travel time of the sound wave is computed, the sound energy is converted into electrical pulses, and the data are sent to the power circuits that activate the focus motor rotation on the lens. The focus motor then drives the front element of the lens to the appropriate position for sharp focus. The entire operation is accomplished in milliseconds. When the shutter button is completely depressed, the picture is recorded in perfect focus.

While understanding how an instant camera works may have little bearing on basic picture-taking abilities, a glimpse into the inner workings of these twentieth-century machines can be intriguing and enlightening. More detailed information on the technology is included with each camera in the Guide at the end of the book

One of the advances seen in some of today's line of instant cameras is the amazing autofocusing system, based on sound waves.

Folding cameras for
Kodamatic Instant Color
film

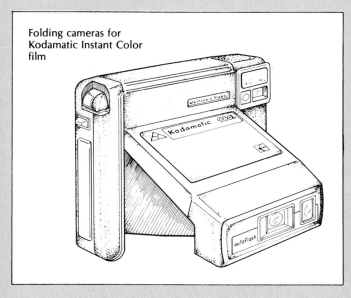

Nonfolding cameras for
Kodak Instant Color Print
film

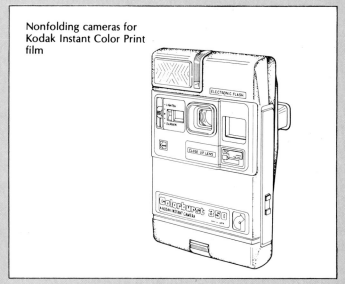

Folding single-lens-reflex
(SLR) cameras for Polaroid
SX–70 Time-Zero film

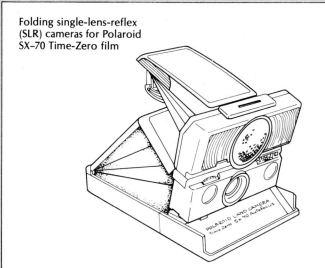

Nonfolding cameras for
Polaroid SX–70 Time-Zero
film

Sun Cameras for Polaroid
600 film

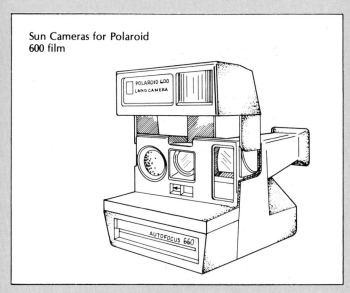

Polaroid pack film cameras
for peel-apart film

Exposure

Instant cameras are equipped with automatic exposure control. As you take a picture, an exposure sensor reads the light reflecting off the subject and automatically sets the camera's lens opening and shutter speed according to the amount of light needed to register the scene on film. For a very bright scene, the lens opening is tiny and the shutter speed (which determines how long the lens stays open) is very fast; for a dim scene, the lens opens wider and the shutter speed is slower in order to allow more light to enter the camera and expose the film.

The actual process of taking a picture appears perfectly simple. The photographer focuses and presses the shutter button; the camera does the rest. For evenly lighted situations—with all parts of the scene having about the same brightness—the exposure control works fine and the subject has well-balanced colors. However, sometimes in uneven lighting—with bright backgrounds and dimly lighted main subjects, for instance—the exposure sensor is fooled and as a result the lens opening and shutter speed are set improperly. In this instance, the lens would have a tiny opening and the shutter speed would be fast in order to let in a small amount of light to properly expose the background, but the main subject would appear far too dark. In certain lighting conditions, the photographer must compensate by making a few adjustments on the camera's manual controls. Of course, before the controls can be changed, you must be aware of the lighting situation and know what to do.

Bright surfaces such as water, white walls, ice, snow, and mirrors are highly reflective. When included as a large part of the picture, they can reflect too much light and thus fool the electric eye into setting the camera for the background instead of the main subject. As mentioned before, this results in the subject becoming too dark, sometimes even silhouetted. There are two ways to compensate: you can either move closer to the subject to eliminate most of the background reflectiveness or turn the lighten/darken control on your camera one or two marks toward lighten. The background colors may wash out because they will now receive too much light, but the main subject will be properly exposed.

Effects of using the lighten/darken control

Two marks toward lighten.

Normal setting.

Two marks toward darken.

Dark backgrounds behind a subject, such as green foliage, a black wall, or dark wood, reflect too little light and can mislead the electric eye in the opposite direction. As a result, the exposure is too long and the subject is overexposed, the colors washed out. Again, you have two options: either move closer to the subject to eliminate the large dark areas from the composition or use the lighten/darken control, setting one or two marks toward darken.

You may notice when experimenting with the lighten/darken control that the color balance of the composition is changed. If a subject is lightened too much it can lose its colors, the reds and blues fading to pale pastels. Or in the other extreme, if a subject is made too dark through exposure, colors become somber and muddy. After adjusting the lighten/darken control to achieve the desired results, be sure to return the control to its normal position.

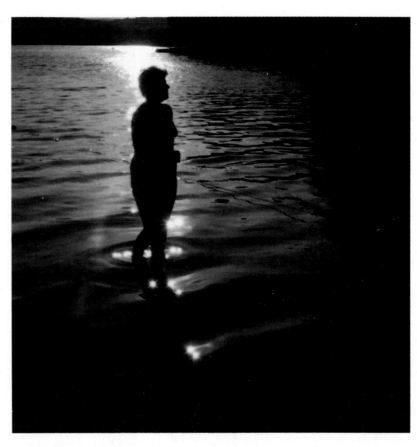

Using the lighten/darken control to enhance bright daylight scenes can be extremely effective. In this comparison, the difference in contrast and color saturation between the photographs is quite obvious. In the first exposure it is difficult to make out the dome of the building or the clouds, as compared to the second exposure in which the sky's tone is deepened, setting off the dome and making the clouds clearly visible. _Below:_ Lighten/darken control: Normal. _Below right:_ Lighten/darken control: One mark toward darken.

Above: Bright water backgrounds like this can fool the camera's electric eye into exposing for the water brightness instead of the more dimly lighted person. The sparkling sunlight glinting off the surface exaggerated the problem, making the scene appear as a moonlit night. As a result, the person is silhouetted, which happens to make a very effective image in this instance. However, to reveal the person more clearly, the photographer would have had to move the lighten/darken control all the way to lighten.

Exposure

Another subtle influence on exposure is color. For example, in a composition of mostly harmonious tones—say, greens and blues—the addition of a bright red can affect more than just our perception of the subject (as pointed out in "The Vision"). It physically alters the way the film records surrounding colors slightly and increases contrast. The hot, primary color deepens the other tones in the composition; thus the blues and greens become more saturated.

DEPTH OF FIELD

With some cameras, exposure can affect depth of field, too. Depth of field is the distance between the nearest and the farthest points that appear in sharp focus in a scene. When the lens opening is wide—as needed for low-light situations—the depth of field is shallow. In other words, in dim light, if focus is on an object in the foreground, the background will be out of focus; if focus is on the background object, the foreground object will be blurred. When the lens opening is very small—as in brightly lighted situations—the depth of field is much greater. In that situation, if the camera is focused on the same foreground object, the background would also be in focus.

The depth of field variable can be used for selective focusing to bring attention to an important detail within a composition, as illustrated by the photograph of the dancer tying her ballet shoe in the section on "Selection" in "The Vision." This is not possible, however, with instant cameras that have a fixed focus lens, since all objects from a set minimum distance to infinity are always in focus. The portrait of the couple at the falls shows this effect. From the couple, standing 4 feet (1.2 m) from the camera, to the falls in the distance, all points are in focus.

TIME EXPOSURES

If the overall lighting of a scene is extremely low, some cameras have a warning signal; usually a red light comes on. If flash is not used, then the photographer must prepare for a time exposure requiring the shutter and lens to stay open a very long time. As this happens, the camera audibly clicks twice; once as the lens and shutter open, and a

When a dark background or foreground takes up a large area of the picture, the electric eye is misled into exposing for the dark areas instead of for the person, who reflects more light. The result is correct exposure for the dark areas, but overexposure for the light ones. In this example, the subject's face and shirt are much too light. Turning the lighten/darken control toward darken would have corrected the problem.

Since fixed focus cameras maintain a constant focus from a minimum distance to infinity, the depth of field is also constant. Such cameras cannot be used for selective focusing but are extremely effective for scenes with a lot of depth, such as this travel portrait, rendering both the couple and the picturesque falls in the distance in sharp focus.

second time as they close, after enough light has entered. Firm support is needed to steady the camera for any exposure longer than one-fifteenth of a second in order to avoid camera shake. (Time exposures can be as long as two seconds with the Kodak Colorburst camera and up to fourteen seconds with the Polaroid SX-70.) It is best to use a tripod, but you can improvise with tabletops, fences, car hoods, and any other stationary objects.

Using Flash

For most dimly lighted, indoor situations, flash is recommended. To achieve good flash pictures, try to avoid the two major flash errors: inexact focusing and improper subject placement.

Since flash output in some cameras is regulated by the distance between the subject and the camera, an improperly focused lens can mislead the flash into firing the wrong amount of light. Depending on the camera's distance, the subject can appear either bleached white or charcoal black. Therefore it is important to determine the correct distance between the subject and the camera and set the lens precisely.

For the same reasons, subject placement is critical. If subjects are positioned at varying distances from the camera, the focus on them cannot possibly be the same and therefore the correct flash output will differ from subject to subject. If a dozen people are seated at a long table and photographed from one end, the flash cannot cover evenly. If focus is on the nearest person, the flash will provide the proper light for that person but throw distant people into blackness. If focus is on a distant person, a nearer person will be overexposed, much too light, and out of focus. The obvious solution is to arrange groups so that everyone is about the same distance from the camera. In this instance, everyone should be positioned on one side of the table; six people could be sitting and six standing, so that they are all within a range of 7 to 8 feet (2.1 to 2.4 m) from the camera.

Another important consideration is the range of your flash. If you exceed the range, your subjects will not be properly exposed.

FLASH RANGE

Cameras	Bars	Cubes	Electronic Units
Kodak Colorburst	4 to 9 ft. (1.2 to 2.7 m)		2 to 9 ft. (56 cm to 2.7 m)
Kodak Kodamatic 980L			3 to 14 ft. (1 to 4.2 m)
Kodak Kodamatic 970L			2 to 12 ft. (56 cm to 3.7 m)
Kodak Kodamatic 960			4 to 12 ft. (1.2 to 3.7 m)
Polaroid SX–70	10.4 in. to 20 ft. (25 cm to 6 m)		10.4 in. to 20 ft. (25 cm to 6 m)
Polaroid One-Step and Button	4 to 8 ft. (1.2 to 2.4 m)		4 to 9 ft. (1.2 to 2.7 m)
Polaroid Pronto!	3 to 12 ft. (1 to 3.7 m)		3 to 12 ft. (1 to 3.7 m)
Sun Camera			2 to 14 ft. (56 cm to 4.2 m)
Polaroid Pack Cameras for Peel-Apart Film		4 to 8 ft. (1.2 to 2.4 m)	

Using Flash

Some flash units are equipped with lighten/darken controls on the units themselves. With these, if a white reflective background causes the subject to become too dark, set the lighten/darken control a mark or two toward lighten. The background may be washed out but the subject will be well exposed. Or if the background is very dark, turn the control one or two marks toward darken.

Dark-haired subjects can pose a curious problem when flash is used. When positioned too far from a background, a subject is isolated by flash, as the light is not sufficient to illuminate any distant objects. Occasionally the effect can be very dramatic, since the subject's hair or clothes blend into darkness and the face is strikingly emphasized (see an example in "The Pictures," in the section on portraits). Of course, the effect is not as pronounced for light-haired subjects. In any case, this is not usually desirable. To achieve a clear separation of the subject while retaining some of the background for contrast, pose the subject closer to the background. For good contrast, use a colorful background. (See the example in "The Pictures," in the section on children.)

Flash reflections can be another annoying hazard. Glass, mirrors, and other shiny objects reflect hot spots back into the camera that appear in the picture as ugly white circles. To avoid this, position the camera at an angle to the subject. Instruct people wearing eyeglasses not to look directly at the camera, but to incline their heads or look to the side.

Another indoor flash portrait problem is red eye. This is caused by the flash reflecting off the retina of the eye and is registered in the picture as red circles in place of the subject's natural eye color. Blue-eyed adults and small children mostly are affected. To eliminate the problem, turn on bright room lights to make the subject's pupils contract.

FILL-IN FLASH OUTDOORS

A brightly shining sun does not necessarily mean it is time to put away your flash unit. Fill-in flash for daylight situations can turn very poor pictures into excellent ones. The midday sun, notorious for its harsh shadows and blue tones, can be tamed by using flash to fill in shadow areas and balance the colors of an unevenly lighted scene. If part of the

Comparing pictures of the same subject taken with and without flash dramatically illustrates the differences. In the picture without flash, the bright window light bleaches out the outside scene entirely and silhouettes the inside furniture, giving only a hint of the indoor setting. The picture with flash provides far more information, showing details of the furniture, even revealing ski boots in the foreground, and increasing the intensity of colors. And the outdoor scene is now visible, since the very bright window light has been counterbalanced by the flash illumination.

subject is in shadow and part in bright light, flash can even the lighting. For example, a wide-brimmed hat on a young woman may cast her eyes into dark shadows. With fill-in flash, the shadows are eliminated and her face is evenly illuminated. (See the example in "The Pictures," in the portraits section.) For scenic photos, flash may serve to deepen the colors, providing better saturation and richer hues.

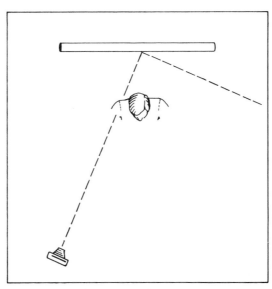

Far left: The flash has caused a hot spot reflection on the window glass and ruined a rather nice portrait. *Left:* To avoid flash reflections, shoot the subject from a 45-degree angle so the flash bounces away rather than back into the camera. *Bottom:* The key to making good flash portraits is to set the focus accurately and position the subjects at an even distance from the camera, as in this wedding picture of bridesmaids.

Basic Films

This section offers a detailed review of today's popular instant films and, more importantly, a checklist on film handling. To ensure optimum picture results, be sure to familiarize yourself with these important basics.

COLOR

Kodak Instant Color Print Film

This film is an integral, self-developing color print film with an image area of approximately 2-3/4×3-1/2 inches (67×90 mm) for use in Kodak instant cameras only. Estimated rating is ASA 150. The Kodak print is ejected from the camera and processed within a self-contained film unit in about eight to ten minutes. The picture has a textured, Satinluxe surface. Each film pack contains ten pictures.

Kodamatic Instant Color Film

The major difference between Kodak's Instant Color Print film and Kodamatic Instant Color film is that the latter has a higher film speed (an ASA of 320). (The film speed was increased by altering the size of the silver halide emulsion grains and thus increasing the dyes' sensitivity to light. Also, a small amount of titanium dioxide has been dispersed through the red and green emulsion layers. See "Film Technology" in the Guide at the end of this book.)

Kodamatic Instant Color film is an integral, self-developing color print film with an image area of 2-3/4×3-1/2 inches (67×90 mm) for use in the Kodamatic line of cameras only. The print is processed within a self-contained film unit in about eight to ten minutes. The picture has a textured Satinluxe surface. Each film pack contains ten pictures.

Polaroid Time-Zero Supercolor SX–70

This is an integral, self-developing color print film with an image area of 3-1/8×3-1/8 inches (79×79 mm) for use in designated Polaroid cameras. Time-Zero is balanced for daylight and electronic or blue flash and has an estimated rating of ASA 150. It is automatically ejected from the camera and processing occurs within a sealed Mylar-covered unit resulting in a brilliant, clear surface. The

processing time at 75°F (24°C) is approximately sixty seconds. Each film pack contains ten pictures and a high-capacity Polapulse battery to power the camera's electronics.

Polaroid SX–70 Color Print

This is an early version of the Time-Zero film with similar characteristics, format, and light balancing. However, it has a longer processing time of approximately four minutes.

Polaroid 600 High-Speed Color Print

Externally similar to Time-Zero Supercolor SX–70 film, Polaroid 600 differs in its increased ASA rating of 600, four times faster than that of Time-Zero film. (The increase has been accomplished by adding two spacer layers below the red-sensitive and blue-sensitive silver halide emulsions to increase the efficiency of light utilization, and by changing to a clear coat in the positive image-receiving layer to reduce light scattering. See "Film Technology" in the Guide at the end of this book.)

The 600 film is an integral, self-developing color print film used in 600 camera systems only. Each film pack contains ten pictures and a higher-capacity Polapulse battery than the SX–70 film pack to power the extensive electronics of the camera.

Polacolor 2

Polacolor 2 is a peel-apart color print film producing high-contrast fade-resistant colors. It has limited exposure latitude and is not recommended for extreme lighting situations with great contrast, such as a scene of bright highlights and dark shadows. It is available in a variety of types and formats, as follows.

Types 668 and 108. Both have an ASA of 75, an image area of 2-7/8×3-3/4 inches (7.3×9.5 cm), a processing time—at 75°F (24°C)—of sixty seconds, and are color balanced for daylight. Both have eight pictures to a pack.

Type 88. Virtually a square-format color film with an image area of 2-3/4×2-7/8 inches (7×7.3 cm), it has an ASA rating of 75. Eight pictures are contained in each pack.

BLACK AND WHITE
High-Speed Polaroid Films

For general purpose black-and-white photography, several types and formats of instant print ASA 3000 film are available.

Type 107. Type 107 is a rectangular-format film with an image area measuring 2-7/8 × 3-3/4 inches (7.3 × 9.5 cm) and a processing time of fifteen seconds. Eight prints come in each film pack.

Type 87. Virtually a square-format film, it has an image area of 2-3/4 × 2-7/8 inches (7 × 7.3 cm) and a processing time of thirty seconds. Type 87 prints do not require coating. Eight prints come in each film pack.

Type 667. A rectangular-format film similar to 107, Type 667 differs in its processing time of thirty seconds as well as in producing prints that do not require coating.

Roll Films

Types 47 and 42. Type 47 is a roll-film format with a processing time of fifteen seconds. Type 42 is also a roll-film format but is fine-grained and has an ASA of 200 and a wide tonal range.

Positive/Negative Polaroid Film Type 665

This is a rectangular-format film with an image area of 2-7/8 × 3-3/4 inches (7.3 × 9.5 cm) and an ASA of 75 for print, ASA 35 for negatives. One pack contains eight prints/negatives. It produces a lustrous, high-resolution print along with a usable negative. The negative requires clearing in sodium sulfite solution and washing and drying before use.

Film Handling:

√ Keep film in its protective carton until ready for use.

√ Store in a cool, dry place. Film may be kept in a refrigerator to retard aging and color shifting, but before using wait at least one hour for cold film to reach room temperature or condensation will form.

√ Use film before it becomes outdated. Film expiration dates are printed on the bottom of film packs.

√ Do not expose film to heat, humidity, chemical vapors, industrial gases, or radiation.

√ Never squeeze or crush the center of film packs.

√ Avoid loading film in direct sunlight.

√ For pack and roll films, be sure to set ASA according to directions on film pack.

√ When using integral films, do not block the camera's exit slot. When using pack or roll film, pull picture smoothly from camera.

√ Never bend or squeeze a picture when the developing process has begun. Always handle the picture by its white borders.

√ Keep developing pictures within specified temperature ranges. Ideal temperatures are 60 to 90°F (16 to 32°C).

√ Never leave film in direct sunlight or on hot surfaces during development or pictures will become too dark.

√ Be sure to remove film cover before using.

√ When using black-and-white films requiring coating, coat prints (with enclosed coater in box) within 30 minutes. Coat on a flat surface, using six to eight smooth overlapping strokes to cover the print evenly. Allow prints to dry.

√ Always read the film instruction sheet packed with each box. Integral film instructions are printed on the film box itself and on the ejected cover sheet.

Basic Films

To Process the Negative of Positive/ Negative Type Film:

1. Separate the print from the negative swiftly and evenly after the processing time has elapsed.

2. Tear off the paper leader just below the pod and remove the paper mask from the negative. Discard the paper.

3. Place the negative in a 12-percent sodium sulfite solution to remove the residual chemicals. This should be done within three minutes. A tray or bucket may be used. Negatives may be left in the solution for up to seventy-two hours. To mix the solution, use 112 ounces (3.7 liters) of warm water and add 16 ounces (500 grams) of sodium sulfite powder (anhydrous/desiccated), stirring continuously until the powder is dissolved. Allow the solution to cool to approximately 70°F (21°C) before using. If a sodium sulfite solution is unavailable, wash the negative in cool running water to clear the black back coat. Handle the negatives with extreme care, as they may be easily scratched.

4. After the sodium sulfite treatment, remove any remaining tabs and wash negatives for five minutes in running water. If washing several negatives at once, keep them separated to avoid scratching.

5. Dry the negatives in a dry, dust-free place. Use film clips, hangers, or clothespins. (To prevent drying marks, use a wetting agent—such as Kodak's Photo-Flo diluted at least 1:600. Dip the negative into the wetting agent before hanging it up to dry.)

6. Store each negative in an acid-free glassine envelope.

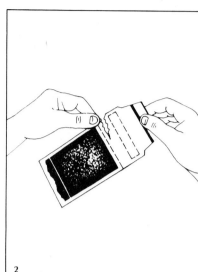

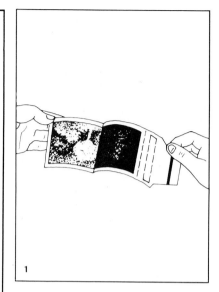

Maintenance

Store the camera and film in a clean, cool place away from heat, dust, and excessive humidity. Folding cameras should be kept closed and preferably protected in a camera case. Film should stay sealed in film boxes until ready for use. Film boxes may be kept in a refrigerator, but never in a freezer. Before using refrigerated film, allow it to warm at room temperature for at least one hour.

Keep the camera and lens clean. Blow off dust. Wipe the camera body with a damp cloth. Clean the lens, viewfinder window, and electric eye with a soft, clean, lint-free cloth or special lens cleaning tissue made for cameras. (Never use eyeglass cleaning tissues, which can scratch lens surfaces.) Use a gentle, circular motion. For greasy fingerprints, use a drop of camera lens cleaner. For dust on mirrors inside the camera, use a rubber syringe to blow air into the film compartment. Never use any other cleaning material inside the camera.

Keep the developer rollers clean. The developer rollers are located inside the film door. If film is remaining in the camera, open the door in subdued light. Clean the rollers with a soft, lint-free cloth dampened with clean water. Rotate the rollers. This should be done regularly.

Use fresh batteries.

When cleaning the rollers, use a lint-free swab and rotate the rollers.

Troubleshooting

Though the ability to see pictures instantaneously is a sublime advantage with instant photography, it can be a source of tremendous frustration when things go wrong. This guide is provided to resolve your instant-picture-taking troubles. Simply find the description of your problem—whether your picture is too light, fogged, or marred by brown globs—and then read the solution(s) you can use.

Improper Handling of Camera or Film	**Solution**
• Blurred pictures	Hold camera steady; press shutter button gently. If red caution light comes on indicating long exposure, brace camera firmly (use tripod) or use flash. With the Polaroid SX–70, blurring can be caused by accidentally hitting the bellows during exposure (see the section on using the SX–70 in the Guide). With an autofocusing sonar, blurring may result from shooting through glass. Use manual focus control.
• Picture area black	Keep hands away from lens.
• Fogged pictures	Avoid removing and reinserting film pack. Avoid opening film door in bright light after film cover has been ejected.
• Brown globs	Avoid pressing center of film pack. Hold pack by its edges. This problem can also be caused by excessive cold (developer thickens and does not spread evenly). Keep film in an insulated bag, inside jacket, or in heated vehicle until ready to shoot.
• Blue-toned pictures	This problem is caused by excessive cold. Keep film protected from cold as above. Use cold clips for cameras loaded with peel-apart pack film.
• Featherlike designs	Avoid pressing center of image area while picture is developing. Hold picture by white border edges.
• Daylight picture too dark	Avoid placing a print on hot surfaces or in direct sunlight during development. In temperatures above 100°F (38°C), compensate by shifting lighten/darken control toward lighten.
• Daylight picture too light	In temperatures below 60°F (16°C), keep film inside warm coat pocket. For pack film cameras, use a cold clip.
• Stains, streaks, patterns, black edge or white specks	These imperfections are caused by improperly pulling the white and yellow tabs in peel-apart film. Tabs should be pulled in proper order. Avoid using a jerky, hesitant motion. Pull tabs with smooth, brisk movement, but not too fast or white specks will result.
• Horizontal marks on integral film	Avoid blocking the exit slot with fingers. Hold camera properly.

Improper Camera Maintenance	**Solution**
• Fuzzy pictures	Clean the lens.
• Repetitive spots	Clean the camera rollers.
• Dark shadowy spots consistently on same place in consecutive pictures	Dust is on the inside mirrors. Use rubber syringe to blow air into opened (unloaded) camera to dislodge.

Top: Brown globs are caused by squeezing the film pack center. *Above:* Blue tone is caused by excessive cold. The feather mark is caused by pressure against the image as it was developing.

Incorrect Exposures	Solution
• Black pictures	Check that the camera is set for correct ASA of film (for pack film cameras). Make sure batteries are not dead.
• Pictures too dark	Lighting conditions fooled the electric eye. Backlighting or too bright a background reflects more light than subject. Move close to subject or change angle of shooting. Or shift the lighten/darken control toward lighten. Or use flash. With peel-apart pack film cameras, pull tabs correctly and time the development properly. Increased processing time darkens shadows.
• White pictures	Avoid blocking the electric eye. Check film speed setting and make sure it is correct for the film being used. Do not remove half-used film pack from camera or the film will be lightstruck.
• Pictures too light	Check lighten/darken control to make sure it is in proper position. Keep fingers from blocking the electric eye. A dark background can fool the electric eye, causing the subject to appear too light. Move close to the subject or change angle. Or move the lighten/darken control toward darken. With peel-apart films, be sure to time development properly. Too little development time lightens shadows.

Improper Flash Usage	Solution
• Pictures too dark	Keep subjects within flash range. Check focus distance setting to ensure accuracy. Avoid arranging subjects at varying distances from camera. Don't use weak batteries. Check that flash is in proper position. Wait for ready light before taking pictures.
• Pictures too light	Keep subjects within flash range. Avoid arranging subjects at varying distances from camera.

Camera Malfunction	Solution
• Film cover does not eject (for integral film cameras)	Press shutter button again. If the cover is still not ejected, remove film pack and reinsert. Check batteries (with Polaroid films, try a new film pack). If film door does not close, film cover may be pushed partially out of the camera. Remove cover and close door.
• Print partially ejected (for integral film cameras)	Pull partially ejected picture from exit door. Try fresh batteries (or new film pack if using Polaroid films). Try squeezing the shutter button again, and hold. If the camera still does not complete the cycle, open film door in subdued light. Pull out the film pack and reinsert all the way. With Polaroid cameras, the top film piece, which has been exposed to light, is automatically ejected. With Kodak cameras, press the shutter button to eject top (lightstruck) print.
• Print not ejected at all (for integral film cameras)	Check film counter to see if any pictures are remaining. If there is more film, open film door in subdued light and try reinserting pack as described above. With folding SX–70 cameras, try closing and reopening the camera to clear the jam. (If camera does not close, never use force. Try squeezing shutter button again or repeat above procedure for reinserting film pack.) If using electronic flash, check that flash is on and fully charged. If using a flashbar, try reversing its side. If used bulbs are facing front, camera will not function.
• Viewfinder black (for Polaroid SX–70 cameras)	Try a new pack of film. Chances are the battery is weak.

THE PICTURES

The joy of looking, sensitivity, sensuality, imagination, all that one takes to heart, come together in the viewfinder of a camera.
—Henri Cartier-Bresson
Dialogue with Photography

Pictures are everywhere, occurring every millisecond; a fleeting smile, a delicate flower, a competitive tennis player, an island seascape are all potential photographic subjects. Left uncaptured, these moments are likely to be forgotten and slip into oblivion; recorded, they are preserved and remind us about important and interesting events of our lives.

Since pictures are omnipresent, it is not necessary to wait for special occasions to start photographing; nor is it necessary to travel to exotic places for inspiration. Photographs are in your backyard, your neighborhood, your house. To derive the greatest pleasures from picture-taking, you should have an understanding of some techniques to use in a wide range of situations.

This section supplies detailed information on picture-taking techniques and presents various types of pictures, including portraits, nature, landscapes, action, nudes, night photography, and so forth. Use the material as a springboard for improving your pictures and getting more enjoyment out of the instant picture experience. The previous sections, "The Vision" and "The Tools," gave you the basics of photography; now you are ready to apply what you have learned.

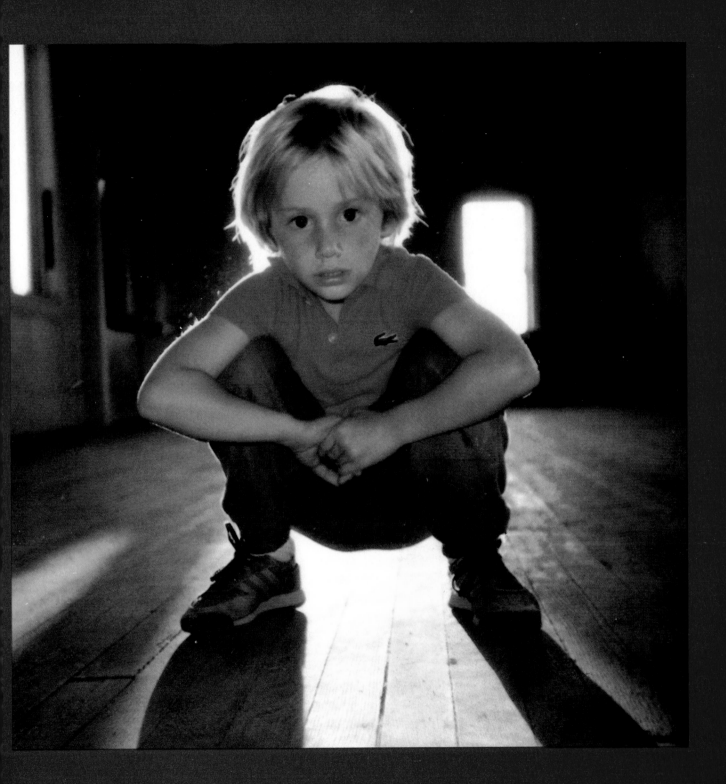

Action

The essential ingredient in action photography is a sense of vitality and movement. Stopping an instant of action would seem to deaden its energetic quality, but this simply need not be the case in photography. By using one of several simple techniques, a photographer can actually heighten the feeling of speed and zest in a still picture captured from a continuous flow of action.

Many beginning photographers mistakenly think that good photographs always show a subject in sharp focus. Stopping the action and maintaining an in-focus subject is certainly one viable technique in action photography, but deliberate blurring can also communicate the feeling of momentum.

A photographer should start with a firm understanding of the techniques for action pictures—not only how to use them, but also when to use them to best advantage. For example, simply knowing how to stop the action of a high diver soaring off the Acapulco cliffs is of little value if the shot isolates the diver against a blue sky without reference to the steep cliffside behind or the water far below. The resulting photograph might be an interesting silhouette of the diver, but it would not convey the thrill of the sport. The techniques, then, only work if they are applied intelligently.

When approaching an action subject, you should consider how you want to sum up the activity. For example, if you are shooting a roller coaster, do you want the careening roller coaster's vivid streaks of color to express the surge of motion, or do you want to show the exhilaration on the riders' faces? One shot requires a blurring technique; the other, stop action. Sometimes a photograph of peripheral elements—and not the action itself—can show the intensity of an activity, such as the exuberance displayed by spectators.

Blurring is perhaps the easiest technique but the trickiest to control. Basically, if a subject is moving across the film plane—in other words, parallel to the back of the camera—and the camera is held steady, the subject will be recorded as a streak of colors. The faster the subject is moving and the dimmer the lighting is, the fuzzier the subject will appear. In fact, if the light is too low and the subject is moving too quickly through the frame, the film will not have a chance to

The blurring of objects as they move across the camera's field of view can be used to convey action, as evident in the picture of the amusement park ride. The bold swirls of color, the diagonal streaks, and the background blurs add to a sense of excitement and fast movement.

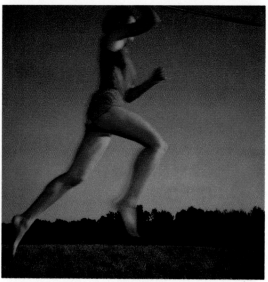

When action moves across the field of view—parallel to the camera back—a subject loses sharpness and delineation. In this example, the slight fuzziness lends fluidity to the scene.

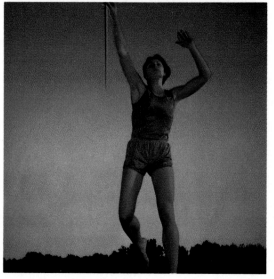

In this picture taken from a different vantage point, the javelin thrower's movement is frozen in place, even though she is moving at about the same speed as in the previous picture. Action is virtually stopped when the camera is positioned so that the subject moves toward the lens—perpendicular to the camera back. Note how this stop action technique records the subject in full focus.

make an impression of the subject at all. Blurring, which is exaggerated as the object gets closer to the camera, can be difficult to control; several attempts may be required before you achieve the desired effect.

To stop the action and freeze a subject such as a skier in midjump or a runner in midstride, you can do one of two things: photograph the subject as it comes toward you—in other words, as it moves perpendicular to the back of the camera—or anticipate and catch the peak of action, the singular moment at the height of a jump or a stride when action is momentarily suspended. The latter requires phenomenally precise timing, since it occurs in a fleeting millisecond. Therefore, it is crucial to know the sport or action and be able to sense when that instant is about to happen. Observe the activity for a while before actually shooting. When ready, keep the camera up to your eye as the action is unfolding, and keep your index finger poised to press the shutter button.

If you can get close to the subject, you can use flash to stop action. A strobe or flashbar attachment provides the camera with enough light to set a fast exposure and thus arrest the subject's movement.

In all action photography, readiness is fundamental. Once you decide what to show, you need to be in position, have the camera loaded with film and properly set, and keep reflexes well primed. Fortunately, with motorized instant cameras using Polaroid and Kodak instant films you won't have to pause between shots to pull tabs and peel film; you are automatically readied for the next shot. This is an advantage in fast-moving situations.

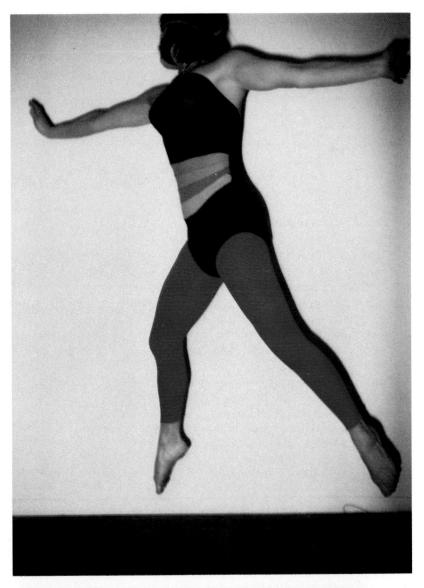

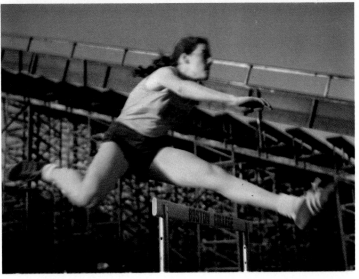

Top right: Flash can stop action, as shown in this image of a gymnast caught in midair. Naturally the subject must be close enough for the flash to be effective. *Right:* A subject can be in sharp focus, frozen in a still photograph, and yet project a strong feeling of action, as seen in this image. Photographer Lincoln Russell captured the peak of action—the moment when the hurdler was actually suspended for an instant at the height of her motion—by anticipating the moment and being ready to shoot.

Action

Panning is an excellent method for keeping the subject in focus but throwing the background out of focus to create a strong illusion of movement. When using this technique, you might prefocus the camera on the spot where you expect the subject to pass—unless, of course, you're using a fixed-focus or autofocus camera. Even with an autofocus camera, if you can anticipate where the action will take place, switch to the manual mode and prefocus so as to avoid losing even the brief second during which the camera's autofocus system is activated. Either approximate the distance and turn the focus knob until the lens's distance scale agrees, or find a reference point such as a stone at the estimated distance and focus normally. Practice panning the subject a few times before taking a picture just to get the feel of it, and remember to begin panning before you actually press the shutter. Try to keep the line of the object's movement level with the edges of the frame.

Another important consideration is object placement. If you catch a moving subject entering or leaving the frame, the speed of movement will seem greater than if the subject is captured dead center. Essentially the principles of composition and balance will be strongly at play (as outlined in the chapter on "The Vision").

Another way to show motion is to make a sequence of pictures. In the nineteenth century, scientific photographer Eadweard Muybridge explored the movement of a galloping horse by taking a series of pictures in a fast sequence. Each individual frame is a still study of the horse's movement; yet together they provide a sweeping sense of motion. A sequence, therefore, provides an excellent way to give continuity to a rapidly unfolding event as well as to study specific parts of that activity (refer to "Sequences" in "The Art" chapter).

The effects of panning are demonstrated by this series taken of a cyclist.

In this example, panning was not used. The camera was held in one position as the subject moved across the field of view. The result is an indistinct picture of the subject.

In this picture, panning was used. The subject is distinct against an unclear, streaky background. This is an excellent way to show a subject's speed and at the same time maintain subject detail and expression. The camera was moving at approximately the same speed as the cyclist.

To pan a subject, stand with feet planted about shoulder width apart. Hold the camera firmly, with arms tucked close to your body. Point the camera toward the direction the subject is coming from. With a fluid, sweeping motion, glide the camera on an even, level path while pivoting your body from the waist as you follow the action of the subject as it enters and moves through the frame. When the subject enters the edge of the frame, you should firmly press the shutter button, but do not stop your panning movement—follow through.

In this instance, vertical panning helped to focus attention and reduce blurring of the very fast-moving diver. Rather than use a typical side to side panning movement, I had to pivot the camera in a smooth vertical motion to follow the diver's action.

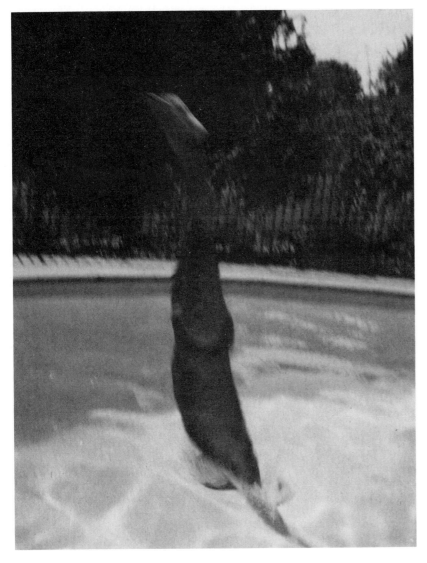

Action

For more interesting action pictures, search for unusual angles. When shooting nonprofessional sporting events try to get access to the field, track, arena, or stage before the event and spend time exploring various vantage points. If your camera has a Tele Lens accessory, use it to alter perspectives and bring the subject closer.

Often when photographing indoor events such as local or school stage performances, you will not be permitted to take pictures during the show. However, if the performers are cooperative, you can arrange a shooting session before or after and reenact a few prime moments. For low-light situations, you will need to use a flash attachment or put the camera on a tripod to avoid camera shake.

Although instant film manufacturers do not recommend removing film from the original packaging until you are ready to pop the film into the camera, the time lost unwrapping film can be crucial in shooting action pictures. Therefore, try preparing several packs of film in advance. Take them out of their cardboard containers, but be sure to keep them in a clean bag or pocket. Once unwrapped, film packs are vulnerable to dirt, sand, and breakage, so handle them with great care. Remember, too, not to put any pressure on the middle of the film pack when taking it out. This may cause damage to the film's delicate chemistry, and the pictures may show strange blotches or streaks.

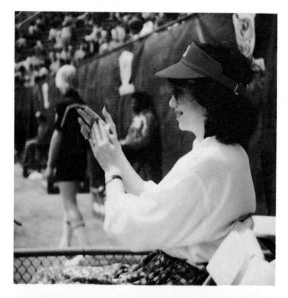

Sports pictures do not necessarily have to show the main action of an event to project the vitality and intensity of the moment. An exuberant spectator reacting to a point made at a Tournament of Champions tennis match conveys almost as much about the action as focusing on center court might have.

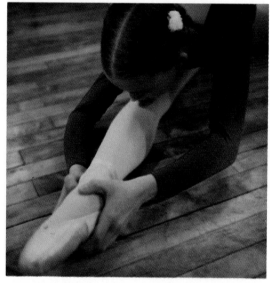

Interesting angles can enhance action pictures. Graceful movement is eloquently captured in this available-light, indoor portrait. The subdued, yet distinct lighting gives the picture an appropriate feeling of serenity.

Checklist for Shooting Action:

✓ Decide how you want to convey the action.

✓ Have equipment ready and film loaded.

✓ Anticipate.

✓ Hone reflexes and timing through practice.

✓ Know your techniques of stop action, panning, and blurring.

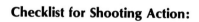

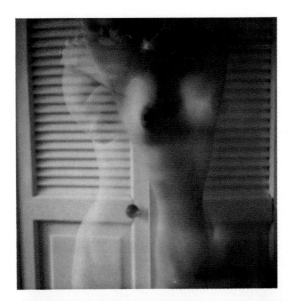

Movement is not confined to sports activities. Photographs can record ocean waters surging over a clump of seaweed or the elegant motions of a nude.

The nude subject was posed in available window light and asked to move in a smooth, side-to-side motion. An SX-70 camera was mounted on a tripod to keep it steady, and because of the low light the camera automatically made a long exposure, resulting in the lovely double impression.

For the ocean picture, the camera was focused on the seaweed, and the shutter was pressed just as the wave began to roll into the picture frame.

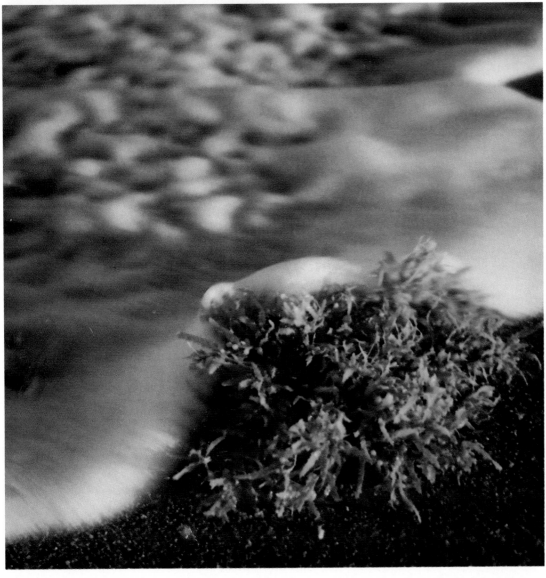

Travel

The instant camera is well adapted for travel photography. On the spot, a traveler knows whether or not the picture has adequately recorded the subject. And if it hasn't, another can be taken easily within minutes. The problem with conventional picture-making—that pictures cannot be processed and viewed until long after the return home—is happily eliminated.

Another special advantage of traveling with an instant camera is the way it provokes people's interest. People often gravitate to watch the "magical" photo machine at work. The attraction often serves as an immediate door opener, especially useful in foreign lands. Even when language is a barrier, taking and sharing photographs quickly bridges the communication gap.

The residents are an exciting aspect of any foreign country, and by taking their pictures you can add vitality and dimension to a photo travelogue. When approaching a subject, be courteous and ask permission to take a photograph. If language is a problem, gestures and a friendly posture help. In some foreign cultures, the way a tourist dresses can affect how local people respond. Therefore, you should choose clothing of colors and fabrics prevalent in a locale if you want to be less obvious as a tourist. Generally people are flattered to have their pictures taken (and will be delighted if given a picture as a souvenir). However, on occasion someone may object to being photographed. Remember to respect an individual's privacy and feelings; if someone resists having a picture taken, never force the issue. In most situations, local people respond with great pride and may even offer a personal guided tour through their area.

When photographing people in their homelands, try to select backgrounds and environments that convey information about the area. In some instances, elements that identify the city can be used. In Moscow, a backdrop of Red Square would be appropriate; in Paris, the Eiffel Tower could serve as an identifying detail.

Pictures of traveling companions or friends, especially posed in front of famous sites, can be particularly meaningful records of a trip, too. However, snapshots showing people as tiny specks overwhelmed by notable surroundings are meaningless. Instead, get close so the subjects' faces are clear while the backdrop remains in sharp focus. Most instant cameras have a focusing range of at least four feet (1.4 m) to infinity. Therefore you can stand as close as four feet (1.4 m) to your friends and still obtain an in-focus portrait of both your companions and the site.

One of the essential secrets to making good travel pictures is preparation. Before setting out on any trip, the itinerant photographer should research background information on the places to be visited. Expectations can be sharpened considerably by developing a prior understanding of a locale, its climate, people, and sights. Just as an intelligent traveler wouldn't attempt a trip without first consulting travel agents or tour guides, a photo enthusiast should not ignore such sources as pamphlets, magazines, and books to prepare both the eye and the mind for exploring new lands.

Brochures are available at tourist agencies, government embassies, or chambers of commerce. Further insight into the atmosphere, people, and unique characteristics can be developed by reading novels set in the countries on your itinerary.

On arrival at your destination, ask the hotel clerk about other interesting sights that might not have been covered in your research. Local people often know about areas not written up in guides. Also, regional newspapers and entertainment-type magazines have worthwhile information on interesting events, newly opened restaurants, and so on.

Left: Photographs of people from foreign countries can catch a great deal of the life and vitality of a place, as shown by this portrait. With the backdrop of China's Great Wall, the picture has a clearly identifiable locale and thus is a fitting travel record as well as a proud addition to any album. *Bottom left:* Taking pictures of people in another country can be a rewarding experience for a sensitive photographer. This colorful closeup of a Yeoman Warder near the London Tower captures not only the typical finery but also a friendly, tired expression. *Bottom right:* This is an excellent identification image. By photographing hotel or restaurant signs, entrances, bus destinations, and so on, travelers essentially can make visual notes of an entire trip to recall the places they stayed, dined, traveled to, and visited.

Travel

The key to making exciting and memorable travel pictures is to explore common tourist attractions in uncommon ways. Try to create a picture you've never seen before. Take one that has a different perspective or framing. Explore the area and view the monument or landscape from varied angles before deciding to shoot. Notice the light. Remember that on bright sunlit days, the lighting is strikingly different from the warm dramatic light of sunrise and sunset or the harsh bluish light of noon. Weather conditions also can affect lighting and mood. And when the sun has set, obviously the subject appears different. But don't put your camera away. Nighttime photography, especially in large cities, can be spectacular. (See the "Night Photography" section.) Shoot extra pictures to send to friends and family in place of store-bought postcards.

For indoor situations, consider lighting, too. If the light is low, be prepared to steady the camera for a long exposure. Or use flash to bring out the detail and precision of a scene.

Details and special motifs can reveal a great deal about a place. For effective pictures, get close and fill the frame with the subject. Such close-focus approaches often can make the difference between a mediocre image and a superb one. Group some of these decorative pictures together in your travel albums to add zest and richness.

Throughout your picture-taking wanderings, it's a good idea to write notes on names of locations, feelings, and observations. These can be useful for later reference. Keep prints stored in empty film pack boxes for protection. If you are so inclined, organize your photographs while you are on the road. At the end of each day, eliminate any disappointing shots and number those remaining in consecutive order. By the time you return home, you will have compiled a complete visual documentary of the entire experience.

Below left: Interior photographs can lend just as much impact and interest to travel albums as outdoor views. In this moody image of a Polish Spring Chapel, Peter Caroff has suggested the austere simplicity of the room by using the flood of light to define only a few of the interior details. *Below:* A stark facade appropriately captures the feeling and texture of Yucatan, Mexico, in this photograph by Charles Hrbek. The clean, simple composition is in keeping with the nature of the subject.

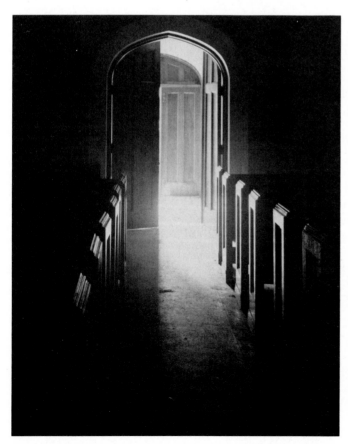

72

Top left: Aerial photographs made from airliners can result in lovely abstract images, as in this example taken outside of Boston's Logan Airport. To make the image, the photographer scouted for the cleanest window, then—without touching the camera against the glass (which could cause vibrations and camera shake)—focused the lens manually. The bold graphics resulted from the contrast of the peninsula of land against the blue-green waters.

Top right: Pete Turner's intriguing photograph of Red Square, Moscow, uses the dramatic device of foreground lines receding into the distance to draw the viewer's eye to the subject. *Center left:* This photo documents the changing face of New York City by juxtaposing the antiquity of St. Patrick's Cathedral against modern skyscrapers. Notice the air of whimsy that results by photographing the cathedral's conical shapes and decorative details next to uniform, rectangular skyscrapers. *Center right:* Travel pictures of famous monuments can be made more exciting simply by approaching the subject in a unique way. For this unusual vantage point, the photographer used a low angle and got close to the well-known Parisian tower, filling the frame with a tightly cropped portion. Instead of the typical straight-on view, the picture projects a sense of drama befitting the Eiffel Tower. *Bottom left:* A photograph of a sunset on Maui island recalls the end of a spectacular day during a Hawaiian vacation. Sunset pictures often make fitting closing shots for travel albums. *Bottom right:* Sometimes finding unusual approaches to familiar sights requires exploration. The different look at San Francisco's famous bridge was taken from an interesting point in Golden Gate Park.

Travel

Checklist for Packing an Instant Camera Travel Bag:

✓ Camera and camera strap

✓ Fifteen packs of film (for one week); thirty packs (for two weeks)

✓ Flash equipment (electronic flash or flashbars)

✓ Spare batteries

✓ Lens-cleaning tissue and airbrush

✓ Pencil or indelible ink pen (for noting comments and dates on pictures)

✓ Transparent tape (for taping filters on camera and miscellaneous uses)

✓ Plastic bag (for cold climates)

✓ Silica gel packets (for hot, humid climates)

(Optional)

✓ Self-timer

✓ Tele Lens

✓ Filters (to suit your taste)

✓ Compact tripod and cable release

TECHNIQUE: EQUIPMENT PREPARATION

Before departing on any trip, a photographer should always do a thorough equipment check. Shoot a pack of film to make sure that the camera is functioning properly and to refresh your memory on its proper operation. In addition, clean the rollers and lens and replace old batteries.

Instant camera equipment can be carried conveniently in camera bags made especially for each system. These usually afford adequate protection and good portability. However, in some instances, instant camera bags might not provide enough space to accommodate accessories such as film and flashbars or Tele Lenses. Conventional camera bags, which have foam linings for extra shock protection and additional storage compartments, may be preferable.

When traveling by air, some photographers pack film in hardcover suitcases—which are checked—and carry the rest of their photo equipment onto the plane. I feel infinitely more secure carrying all photo materials onto the plane. I usually use a camera bag that fits easily under the seat. Tests have shown that multiple X ray inspections can be harmful to film. (Magnetic inspections are not damaging.) Therefore, if traveling through several places during one trip, you should request hand inspection of your carry-on bag. And even though instant films are available practically all over the world, bringing along a personal supply is handier and much less expensive.

SPECIAL PROVISIONS: TROPICAL CLIMATES

Silica gel packets (available at most camera stores) are excellent for absorbing excess moisture and keeping humidity from attacking the insides of camera equipment. These handy packets should be deposited in the corners of your camera bag. For hot-weather driving, a Styrofoam cooler helps protect film and equipment from the heat. Photo gear, especially film, should never be left in direct sun, or in the glove compartment or trunk of a car, where excessive heat can damage the film and possibly deform the camera's plastic. If equipment must be left in the car, place it in the cooler on the floor of the back seat, usually the coolest location. If you are traveling by boat, the cooler also can help protect equipment not being used from water spray. When you are using the camera, put a plastic bag around it for protection. (Refer to "Fog, Rain, and Snow" for details.)

SPECIAL PROVISIONS: COLD WEATHER CLIMATES

A plastic bag is an essential aid for going from freezing outdoors to heated indoors. To protect the camera from condensation dripping inside, place the camera in a plastic bag and tie it shut so the condensation forms on the bag and not the camera. For outdoor shooting, keep the camera strap shortened so that the camera slips easily into the front of your jacket and can be held close to your chest for warmth, as well as easy access.

Venice, Italy, is an enchanting city with decorative details and deep-blue canals. Photographer Clint Clements has managed to capture some special Venetian features in the street lamp motifs and in the gondolas scattered along the shore.

Still Life

Taking expressive still life pictures can be one of the most gratifying experiences in photography. The photographer has absolute control over subject matter and unrestricted time to arrange composition and evolve lighting. The process of adding and subtracting elements to create a still life—comparable in some ways to a painter's techniques—satisfies a strong creative drive for many artists. Many enjoy the solitude, relieved that inanimate objects require neither cajoling nor conversation during shooting sessions.

While many styles of still life photographs exist, two major categories are prevalent. The classical still life, resembling works by master painters, is formal and tightly composed, and aims at revealing the essence of subjects. Contemporary still lifes tend to focus on ordinary, often mundane subjects in uncharacteristic ways, using unusual perspectives or concentrating on form and color rather than content. Each type, of course, runs the range of subjects from fruits and vegetables to unrelated found objects.

"For in art everything is best said once and in the simplest way," artist Paul Klee noted in his diaries. Indeed the most successful still life pictures are carefully thought out and reduced to bare essentials. That is not to say numerous elements cannot be included, but rather to emphasize the importance of paring down to a minimum, unless you intend to create visual confusion with a cluttered image. Otherwise, be sure to trim down and organize precisely.

Lighting is crucial. Forms, colors, and shadows are significantly altered by changes in lighting intensity and direction. Front-lighting minimizes shapes and volume by flattening subjects so they appear less three-dimensional. Sidelighting casts dramatic shadows and creates severe contrasts between planes of the subject, lending a more solid appearance and highlighting its surface texture. Backlighting shifts tonal values and exaggerates contrast, for an air of mystery.

Lighting also can set mood and atmosphere. Direct light produces a bold, confrontational effect; diffused light gives a soft, somewhat impressionistic look. To produce the former effect, use flash or a spotlight directed at the subject. For more subdued lighting, use a floodlight for a soft, general light or try bounce lighting.

Bounce lighting is easily accomplished by aiming a photolamp or flash toward a white ceiling. If the ceiling is painted a color other than white, a percentage of that hue will be reflected onto the subject, possibly resulting in an undesirable color shift. As a remedy, stretch a piece of white background "seamless" paper above the subject and position the light to bounce off it instead.

In approaching any still life, whether abstract or realistic, take time to organize the composition. Position the most important object in your photographic frame first. Then add other elements, but include only those items that contribute to the mood or idea you wish to convey. As you add objects, view the arrangement the way it appears through the camera's viewfinder. Remember, photographic reality differs from human vision so keep an eye on the camera's vantage point. Play with balance, volume, tones, shapes, texture, and colors of objects until the whole frame seems right. Then try a shot. Wait until it develops fully and decide whether or not you want to change aspects of the picture. Be critical.

Artists like Brian Hagiwara have used one still life arrangement to inspire another. His playful tabletop abstractions are loosely unified by the shapes and forms of similar objects. Barbara Kasten's handsome still life creation (featured in "The Art" portfolio) is similarly composed of found objects organized into a careful arrangement. However, Kasten's work is on a life-sized, sculptural scale. Also, her designs are more premeditated, since she sketches out her compositions before shooting. Then, at each step during the setup stage, she views the composition through the camera and meticulously refines the work.

For typical still life subjects, you might want to take hints from tricks used by professionals. Innate qualities of certain objects—fruits and vegetables, for instance—can be enhanced by dousing them with water or coating them with vegetable oil to bring out their smooth surfaces. The procedure also makes them more reflective; with the proper lighting, texture and shape can be dramatically emphasized. In general, when doing food photography, stay with daylight-balanced lights (or use color correction filters for tungsten or fluorescent lights) for true-

to-life colors. And, of course, select the freshest, deepest-colored foods to produce pleasing pictures.

To photograph jewelry or other highly reflective objects of gold, silver, brass, or chrome, professionals rely mostly on diffused light with fill-in reflectors for shadow areas. Do not use direct light unless you want to create sharp, pinpointed reflection spots. Soften glare on metallic surfaces and define form by using a floodlight or bounced light. A good counterpoint for sparkling subjects such as diamonds, gold, or silver is a dark background of black velvet or deep-colored fabrics.

This quadruplet of images by Brian Hagiwara was done with dime store objects arranged on a piece of black plastic and photographed with flash, accentuating the plasticity of the objects and film. As one SX–70 picture emerged, it inspired the next arrangement. The four were overlapped and fastened together to produce this Kandinsky-esque composition of echoed lines, shapes, and colors.

Still Life

TECHNIQUE: STILL LIFE STUDIO SETUP

A studio can be temporarily set up in a living room or den. The following items are necessary:

- A space adequate for working comfortably.
- A table or platform on which to locate the subject.
- A roll of background paper, preferably white because it reflects best. Most professionals use white "seamless" paper available from camera stores.
- A tripod to steady the camera for composing and shooting.
- Flash and/or floodlights. (Optional)
- Light stands or chairs on which lights can be clamped.
- Reflectors for bouncing light back onto areas of the subject. These can be crinkled aluminum foil taped to a cardboard sheet, polystyrene sheets, newspapers, or white seamless.
- Colored gels to be taped over floodlights to create color variations.

First eliminate any unwanted light by covering windows and turning off overhead room lights. Roll out a section of white seamless to cover the table. Arrange the subject on the seamless. (An added advantage of using rolled seamless is that when a section

becomes dirty, you can cut it off and simply roll down a new piece.) Place the camera on a tripod and position it at the desired angle. If frontal light is desired, use camera flash. No auxiliary lights are necessary. If more sophisticated lighting is desired, at least one floodlight will be needed. Strong directional lighting is demonstrated in the illustration. The floodlight is positioned to one side of the subject. If you wanted even more light, you could place a reflector to reflect light onto the other side of the subject. (See the effect demonstrated in "Portraits.")

Left: The Polaroid CU–70 Closeup Systems is excellent for bringing out details of small gems. (See p. 216 for a look at the system.) This exquisite diamond ring was placed on a piece of dark-colored cloth to offset its shiny surface more distinctly. *Opposite right:* A kind of poetry is evoked by the delicate balance of forms and harmonious colors in this image by Drew Sanborn. The arch of the flower and curve of the ballet slipper's strap subtly suggest an elegant motion, as if the slippers had come alive silently. *Opposite far right:* Brass subjects can be hard and cold. But in this highly controlled composition, the subjects have a warmth of tone and brilliant lyricism in their shapes, forms, and placements.

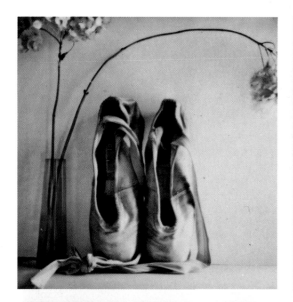

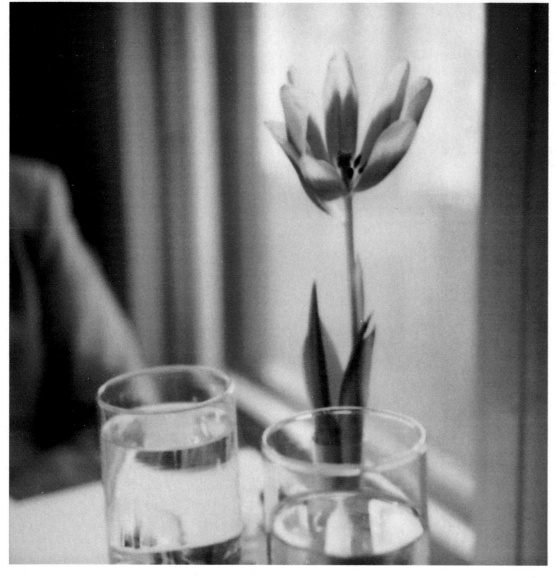

A still life is not always something that is precisely set up and arranged. While sitting in a restaurant, I noticed the available window light framing a tulip and forming reflective patterns in the water glasses. The hazy outline of a man's shoulder in the background—the result of using shallow depth of field for selective focus on the flower—adds a mysterious touch.

Nature

In many ways photography is similar to the sport of hunting. A hunter wanders through the outdoors searching for prey, stalks, aims, and finally shoots the subject. Of course, unlike hunting, the act of shooting a subject with a camera preserves rather than destroys. The subject, caught in the process of living by a photograph, continues to exist after the image is fixed.

Pictures allow us to collect natural things for further scrutiny. We can see more closely the intricate patterns of veins in a leaf, the strange body of an insect, the sensuous form of a seashell. Nature photography is a constant process of discovery.

Much of the joy of taking nature pictures lies in the hunt, finding the subject. Thus the moment rarely can be preplanned but just happens—seemingly by accident. In reality the discovery is not an accident. As Louis Pasteur once noted: "In the fields of observation, chance favors only the prepared mind."

The most sensational nature photographs emanate from the picture-taker's sensitivity to and interest in the subject. There must be a compelling attraction, a powerful emotional reaction. A subject—whether a willow waving in the breeze, a delicate spider's web, or the gnarled trunk of a tree—should almost signal to the photographer.

While many responses to the natural world are automatic and intuitive, some conscious choices remain. The first is the time of day selected for shooting. On a bright sunny day, directional early morning and late afternoon light is infinitely better for revealing a subject's intricacy than the flat, bluish light of midday. Flowers are especially photogenic just after sunrise, when petals are still shimmering with morning dew. (During other times of the day, a flower's appearance can be altered slightly by lightly sprinkling water on its petals.) When lighting is unflattering for your subject, use flash to change the light altogether. Or use reflectors to add light in shadowy areas.

Season is another consideration. Nature photographers depend heavily on seasonal influences affecting colors, lighting, and moods. Fall is splendid for photographing changing colors of leaves. Winter is perfect for exploring facets of snowflakes and icicle formations. Spring unveils a world of rejuvenation—a return of insects, buds, plants.

Some nature enthusiasts who seek specific nature pictures actually will canvass a location, waiting for the appropriate season in order to capture the subject in the proper climate and environment.

Timing is everything. You may regret not stopping to take a picture, for on your return you may discover something has changed. In fact, the subject may even have vanished. Using film is preferable to failing to capture the image.

Photographing a subject at close range makes depth of field extremely shallow. In

Below: "Callas" by Caroline Vaughn magnificently displays the sensuous and delicate forms to be discovered in nature's varied subjects. The velvety surface and impressive highlights are the result of directional sidelighting. The photograph was taken with Polaroid Type 52 film.
Opposite: Using a photomicrography setup, Fritz Goro made this striking photograph of a *radiolaria,* a marine protozoan, enlarged 250 times. (See the Guide at the end of the book for details on equipment used for special closeups.)

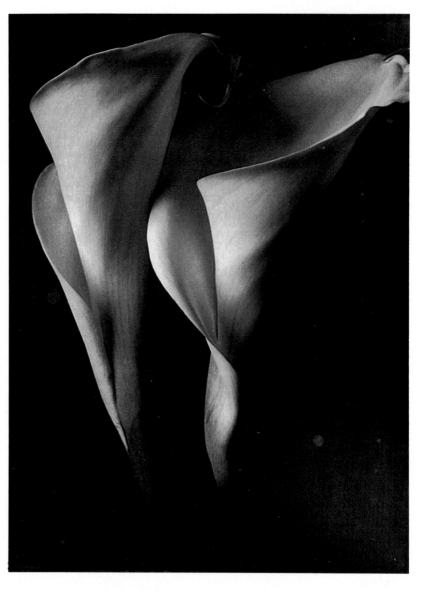

other words, only the exact spot you focus on will be sharp, while the rest of the subject will blur into splashes of colors and shapes. Some photographers object to this effect, but it can produce stunning results. Focus precisely on the elements you want to be crystal clear, then reframe your composition for balance. Look for contrasting tones to set off the subject from its background.

A tripod and cable release make picture-taking at close range much easier. The setup affords precise control over final composi-tion and steadies the camera to avoid acci-dental movement. With such a shallow depth of field the tripod is especially crucial, for the slightest motion will result in out-of-focus images. Further, a tripod certainly can make the experience of picture-taking more comfortable and less fatiguing. For instance, imagine how tiring it would be if you were waiting to capture the flight of a bumblebee across a rose petal with the camera ready and raised to your eye. After a while, your enthu-siasm for your subject would diminish!

These two images _(below)_ taken by John Moriarty show entirely different im-pressions of the same sub-ject. Note in the closeup of the daisies how shallow the depth of field be-comes. You can use the shallow depth of field to isolate the main subject—anything in the scene which is nearer or farther away from the camera will be blurred, while the main subject will be focused. The background is blurred because the camera is focused on the fore-ground.

Landscapes, Seascapes, Cityscapes

A great photograph is a full expression of what one feels about what is being photographed in the deepest sense, and is, thereby, a true expression of what one feels about life in its entirety.
— Ansel Adams
American Annual of Photography, Vol. 58

A snowscaped mountain range, a gently rippling lake, ominous storm clouds gathering over a peaceful village: all are scenes of natural grandeur. The tiny photographic frame seems the antithesis of such a mighty panorama. Hence the key to good landscape photographs lies in the ability to see the *essence* of a scene, to capture the dominating characteristics, and to *imply* the grandeur.

Natural phenomena such as seasons, time of day, and weather conditions strongly influence mood and impact and must be taken into account. Some landscape photographers actually plan their shooting times to coincide with a particular season or await stormy weather in order to achieve a desired effect. While you may not be inclined to wait several weeks or even several hours for certain natural conditions to prevail, you should at least be aware of the varying possibilities. Even within the course of a single day, the quality of light changes noticeably. As dawn breaks and the sun rises higher in the sky, the color of natural light is strikingly altered. Scenes photographed around sunrise and sunset are far richer in texture, detail, and pastel colors than those taken during midday when the overhead sunlight is very blue and harsh. Noon is considered the least desirable time to take scenic pictures, as it produces flat, dull-looking images.

Although natural conditions influence landscape photography, you should not for a moment think you are without some control. In fact, photographers who succumb to such misconceptions cannot possibly appreciate the extreme variances in any scene nor begin to exercise their powers of imaginative selection.

To begin with, a landscape is composed of elements of form, shape, color, and texture which vary considerably as you scan the whole view. Obviously you cannot expect to encompass the entire scene in one picture, so you must concentrate attention on one fragment. Search for features that are most indicative of the whole and are most dynamic compositionally. Focus on a main element in order to give your picture structure. This can be a single object—a windmill, a lighthouse, a lone tree in the distance, a craggy mountain peak, a curving dirt road—or it can be a pattern or motif of objects—a rock formation, a pond's reflection of weeping willows, a repetition of sailboats lining the shore. Try to avoid cluttering the picture area with unnecessary details, but include enough information to convey the feeling you derive from the scene itself. Fortunately, instant pictures work in your favor since you can see immediately if you've captured what you wanted. If you haven't, you can always try again. In fact, working with instant materials can enhance your appreciation of nature since it forces you to examine a scene two ways: through your own vision and through the camera's frame.

Weather conditions can have an enormous influence on the colors and mood of a picture. The gray storm clouds in this beach scene create an overall diffusion of light and a low-contrast situation, which lends a softening, monochromatic quality to the image. The impression is a kind of hushed melancholy.

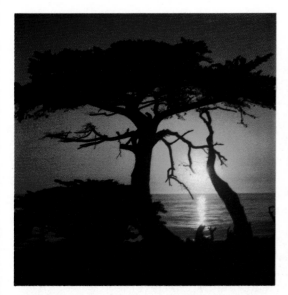

Far left: In contrast to the overcast seascape, this silhouetted sunset picture is vibrant and alive with vivid orange hues. Different times of day affect colors and influence the impact of a picture. *Left:* Effective landscapes have a central feature which draws the viewer's attention. In this view of Rainbow Bridge taken by Sam Liggero, the rivulet guides the eye quite naturally to the point of interest: the arched bridge in the background. This is a good example of using the foreground to center attention and create the illusion of depth as well. *Bottom:* The stillness of the water allowed John Kristoffersen to catch this perfect reflection and natural symmetry. Positioning the main subject in the upper third of the frame makes this a balanced and interesting composition. The inclusion of the foreground strip of land provides the image orientation and produces a perspective of depth.

Landscapes, Seascapes, Cityscapes

A successful landscape photograph conveys a strong feeling of scale, which can be evoked through perspective and viewpoint. To represent the awesomeness of the French Alps, for instance, you might include an element in the frame that contrasts with the extraordinary size of the mountain range. A shot including a climber or skier would contrast the infinitessimally tiny size of the person with the soaring heights of the mountains.

The horizon line should be level in a composition, but its placement can be varied for effect. A low placement achieved by a low camera angle emphasizes the sky. This is appropriate for dramatic cloud formations or lighting patterns. A high horizon has less movement and focuses the eye more directly on a foreground subject. This may be desirable when an important feature of the scene lies in the foreground.

Depth can be suggested through counterpoint, such as a foreground frame of distant forms. Tree branches, archways, and fences are the most commonly used framing objects. Other objects that can add depth include a meandering road, a river, and converging lines of a railroad track. Sometimes natural phenomena such as atmospheric haze can suggest distance. However, occasionally atmospheric coloring can be an intrusion, its bluish mist camouflaging some of the delightful distant peaks. To reduce its effects you can attach an ultraviolet (UV) or haze filter to the front of your camera's lens, taking care to place the filter over the light sensor as well (to ensure proper exposure). The filter will not completely remove the haze but will minimize the bluishness.

When photographing people in certain landscapes with highly reflective areas of snow, water, or sand, be aware that the exposure sensor in your camera can be fooled into setting the wrong exposures. Typically, in these instances, the camera reads too much light, producing dark, underexposed pictures. A skier photographed against snow will be virtually silhouetted unless you compensate by turning the lighten/darken control one or two marks to the lighten side. If you're close to the subject, you can also use flash for fill-in light so that both the subject and background will be properly lighted. To reduce reflection on water, ice, or snow, you can use a polarizing filter.

Scenic photographs composed of large light and dark areas pose severe exposure difficulties. Experiment with the lighten/darken control for varying effects, and choose what best conveys the mood. If you concentrate on the bright areas in a scene, you'll find that the shaded areas will fall into dark obscurity. If you expose for the dark areas, the bright highlights will wash out. Either result can be pleasing, depending on your evaluation of the important aspects of the overall scene.

In most cases, you will want to record the colors of a scene as faithfully as possible. However, on rare occasions, you might consider altering colors to create unusual effects. This can be accomplished through artificial filtration. You may recall from the section on "The Vision" that colors have specific associations. Green is identified with grass and often seen in the foreground of pictures. Blues and browns generally represent sky or earthy backgrounds. By filtering to change colors, you can produce very different impressions of a scene. (See the section in "The Art" on gels and filters for a list of filters and how to use them.)

For impressionistic landscapes, recalling the paintings of Renoir and Monet, you can jiggle the camera slightly while taking the picture. The technique works especially well in low-light situations such as overcast and misty days. Since the lens must stay open longer to permit enough light to reach the film, you have more time to move the camera and create painterly images.

Professional photographers approach scenic pictures in many ways. Ansel Adams is a purist in his portrayal of majestic landscapes and renders them with a pictorial concern for beauty and an appreciation of the range of tonalities. Other contemporary photographers have more eclectic and fragmented approaches. Sometimes they focus on a minute detail to sum up the scene; other times they will choose an unusual angle to communicate their response to the view. The guiding consideration in depicting any scene should be an honest, alert, and sensitive approach. See the moment and allow yourself to respond to what's there. Many photographers continually look for visual

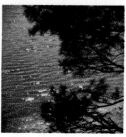

Bright water highlights can be accentuated with proper focusing.

Top: In this example, focus was fixed on the water rather than the trees. This minimizes the round, reflective spots. *Above:* In this picture, focus was fixed on the foreground trees so that the shimmering highlights on the watery background blurred and enlarged for a more spectacular effect.

clues, a special sense of connection with the subject. Then, and only then, do they press the shutter, capturing the significance of the scene in a profoundly personal way.

Checklist for Shooting Landscapes, Seascapes, and Cityscapes

✓ Decide on the essence of the subject so that you can best convey the feeling you want.

✓ Look for a main feature to lend structure to your composition.

✓ Use elements of composition and natural phenomena such as weather conditions and seasons.

✓ Try different vantage points.

✓ Use contrasts of foreground frames or leading lines of rivers, roads, etc., to convey depth and vastness.

✓ Be aware of highly reflective backgrounds such as snow, sand, and water which can fool the exposure sensor on instant cameras.

✓ Experiment with filters to reduce haze or create unique effects. (See "Gels and Filters" in "The Art" section.)

✓ Explore unusual approaches. Try fragmenting the landscape or concentrating on revealing details.

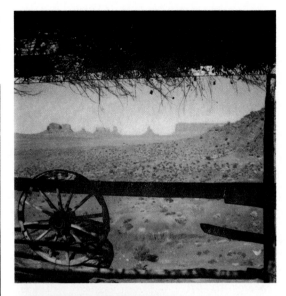

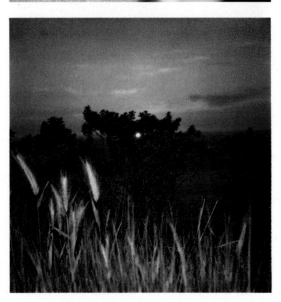

Left: A foreground frame effectively concentrates attention and gives a feeling of vastness in this view of Monument Valley taken from a nearby lodge. The rustic wooden wheel also provides a good counterpoint to the distant scene. *Center:* For a bizarre sensation, this photographer chose to record the Jasper icefields in the reflection of a car's sideview mirror. Finding unique approaches to scenic pictures requires a curious, imaginative eye and a willingness to spend time exploring. These attempts can consume film, but the end result can be thoroughly rewarding and well worth the cost of film. *Bottom:* Don Ceppi found the perfect spot to capture the setting sun peeking through the foliage. He focused on the distant objects so that the foreground is slightly blurred. To further enhance the surrealistic effect, Ceppi used flash to illuminate the foreground but still maintain the hot colors of sunset.

Fog, Rain, and Snow

Inclement weather is discouraging to many picture takers, who fear that rain and snow will damage equipment or who simply find it gloomy and uninspiring. Most have been conditioned to react to bad weather in a negative way rather than to recognize its photographic potential.

Overcast, stormy skies discourage taking walks or playing soccer, but they can lend a mysterious, brooding quality to pictures. Snowy, rainy, or foggy landscapes appear romantic and moody when captured in photographs. Consider the image of a lone figure walking down a rainy road, enveloped in a hushed, gray haze. The quiet loneliness and moody intensity clearly could not be conveyed on a bright sunny day.

Bad weather usually creates extensive light diffusion. For photographers this means muted hues and an overall low-key effect. Atmospheric perspective is intensified so backgrounds are obscured, while foreground objects take on more clarity in comparison. (In fact, some photographers like the effects of rain and fog diffusion so much that filter makers now offer "mist" filters to simulate the impression!)

One potentially negative effect of cloudy skies is a permeating bluish cast. Sometimes the effect can contribute a desired sullen quality, but at other times it can be an intrusion. To reduce the bluish cast, use a UV (or skylight) filter placed over the lens and exposure sensor. (Refer to "Gels and Filters" for details.)

A major concern of photographers who shoot in rain or snow is protecting the camera. After all, water trickling into your instant camera will not lengthen its lifetime.

Damage easily can be avoided by wiping the camera thoroughly between shots and placing it in a plastic bag for protection. Rainwater generally is not harmful to cameras, and as long as you wipe equipment carefully, serious problems should be prevented. When cleaning the lens, use a lint-free cloth. Never use a shirt-sleeve or silicone-coated eyeglass tissue which can scratch the lens surface. Move the camera lens cleaning tissue in a light circular motion.

Obviously, in foul weather light is generally dim. Automatic exposure cameras compensate by allowing longer exposures. To avoid blurring, hold the camera steady and brace yourself on a solid surface or use a tripod.

In some weather conditions, exposure is tricky. Large reflective areas cause exposure sensors to set inaccurate exposures, making subjects either too light or too dark in the final picture. As mentioned earlier, when directed on a skier against a glistening snowy backdrop, the camera's light sensor reads light from the reflective snow and exposes for the background instead of the person, who appears as a dark silhouetted figure. Sometimes you won't even realize how difficult the lighting situation is until you've wasted a picture. Compensate by moving the lighten/darken control toward the lighten mark.

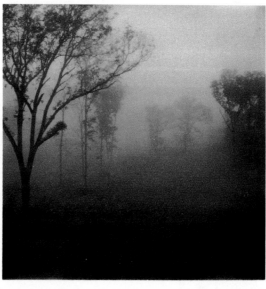

Far left: Amusing portraits can be taken even in snow. To capture this bemused couple, the photographer used a flash which illuminated the falling snow as well as the subjects. As a rule of thumb, the closer the snowflakes (or rain droplets) are to the camera, the more accentuated they will appear in the picture. *Left:* Underexposure intensifies the haziness of fog, as in this haunting landscape by Linda Benedict-Jones. If she had wanted to penetrate the fog for a more washed-out effect, she would have overexposed slightly by turning the lighten/darken control toward the lighten direction. Notice the stunning effects of atmospheric perspective, obscuring the distant trees in haze while maintaining clearer definitions of the foreground tree.

(See the "Exposure" section in "The Tools" for other methods of compensating for various lighting conditions.)

Instant cameras and films are not overly tolerant of excessively cold or hot weather. In frigid climates, cameras can become sluggish, and film development is impeded. Pictures may be too dark or acquire a bluish cast as a result. Of course, sometimes cold blue tones add to the feeling of a freezing, wintry scene, but more than likely you'll want to minimize the effect. Keep film warm by holding it close to your body. (You might even want to sew a pocket inside your sweater or coat.) If you are using a pack film camera, use the cold clip provided for keeping film at proper developing temperatures. To keep batteries and camera warm and operational, tuck the camera inside your coat, too. Body warmth does wonders for maintaining the right temperatures for equipment. Take the camera out to snap the picture; when the picture is ejected, put it and the camera back near body heat.

A further problem in winter shooting is condensation, which usually forms on the camera when you go inside from the icy outdoors. See "Special Provisions" in the "Travel" section for what to do.

TECHNIQUE

A plastic bag can be used effectively for foul weather protection. Cut holes for the lens and exposure sensor. Tape the bag securely around these openings, making sure they do not in any way obstruct, or else pictures will be ruined. For cameras using integral film (Polaroid SX–70, 600, or Kodak instant types), leave an opening for the film exit slot. Either leave space in the bag itself or cut a slit so that the developing picture can be removed after every shot. Integral films develop safely outside the camera and will not be hindered by water or snow. Pack or roll film prints, however, can be marred by water drops. When using these types of instant print films, work near a car or an enclosed dry area to be used for coating and storing prints.

Top: Cloud formations before or after a storm can lend drama to a picture, as in this photo taken by James Haberman on Polaroid Type 52 film. A quiet setting has taken on an agitated quality because of blotchy, bad-weather lighting. *Above:* Rainy day blues are evoked by this deserted beach, photographed just after a downpour. Subdued light and the emptiness of the scene create a feeling of abandonment. The potentially static scene is enlivened by the railing's vertical line, which thrusts into the distance. The reflection of the bench in the foreground puddle also adds a nice detail, attracting the eye and effectively using space.

Night Photography

Too many photographers revel in taking pictures of the setting sun, but then put away their cameras as nightfall approaches. Some of the most exciting picture opportunities await the camera's lens after dark, offering spectacular effects. Subjects are plentiful: lighted fountains and their reflections, highways with zigzagging ribbons of car lights, the stars and planets, lighted windows beckoning us to look in, roaring campfires, and more.

The most essential accessory for night shooting is a tripod. Very low light situations require very long exposures. Without some steadying device, photographers would be unable to hold the camera absolutely immobile for exposures of 1/60 of a second or less. A small, inexpensive tripod is adequate. Even a monopod—a brace with only one leg—provides enough stability. In a pinch, a car hood, fence, tree stump, or any other stationary object on which a camera can be propped will do. A cable release is also helpful in minimizing camera movement.

Evocative light still lingers in the sky at dusk, just after sunset. As the last sliver of sun slips below the horizon, the sky still glows with a light that is superb for backdrops, especially for city skylines. Unfortunately, twilight does not last for more than about twenty minutes, so you have to work quickly if you want several vantage points in that brief period.

The nighttime world is illuminated by artificial lights, giving a different aspect to monuments, buildings, and houses. Since instant films are balanced for daylight, artificial light sources assume peculiar colorations in pictures. Tungsten and incandescent lights have a reddish cast, mercury vapor lights turn blue, while fluorescents have a greenish color. Color shifts can be used to help represent the unique facets of nighttime existence. Experimenting with the lighten/darken control will produce additional effects. For example, if you are shooting neon lights and turn the lighten/darken control toward darken, your pictures will display a halo effect.

Nocturnal panoramas are striking, especially cityscapes or moonlit waters. To avoid a mass of light blurs, use a tripod or very solid support and prepare for long exposures. Flash, by the way, is useless for panoramas.

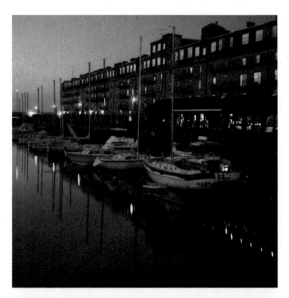

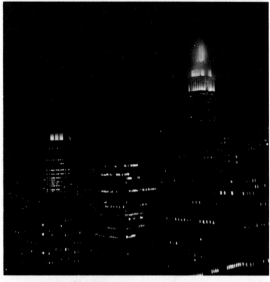

Right: The bluish glow of twilight and the pinpointed incandescent lights along a wharf create a peaceful evening scene. The repetition of masts and their reflections gives the photo a rhythmic quality. _Center:_ After nightfall, a city is illuminated only by artificial lights. A long exposure on an SX–70 camera mounted on a tripod produced the patterns of skyscraper lights. _Bottom:_ Fireworks are popular nighttime photography attractions. Murray Lapides set his camera on a tripod for a long exposure to capture the light of the background fireworks, using flash at one point during the exposure to record the attentive onlookers.

Too many tourists make the mistake of trying to take distant night pictures of, say, Paris from the top of the Eiffel Tower with flash. Such photos will never work unless perhaps there is enough ambient light in the distance to be recorded and you can override or turn off the flash unit. A camera's tiny flash unit hardly is capable of illuminating a sprawling metropolis like Paris.

On the other hand, flash can be very effective at night for people pictures. Besides making great snapshot portraits, flash can create a nice effect if the subject is positioned near a lighted background, whether it be a house, monument, or fireworks. The flash illuminates the person, and the ambient background light is also registered on the film. For nighttime travel portraits, try posing a companion in front of a lighted fountain or monument and using flash. Make sure the subject is not too far from the background or you will get a portrait of your friend against a black backdrop.

Fireworks are vivid and impressive nighttime subjects. To capture several sparklers in one photograph, use long exposures that provide enough time for the fireworks' light to register on the film. Some folding pack cameras automatically make time exposures up to twenty or thirty seconds. SX–70 cameras allow for a fourteen-second exposure. These times should be adequate. Other instant cameras can be rigged to make longer exposures. For pack cameras that do not have lighting selectors, estimate the amount of exposure time needed. Hold the shutter release down for that estimated period and wait until you hear the shutter click closed before releasing. If you hear a second click too soon, depress the shutter again and hold until the full time has elapsed. Another alternative is taping over the camera's electric eye to keep the shutter open for as long as you depress the shutter release. For Kodak Colorburst and Kodamatic cameras, open the film door and depress the shutter release for the desired period of time. Then close the film door, depress the shutter button again, and the picture will be ejected and processing will begin. The same procedure can be used to take pictures of car lights moving along a dark highway or stars streaking across the night sky.

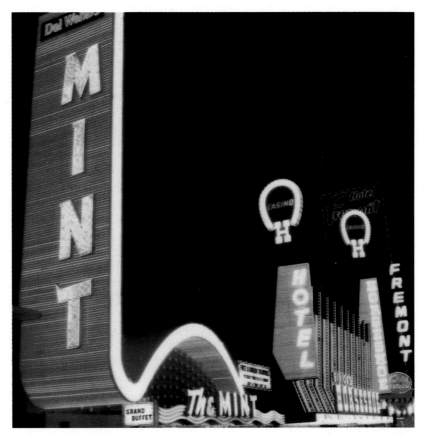

Sometimes picture-taking at night without a tripod produces unique light blurs. While the camera is making a long exposure, deliberately move, shake, or jar it. Lights will be recorded as streaked patterns and colors.

Neon lights are colorful subjects, as exemplified by this picture of gambling casinos in Las Vegas taken by Sam Liggero. The fluid shapes and bright colors make a stunning photograph.

Nudes

The human form is a visual wealth of silky textures, graceful contours, sumptuous forms, sinewy surfaces, and rich tones. Master painters have long been inspired by the natural beauty of a naked body and have explored its connotations of innocence, romance, sensuality, and eroticism. Photographers, too, have luxuriated in the many artistic possibilities and have followed traditional painterly approaches to some extent, although the reality of a photographic print clearly is more revealing and more immediate than a painted canvas. After all, the photograph is a direct reflection of reality. Therefore, to evoke a similar response, a photographer must exercise tasteful control and discretion in approaching the nude form; otherwise, the result might well be pornographic.

What lends a photograph a classical or contemporary attitude? If you compare formal approaches with modern, more unconventional photographs, you'll notice a clear difference in pose, facial expression, and lighting. The Greek-inspired contraposto pose—a full-length view of the body in a relaxed, one-knee-bent position—is classically soft and refined, while a closeup of a young woman's body half-clad in jeans is strictly modern and provocative. An innocent downcast gaze is somewhat Victorian, while direct eye contact with the camera has a modern, confrontational intimacy.

Lighting sets tone and atmosphere. Hard, flat, frontal light reduces the nude form to its essential shape, without defining either three-dimensionality or texture. As a general rule, such light is unflattering unless used specifically for the purpose of reducing form to an abstraction. The most appealing light for defining the human body and emphasizing textures of hair and skin is diffused sidelighting. This soft yet directional light minimizes imperfections of the skin, gently distinguishing curves and surface details.

Many contemporary artists prefer to isolate features of the human form, cropping closely or lighting in a dramatic way. In some instances, the subject's face is excluded from the composition, to produce an anonymous figure. When the face is included, the facial expression must complement the mood if the photograph is to work.

As in portraiture, establishing a good rapport with your model is important in order to elicit the proper responses and achieve the right mood and expression. Try to use the model's personality to help create the mood rather than containing the subject in an atmosphere not in keeping with his or her basic nature.

Nude photography can be accomplished in a quiet studio setting where the photographer has control over all elements or in a natural indoor or outdoor location. A model's sitting room, a shower, a bedroom with stylized decor—all are typical indoor spots. Outdoors, you can explore spatial relationships of beaches, fields, rocks, and other natural formations.

Suggestions of nudity can sometimes be

Nude photography is often associated with the female body, but the male form has become increasingly interesting to modern photographers. This partially draped male figure, photographed by Robert Mapplethorpe, combines contemporary and classical elements. Direct eye contact with the photographer and isolation of the figure are significantly contemporary, while the stance is quite classical. The model's expression is a crucial element in the powerful impact of the image. Cover the face to see how different the effect can be.

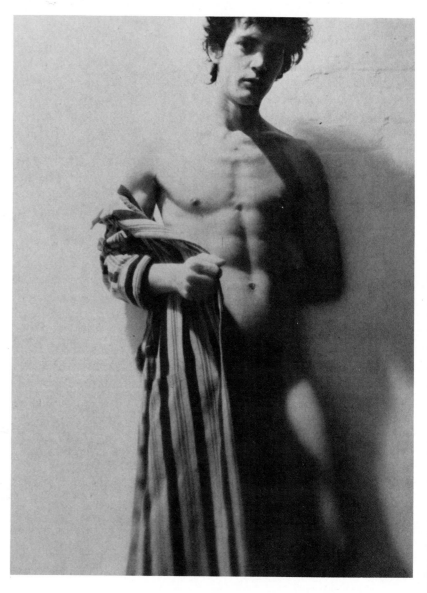

even more sensuous and alluring than showing a fully nude body. Partial draping of clothing or fabrics creates seductive illusions and excellent counterpoints to the nude figure. Try using a variety of materials from highly textured burlaps to smooth luxurious satins for varied effects.

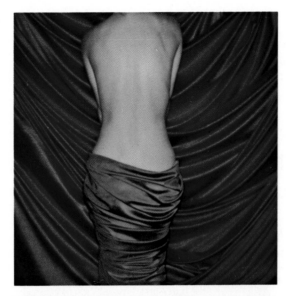

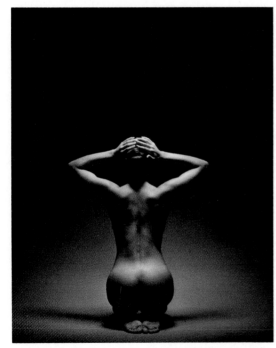

Far left: The drama of this exquisite form is exaggerated by the placement of a single light above the model. Note how the body is highlighted and the floor shadows echo the outward thrust of the arms. The photo was taken by R. R. Twarog on an 8×10 camera. *Top left:* Reminiscent of the pose of classical painters' models, this picture of a voluptuously draped nude by artist Rena Small has been controlled carefully through posing and lighting. Sidelighting brings out the rich velvety texture of the skin and satiny surface of the layered fabric. The photograph was made in a studio with an SX–70 camera. *Center:* Representative of a contemporary trend in nude photography, this abstract, headless nude by Nicholas Callaway is reduced essentially to lines and shapes with only a mild hint at form. The juxtaposition against the poolside shapes creates a pleasant repetition of lines, as the curve of the buttocks follows the upper curve of the pool's edge. *Bottom:* A complicated setup, this perplexing image by R. R. Twarog sustains an almost Dali-esque intrigue. The only "real" elements are the carafe, wineglass, and SX–70 photograph; the rest are created by reflections and lights. Twarog placed a mirror on a platform (visible in the upper left edge of the picture). A nude model was positioned toward the rear of the platform to reflect into the mirror. A light was placed above the wineglass; another light was positioned behind the model. Notice the reflection of the nude in the glass stopper of the carafe.

Portraits

A portrait is an attitude, an environment, a statement about being human. It's the association the photographer makes between the subject and the subject's surroundings.
—J. Frederick Smith
Nikon World, April 1980

"I don't like having my picture taken," said one woman, refusing her camera-carrying friend's requests to take her portrait. "I don't like the way I look in pictures," she protested.

This woman's response is fairly common. Therefore, if you are taking portraits, you must be extremely considerate, since many people are ill at ease in front of a camera. In fact, in a survey conducted by the Polaroid Corporation and the Maine Photographic Workshops, one-quarter of those interviewed expressed great discomfort about having their pictures taken.

Being photographed is disconcerting for most people because they envision themselves differently than the camera's lens records them. When we look in a mirror we see a straightforward frontal view, rarely a profile or a spontaneous expression. So when a camera catches us from a unique point of view, we often are disappointed that the image does not resemble the way *we* think we look. As a result, many of us are painfully self-conscious in front of the camera's penetrating eye.

One of the secrets in doing portrait photography is to overcome a subject's natural inhibitions. A pleasant, nonthreatening rapport must be developed with the model. If the subject feels exploited or uneasy in any way, the photograph will look stiff and awkward. Informal conversation is the quickest method for easing a tense atmosphere. Some professionals even use music to help set the mood and relax a model. Most important, the photographer must constantly be reassuring, upbeat, and enthusiastic. Often a photographer will elicit responses from a model through gentle mood suggestions. All the while, the photographer is watching and waiting for the model to let go—to reveal something—and is giving constant positive reinforcement.

Behind the camera, you are the director. You alone see how the image appears in the viewfinder. You have control over the final product. If you develop a good working rela-tionship with your model—whether your five-year-old niece or your eighty-five-year-old grandmother—the portrait will be honest and representative. As renowned portraitist Philippe Halsman noted about his technique: "I don't try to impress my own style on the subject. I try to get the subject to impress his own style on my photograph."

Sometimes you can use instant cameras to advantage by sharing each portrait as it is taken with your model. The subject thus can become involved in deciding on the next pose or situation. A genuine trust emerges through joint efforts. If the subject is willing and enthusiastic, the outcome will be better, more satisfying portraits.

You occasionally may wish to take a

Left: For fashion or beauty portraits, a good working rapport with the model is critical to evoking the right expression and feeling. In this striking portrait by Karen Boyes-Bogie, notice the sultry pose, judicious framing, and camera angle beautifully outlining the model's profile against the sweeping black hat. *Bottom:* Outdoor portraits are enhanced with fill-in flash. In this lovely portrait, the model's hat brim had created an unpleasant shadow across her eyes. Flash eliminated the unwanted shading but did not alter the color balance. The reds and pastels are still vibrant.

stranger's portrait—someone encountered while traveling, for example. Be polite and straightforward. Ask permission to take a picture. If the person resists, explain why you are interested in taking the photograph. Never take someone's photograph if he or she is adamantly opposed. You'll only create hostile feelings and risk a confrontation. It isn't worth it.

For outdoor portraits, be aware of background, time of day, and lighting. Distracting backgrounds direct attention away from your subject. Even worse, you may discover that a distant telephone pole is translated in a two-dimensional photograph into an object that seems to protrude from your subject's head. You cannot easily chop down the pole, but you can move your subject. If you have trouble eliminating distracting objects, get close to the subject to exclude all surroundings.

Time of day affects the quality of sunlight and colors. Midday offers the least pleasing tones for portraiture. When the sun is at its high point in the sky, light is bluish and unflattering to the skin. Furthermore, when the sun is directly overhead, harsh light tends to cast dark shadows under the eyes. Fill-in flash will help to balance the light and soften under-eye shadows. A white glossy cardboard or crumpled aluminum foil can be used to reflect light into the dark areas. Or a different time of day can be chosen. A shaded area or hazy day is often best for evenly lighted portraits. However, be aware of reflections from nearby objects. For instance, if your subject is standing under a tree, chances are that skin tones will take on a greenish cast from the light reflected through the leaves. Next to a red brick wall, a subject's skin might turn ruddy. Either move to another location, use flash to fill in and balance the light, or use a filter. Light reflection is a common occurrence with sand, water, or snow; but rather than detracting from the subject or shifting colors, the light aids by reflecting up at the subject so that shadowed eye areas are naturally filled in. However, exposure compensation is required to counteract the background brightness, so dial the lighten/darken control toward lighten. In posing subjects outdoors, avoid having bright sun shine into the person's eyes. This causes discomfort and unattractive squinting.

A simple direct portrait can be extremely revealing. In this picture by Stephen Gersh, attention is drawn to the old woman's weathered face and the young girl's vulnerable, tentative expression. The camera was positioned close enough to eliminate any distracting background but far enough away to show the women's clothes and hands. The straightforward approach is one used by many documentary, travel, and art photographers who try to isolate and observe individuals in order to bring out their essential character.

Portraits

Indoor portraits are easier to control than outdoor locations in terms of background and lighting. For formal portraits, professional photographers often rely on a studio setup equipped with lights and seamless paper for an unobtrusive neutral backdrop.

A formal studio setup can be arranged in a corner of a room. The camera should be placed on a tripod. Seamless paper is hung on a wall and unrolled to extend onto the floor. If you are planning to do full-length portraits, keep the seamless clean. If it gets dirty, unroll a new piece. Place a chair or stool on the seamless. Arrange the lighting and camera before the subject sits down. You won't want to be fumbling with equipment while trying to develop rapport with the subject. Using a cable release allows you to maintain reassuring, constant eye contact with the subject, instead of keeping your eye to the viewfinder.

Celebrated photographer Irving Penn used a basic, clean, available-light approach for his insightful portraits in *Worlds in a Small Room*. Although Penn did not use instant films for his portraits, his simple improvisational method is worth discussing here. He set up a portable north-light studio in various countries and invited the local people to pose for their portraits. Against a totally neutral background, with the even illumination afforded by north-light exposure, Penn captured the Mudmen of Asaro, the Indians of Peru, as well as the Hell's Angels of California. Their dress, make-up, and attitude created a revealing study in the varied faces of humanity.

While I do not suggest setting up a mobile studio and wandering around the world taking formal instant pictures, I do recommend trying a formal approach to taking pictures of friends, family, and acquaintances. Naturally, the added bonus of working with instant films is being able to shoot an extra photograph for your subject as a memento of the shooting session.

When posing your models, be flexible. Suggest certain poses and allow the model to respond and contribute. Make it a working interaction. If you want your subject to smile, say something amusing to elicit a natural expression. Unfortunately, most people automatically stiffen in front of a camera and their eyes glaze over, unseeing. Try to catch them at a relaxed second. Be sneaky if necessary. Tell them you will count to three, then surprise them by taking the picture on count two. Or take the picture on the count of three, then immediately snap another after they have relaxed and assumed the picture-taking was over.

For some subjects, you might suggest an appropriate outfit. But do not insist. If you are given the opportunity, choose clothes that reflect the person's personality. If you want a portrait of your neighbor who raises gardenias as a hobby, ask her to pose in her gardening clothes. A painter friend might be best portrayed—and most comfortable—in a painting smock. Props are sometimes excellent additions and give the subject something familiar to hold. You might ask your gardening neighbor to bring along a prized gardenia; the painter might carry a palette and brushes. These props can be used as strong elements of composition in your pictures as well.

Environmental portraiture is another significant technique used for revealing the subject. A person usually is posed in his or her natural surroundings: a living room, den, kitchen, or workroom. The photographer uses a medium or long shot to show the person within his or her environment, providing interesting information about the individual, such as taste in interior decorating, interests, habits, and so forth.

In this outstanding example of an environmental portrait, Arnold Newman has created a revealing look at another well-known photographer, Roman Vishniac, in the subject's own study. By placing Vishniac at the lower right of the image and including the subject's books, papers, and photographs, Newman—who specializes in this style of portraiture—has made a clever and well-balanced picture that very much characterizes the subject.

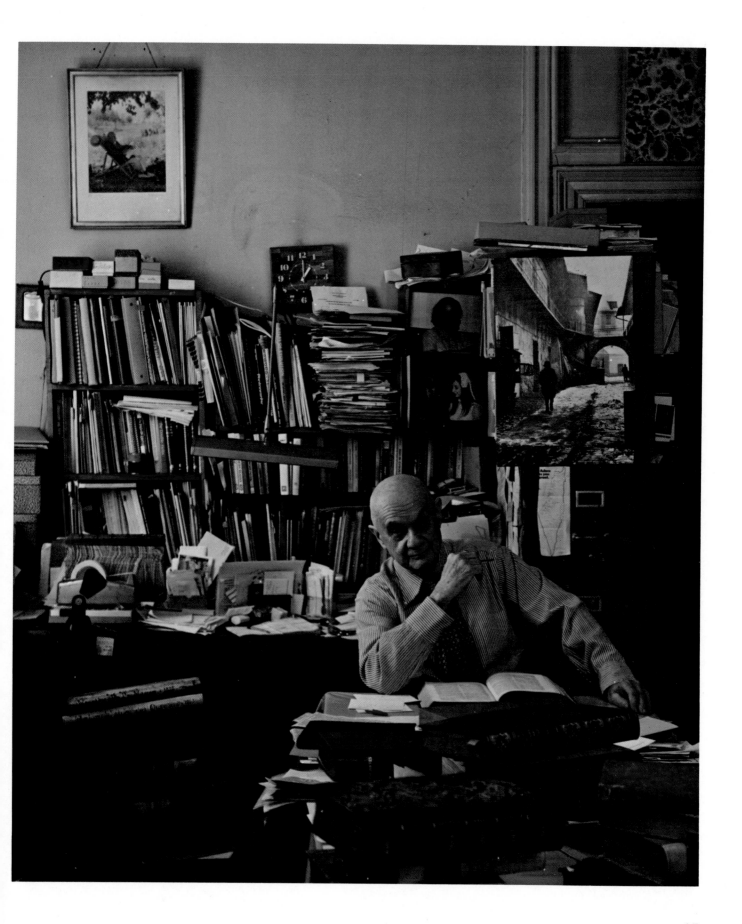

Portraits

TECHNIQUE: PROFESSIONAL LIGHTING

When selecting lighting, decide what you want to emphasize about your subject. What mood do you wish to evoke? If you want to capture the delicate quality of a ballerina, you might select diffused light for a soft, romantic look. For a craggy old seafarer, strong side-lighting would probably best accent lined, rugged features.

To set up your own lighting, use a simple one-lamp light source. Choose a daylight-balanced flood light that is compatible with the color balance of instant films and provides even illumination. Try not to position the light directly in front of your subject unless you want hard light. This position will flatten the subject's features and produce unflattering portraits. Angle the light slightly from the side to bring out the subject's three-dimensional quality and to define textures of skin, hair, and clothes. The more the light is angled from the side, the more dramatic form and texture will become. Very strong directional sidelight emphasizes facial details on one side, but throws the other side into shadow, producing powerful effects. To lessen the shadows, use a reflector to bounce light from the lamp onto the shadowy side. For unusual effects, position a light above or below a subject's face. The lower position will transform the subject into a creature out of a horror film.

Available light is a fine source of illumination. Window light, for instance, provides strong directional light. Try posing your model turned three-quarters of the way toward the window, and capitalize on the bright streams of light. Or use a reflector positioned on the opposite side to reflect some of the window light onto the shadow side of the face. Be aware of the varying types of available light. Remember that household light-bulbs give a reddish cast to pictures, fluorescents have a greenish tint, and candlelight has an orange hue.

When using flash for portraiture, make sure you are within the appropriate distance range from your subject. Otherwise flesh tones will wash out or turn ashen. Focus accurately. Most flash errors are the result of

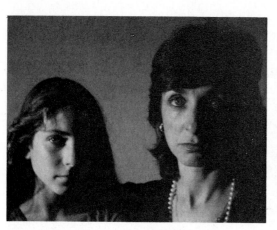

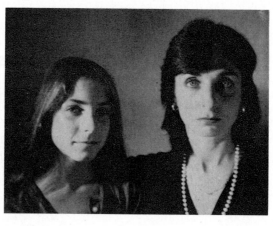

Far left, top and bottom: A one-light source positioned at the side of the models creates dramatic effects, producing highlights on one side of the faces while throwing the opposite side into deep shadows, in this portrait of mother and daughter. *Left, top and bottom:* With the setup exactly the same as before, a reflector was added to the opposite side of the subjects filling light into the shadow areas and bringing out more details. The effect softens the drama, creating a more natural-looking portrait.

improperly set distances. Dark-haired subjects should be placed close to a light-colored background or else the hair will blend into darkness, obscuring the outline of the head. Obviously, if you wish the background to be clearly visible, position the subject close enough so that the flash lights both subject and background adequately.

Since flash provides frontal lighting, try softening the harshness and deepening colors by putting a diffuser in front of the flash. You can improvise a diffuser by using a nylon stocking, folded tissue paper, or any thin, gauzy fabric. Natural-colored materials are best, since any color in the fabric will be transmitted onto the photograph. Since flash output is reduced, lighten the lighten/darken control slightly.

Left: Flash isolates and catches an expression at its height, since the subject is not given time to strike a pose. _Center:_ A soft, moody portrait is elicited by the orange glow of candlelight. For dim, available-light pictures, the camera must be held very still to avoid blurring. In this picture taken by Linda Benedict-Jones, slight blurring actually adds to the effect. _Bottom:_ Artificially colored lights add an unusual dimension by highlighting the hair and arm of this model. (Refer to "Gels and Filters" section.)

Portraits

TECHNIQUE: FINDING THE ANGLE

The angle from which you photograph a person can exaggerate or minimize features. A low angle accentuates the chin. A full-length portrait emphasizes height. A high vantage point exaggerates the forehead and foreshortens a person's height. Sometimes exaggeration enhances a portrait by accenting a characteristic that is readily associated with that individual. Bob Hope's famous ski-jump nose would be accentuated by a high angle, while boxing champ Muhammad Ali's stature would be best conveyed by a low angle. A subject's position can make a difference, too. A wide face is minimized by shooting a three-quarter view. A wide jaw or long nose is reduced by tilting the head slightly downward. A heavy figure appears leaner in dark clothing.

With some instant cameras, if you get too close, facial features will appear distorted. If that is the case with your camera, keep a medium distance from your subject. If you have an SX–70 camera, use the Tele Lens accessory, which minimizes distortion by allowing a greater distance from the subject while at the same time filling the frame.

A profile pose is not flattering to everyone, but this profiled subject photographed by Robert Mapplethorpe looks classically handsome.

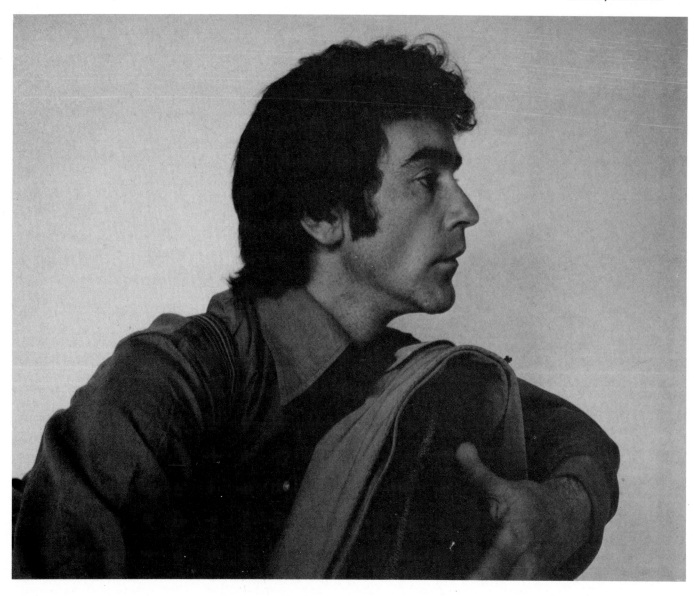

Checklist for Shooting Portraits:

✓ Get close enough.

✓ Develop an easy working rapport with the model through casual conversation.

✓ Maintain a positive, upbeat attitude during the shooting session.

✓ Reassure the model constantly.

✓ Use props if necessary to relax a subject and keep hands occupied.

✓ Consider the subject's features and explore the best shooting angle.

✓ For outdoor portraits, consider time of day, lighting, backgrounds, and reflective scenes.

✓ For informal, moody portraits, use available light.

✓ For formal portraits, set up a floodlight and/or reflectors.

✓ When using flash, be wary of dark-haired subjects against dark backgrounds.

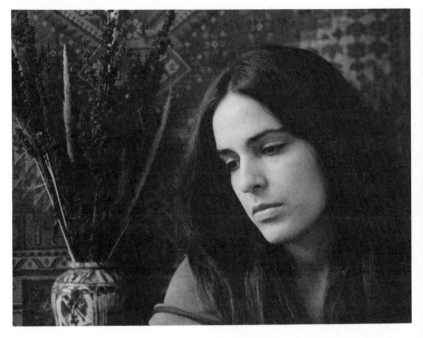

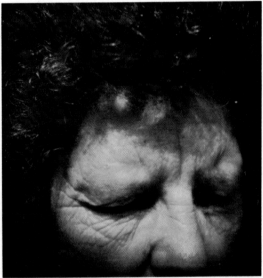

Above left: Downturned eyes give this portrait by Stephen Gersh a contemplative quality. The three-quarter head position slims the face and accentuates the subject's sculptured features. *Above right:* A portrait does not necessarily have to show a full face to be revealing. In this emotionally charged portrait, photographer Eugene Richards has managed to convey the weatherbeaten strength of this subject's face. *Right:* Some portraits need not include the face at all. To portray the working world of a fly tyer, the photographer chose to focus on the tyer's hands, revealing the concentration, intricate handwork, and the paraphernalia of the craft. A facial view also would have produced an interesting portrait, since the subject appears involved in his work and unperturbed by the camera.

Candids

The first impression is essential. The first glance, the shock, the surprise.
— Henri Cartier-Bresson
Images of Man

Candid photography is by nature spontaneous. The photographer must be able to see and react to people in a fraction of a second. Candids can reveal much about the subjects, since they are caught in the act of being themselves. In a way, the photographer becomes an observer of behavior, capturing the essence of a subject's being.

Candids can convey rowdiness and high spirits, as is often the case with pictures taken at parties. Or they can be artistic and documentary, as in pictures showing people absorbed in their activities, unaware of the camera. In either situation, the photographer must be alert and watchful.

Timing is crucial. Since expressions are fleeting, it is impossible to ask someone to laugh or look surprised a second time and expect natural-looking pictures. Always have the camera ready, loaded with film, and opened for shooting.

Patience counts, too. Allow the subject to remain involved in the activity at hand. Try to be unobtrusive and become an interested observer. If the subject becomes aware of the camera, wait until he or she is reinvolved, then try to capture the unposed instant.

Circuses, parades, and street events such as fairs and crafts shows are great places for taking candids. Onlookers' expressions of joy, fascination, or amusement result in terrific studies of people. Parties also are marvelous times for candid photography, and an instant camera often becomes a helpful icebreaker. In fact, an instant camera often will motivate people to do unexpected things just to see the immediate record of their behavior. Enjoyable candids can be created by capturing a humorous moment.

Left: Candids can evoke a peaceful feeling, as evidenced by this photograph of an older couple relaxing by the water. Photographer Lincoln Russell chose to record a private moment when the two people were resting and unaware of the camera. The result gives the viewer a sense of looking through a one-way mirror, of being able to observe without being observed. *Below left:* The heightened moment of laughter gives this candid a natural vitality. Flash was used along with a fairly low camera angle to frame the couple in a balanced composition and still reveal the fire in the background.

The wildest candids can be taken at street fairs or parades, since people are displaying themselves intentionally. Harvey Stein photographed this bizarre face during a Mardi Gras celebration in New Orleans. By underexposing slightly and using flash for the daytime exposure, Stein was able to isolate the face and actually intensify the nightmarish effect of the scene.

Children

Children and infants are the easiest and, at the same time, most difficult subjects to photograph. While expressive and highly responsive to the camera, kids are also energetic and fast-moving and tend to lose interest quickly. These traits are difficult to control. Therefore, the freshest pictures are created by approaching children in their own world—at play, at rest, or in a quiet, pensive moment. You should not force a pose but rather observe and try to capture the liveliness of their youthful spirit.

Fortunately kids are not bashful or inhibited in front of a camera. They are just as likely to demonstrate a cartwheel as they are to cry over a ruined ice-cream cone. Their enthusiasm and openness make them extremely accessible subjects. In fact, beginning photographers often find that photographing children is a marvelous way to improve picture-taking skills and build confidence for taking all kinds of portraits.

Readiness, good reflexes, and a sense of timing are important qualities. Since kids are changeable, be prepared to shoot many pictures to obtain the ones you want. Use toys or pets as props to add interest to the composition and to keep the child occupied and attentive. Sometimes by including other children—a friend, brother, sister—you can create an interesting interaction or a sense of family ties.

Children readily associate with reds and yellows, brightness and frivolity. In order to enhance the childlike association and to take advantage of the innate contrast of instant picture films, include vibrant colors in your composition. Crimsons, yellows, and oranges add zest and are appropriate to a child's world. If children are not dressed in colorful clothes, add color by including bright toys or backdrops. But keep pictures simple and easy to read. Backgrounds can all too easily become confused and distracting, especially at fairgrounds or play areas. Use a medium-long shot to show a child at play, or a tight closeup to reveal facial expressions. Fill the frame and watch all the edges.

If old enough, a child can cooperate in a picture-taking session. Many techniques for developing rapport with adult models can be used with children, too. You might suggest particular activities. You might instruct Eric to bounce a ball or ask Tanya to swing. The

Left: Although faces are not clearly visible in this photograph, the exuberance and constant motion of the children are key subjects. Blurring has been used to intensify the feeling of youthful activity. *Below:* A child's own plaything can be used for framing and focusing attention. In this example, the excitement on young Tina's face has been brightly circled by the form of her toy tunnel. Yellow is a particularly good color for adding vitality.

session can be most successful if children are allowed to participate in the picture-making process. Share the pictures as they emerge and you'll quickly discover how creative and intuitive kids can be. However, when working with very young children, caution them against putting pictures in their mouth. Even with integral films—in which pictures are protected in self-contained units—some chemical leakage is still possible and can be dangerous to a child's health.

In general, infants require a good deal more cajoling and patience than young children. For babies, a playpen or crib location is often an advantage when it comes to focusing, composing, and observing. Involve the child with some object such as a toy or a bottle. Occasionally you might ask another family member to make sounds and faces to keep the child's interest.

As in any other shooting situation, be aware of camera angle and lighting. Try to get down to the child's eye view for an interesting effect. Experiment with available light for expressive, interpretive portraits. (Refer to the "Portraits" section for specific guidelines on lighting.)

Left: Infants are fabulous subjects, but a photographer needs quick reflexes to catch their fast-changing expressions. In this photograph, little Carolyn—just awakened from a nap—had a one-eyed curiosity about the picture-taking machine poked in her face. In order to catch her humorous expression, I moved in close to fill the frame—and to isolate her image from that of her father who was holding her—and fired off a flash. A moment later the expression vanished. I still chuckle every time I look at the image. *Center:* This picture was taken during a break at a "fun" modeling session. The unguarded moment when the subject was relaxed and casual resulted in an easy, natural effect. *Bottom:* Color is associated readily with children and should be taken into consideration when taking pictures of them. These two youngsters look perky dressed in their deep red outfits.

103

Families and Groups

The gathering of the clan usually signifies special times, precious moments that should be preserved in pictures. At the turn of the century, pictures were often an integral part of a family's evening activity. Surrounded by billows of thick cigar smoke, with drinks in hand, family members would assemble after dinner for hours of viewing the family album. Today, instant pictures make the activity more immediate and exciting for everyone involved. Picture-taking and viewing occur almost simultaneously, and all family members are active participants. The result is a lasting document of personal family history.

Prior to any family event, the photographer should prepare a list of specific pictures to be taken. If the occasion is a religious gathering, decide on the essential moments in the ceremony that should not be missed. At a Christmas day celebration, one of the most significant scenes is the unwrapping of gifts around the tinseled tree. The chaos, colors, expressions of surprise and enjoyment are all part of the essence of the holiday season. For a graduation party, the list might include candids of guests enjoying the celebration, formal portraits of the graduate in school robes in the backyard or living room, and group pictures of the graduate with his or her proud family.

When arranging group portraits, give directions and take charge. Wait until everyone is gathered in one place, then quickly tell each person where to stand. Position the tallest people in the back row, shorter people in front, or ask the people in front to kneel or be seated. Try to keep everyone on an even plane so that focusing will be accurate, especially if flash is used.

Keep the group fairly centered and symmetrical. Just as you are about to take the picture, ask everyone to look in the same direction (usually at the camera). This helps unify the composition. Otherwise, if eyes are gazing off in many directions, the overall effect is disorderly.

When you are photographing large groups, it is often an advantage to place the camera on a tripod and use a cable release (if possible). In this way, you can select the appropriate site beforehand in order to determine the approximate outside edges of the

frame within which you will place your subjects. Further, you will be free to direct the group without having to keep your eye constantly on the viewfinder. Once everyone is assembled, check the viewfinder to make sure all faces are visible. A high angle can be advantageous. Take several pictures in rapid succession (if you are using an instant camera that allows for film processing outside the camera). Even though you will not be able to view fully developed results very quickly, at least you will avoid the need to reassemble the entire crowd if the developing picture later reveals someone whose eyes were closed.

To include yourself in the picture, use a self-timer accessory. Compose the picture first and leave a space. Most timers will give you about fifteen seconds to get to that spot. During that time, keep everyone's spirits high by giving a countdown and letting the rest of the group know when the picture is about to be taken. Remember to direct attention to one spot.

Family pictures help us and our children to remember the important times in our lives. Whether you are at a family picnic, celebration, or ceremony, gather the clan for memorable souvenirs.

When taking group pictures with flash, position all subjects at about the same distance from the camera or else the flash will not cover evenly. Foreground subjects will appear bleached, while distant ones will melt into darkness. In this photograph by Stephen R. Milanowski, his basketball friends are all properly arranged in a tightknit group for a well-lighted result. In most group pictures, the photographer should direct all eyes to look at the same spot. However in this instance, the clownish disarray suits the free-wheeling image of the group.

Families and Groups

At large family get-togethers, consider selecting smaller groups for special portraits. Take a picture of grandfather playing ball with his grandson, or of the twins wheeling their new brother, or of all the sisters and sisters-in-law together. To this day, I regret missing the opportunity at a family gathering to take a group picture of my grandmother, mother, sister, and my sister's daughter. This photograph would have represented four generations of women in the family and today would be a family treasure. Fading memories do not compare to a photograph in hand, so do not forget to take important pictures you'll want to have for the future.

TECHNIQUE

After the event has come and gone, be sure to mark dates on the back of every photograph. Years later when sorting through drawers of pictures, you will have difficulty remembering on what occasion certain pictures were taken. Include date, place, occasion, and names of the people pictured. With SX–70 and Polaroid 600 film, you can write the information with any pen on the lower border at the back of the picture. With Kodak or Kodamatic films, you can only write on the white front border using a Sharpie, Kodak Instant Marking Pen, or any other permanent ink pen. Peel-apart pictures can be marked on the backs, but press lightly and avoid using ballpoint pens or you will push through the picture and mar the image surface.

Checklist for Family and Group Pictures:

✓ For special occasions, make a list of important details and moments to be captured.

✓ In arranging groups, position the tallest people at the back, the shortest in front, and direct everyone to look at one place for a unified composition.

✓ When taking flash portraits of groups, make sure all subjects are nearly the same distance from the camera.

✓ Take several group pictures in succession to allow for a final choice.

✓ To include yourself in a group portrait, use a self-timer.

✓ Mark dates and names on every picture for future reference.

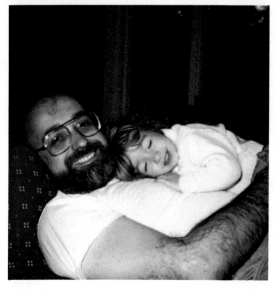

Left: Unique and meaningful interactions can result in very personal pictures which add universal insight and interest to family albums. A closeup of a father's and infant daughter's hands not only records the special tie and emphasizes the striking size difference, but symbolizes the dependency and fragility of all newborns. *Below:* Everyday moments are as important to capture as special occasions. This touching picture was taken during a restful, loving evening time when father and daughter were obviously enjoying one another.

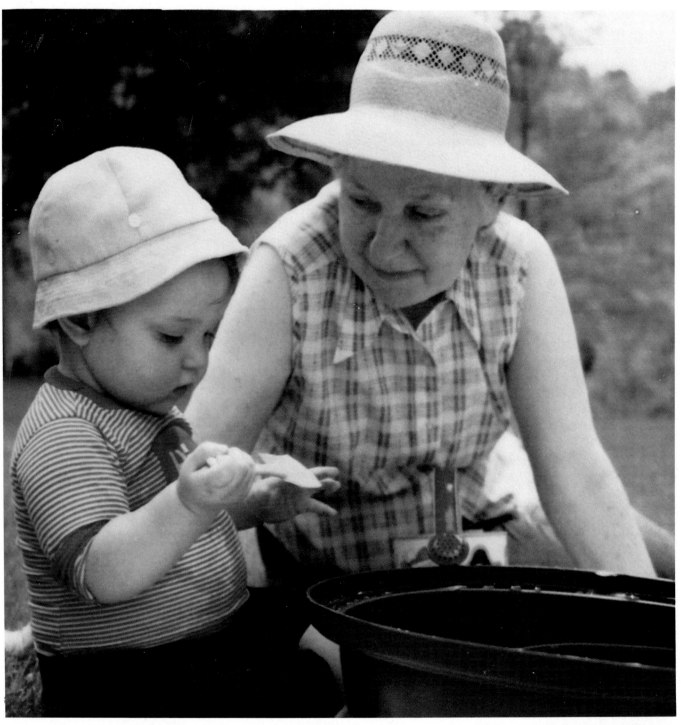

Grandma and grandson make for an especially precious family portrait. Photographer Larry Mach took this informal shot at a moment when the two were engaged in a playful chat, oblivious to the camera. Family pictures help us to share and remember as years slip past and people grow and change.

107

Wildlife and Pets

The animal kingdom provides a treasure trove of picture-taking possibilities. For exciting wildlife and pet pictures, a photographer must have a lion's share of sensitivity, patience, perseverance, and resourcefulness.

The major aim in taking animal portraits should be to understand and capture the subject's "personality" and uniqueness. Every living creature has its particular qualities, and animal pictures are stronger and more successful if they reveal them.

While animal behavior is curious and difficult to predict, often certain patterns and styles are present. By carefully observing a subject over time, you can become familiar with these specific traits and idiosyncrasies. Once tuned in to an animal's basic nature, you can anticipate movements so that picture-taking becomes almost intuitive. With your own pets, of course, this ability will come much more easily.

Readiness is another key prerequisite, along with timing and fast reflexes. Practice is the best way to hone these skills, but a few of the following simple techniques can help.

When the action is quick, keep the camera to your eye so you will not waste even an instant. In some fast-moving situations, you may not even have time to focus. For best results, prefocus to the approximate distance where movement is occurring and forget about focusing. Even autofocus cameras such as the Polaroid Sonar take a second to measure and set focus. With Autofocus sonar cameras, use the manual focusing mode (refer to the Guide).

Zoos are one of the finest and most accessible sources of wildlife pictures short of safaris in Kenya or the South American jungles. Feeding times (which are usually posted) provide excellent opportunities to photograph animals in an active, energetic state. Wildlife preserves, game farms, and national parks are also great places to pursue animal photography. Some even offer tours and special days for photographers.

The fact that animals are very sensitive to other animals, including people, can cramp your style. So wear inconspicuous clothes that blend into the environment. Safari outfits are a workable choice, especially since they have lots of pockets for holding film and accessories. Finally, move slowly. In some instances, if the wildlife is not dangerous, stake out a spot in the field and remain there quietly until the animals no longer are threatened by your presence. But be prepared to wait; it can sometimes take hours.

When photographing wildlife or pets, try to get as close as possible. Fill the frame. Wait for an interesting interaction. Keep an eye on the background, foreground, edges of the frame, and colors.

When working in the field, set the camera on a small tripod with a remote button attached, then compose by estimating where the action will occur. This setup keeps you from fidgeting excessively with the camera, and thus reduces unnecessary movement which can disturb wildlife or pets. Cameras using integral film have noisy motors to eject the film and this sound is frightening to animals. Some get accustomed to it, but others will flee and not return until you and your strange contraption disappear. Try using a Tele Lens (only available for SX–70 cameras)

A closeup of a wild animal, such as the dramatic profile of a lion, is a bold, eye-catching image. The frame is fully filled, the composition is nicely balanced, and the directional lighting brings out the texture of the animal's fur.

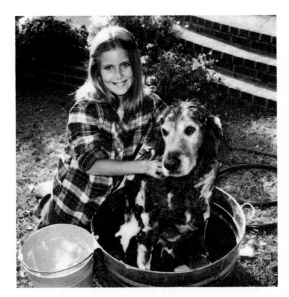

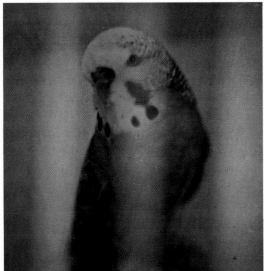

Far left: An amusing portrait can be created by photographing a pet in a typical activity. In this humorous photo, the dog does not seem to be very enthusiastic about his soapy bath. The happy expression on the young girl's face contrasts with the dog's rather pathetic resignation. Notice how nicely the composition works in terms of balance of forms and subject placement. *Left:* Sometimes you can blur the bars on a cage to make an intriguing image, as shown by Michele Gisser's photograph of a parakeet. The camera was positioned close to the cage to achieve this effect.

which allows you to be further from the subject and still get a good-sized image.

The principles of photography should not be neglected when you take wildlife and pet pictures. Composition, balance, and especially lighting are all important features to consider. As you recall from "The Vision" section, sidelighting particularly enhances texture and is therefore desirable for bringing out the detail of animal fur. Try varied approaches to your subjects, from closeups to shots from faraway locations.

In dimly lighted interiors, use flash cautiously. Some animals are violently disturbed by blinding light directed into their eyes. In fact, some zoos will not permit use of flash equipment. So be sensitive and use good judgment. In addition, be aware of backgrounds. Dark-colored animals photographed with flash against dark backgrounds lose their outlines. Look for light-colored backgrounds for good tonal separation.

TECHNIQUE: SHOOTING THROUGH BARS

Since many zoo animals and pets such as parrots and hamsters are confined to cages, photographers constantly face the problem of shooting through bars. To overcome this obstacle, be aware that the farther the camera is positioned from the cage, the more in-focus and obvious the bars will be. This is essentially a function of depth of field. To eliminate the bars, put the camera very close to the bars and shoot. The camera will seem to "see through" the cage as if no bars existed at all. However, do not use flash or the bars will reflect the light and become quite obvious. Also, be sure to use manual focus for sonar autofocusing cameras to avoid having the camera focus on the bars. Of course, if the bars are wide enough apart, place the camera between them.

Underwater

The sensation of floating effortlessly through the lavish undersea world is unparalleled. Schools of fish swim past your head blocking out some of the sun's surface rays; lush formations—seaweed, gems, and shipwrecks—dazzle the eye. Diving with an instant camera can heighten the experience.

Unfortunately, underwater instant photography is limited to SX–70 camera owners since the only internationally available underwater instant camera housing is the Ikelite System, an injection-molded unit made only for the *non*sonar, *non*autofocusing SX–70.

The Ikelite unit completely contains the camera and has external connections allowing the user to adjust the focusing and lighten/darken controls and to release the shutter.

Focusing is achieved by looking through a circular focusing area and centering the top of the circle with the subject. A flash attachment accepts regular high-power flash cubes housed externally on the unit. The attachment plugs into the camera, like a flashbar (and should only be attached if flash is going to be used).

The housing allows a full ten-picture pack to be used. Prints are ejected into a specially protected compartment. The Ikelite Underwater System can be used in depths up to 300 feet (90 m).

Ikelite Underwater System and Polaroid SX–70 Camera.

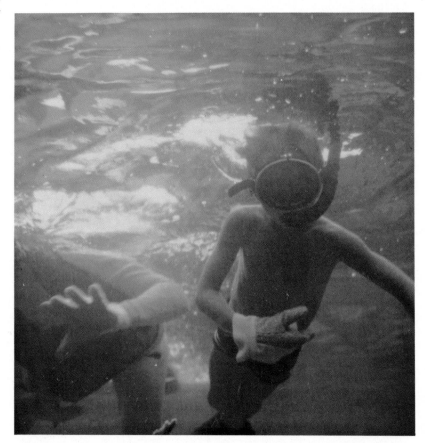

Taking the SX–70 camera underwater can produce excellent results, as in this picture of snorkelers by Tim and Kathy Church. Notice the interesting effect of surface white-light flare while the rest of the image remains aquamarine.

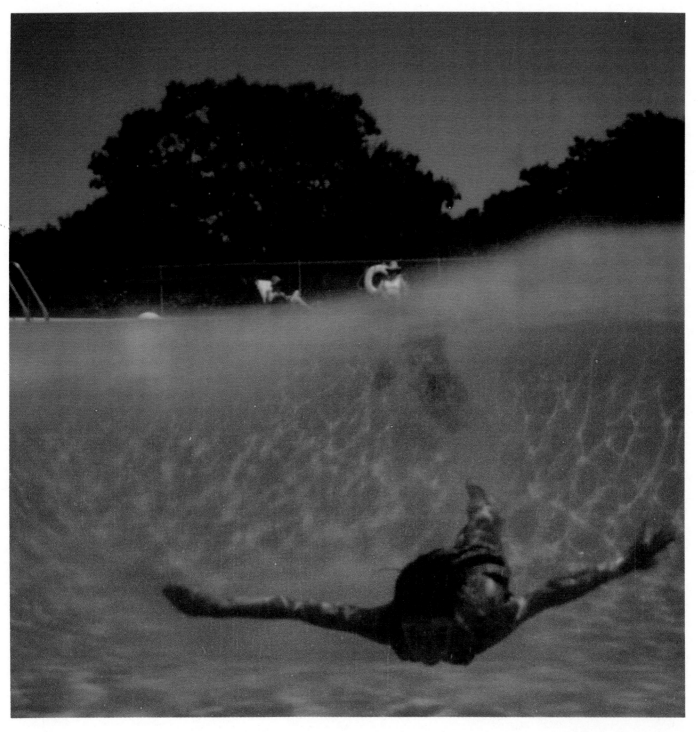

By experimenting with "partial" underwater compositions, Abe Rezny made this bizarre photograph showing both an underwater swimmer and the background, visible above the water surface of the pool.

Patterns and Reflections

Photography reflects the infinite variety of subject matter offered by the natural universe.

—Brassai
Dialogue with Photography

A dazzling source of photographs can be found in textures, colors, and shapes of almost any object. A photograph need not merely document reality but can abstract a real object to reveal an unusual facet or pattern that catches the photographer's eye. The object itself becomes almost insignificant, as emphasis is placed on its color, shape, or form. In fact, the object becomes merely a vehicle giving expression to the "found" photographic elements.

Taking pictures of patterns and reflections is an exciting way of exploring the physical world and seeing things in new ways. And besides, it's great fun. Discovering such images can be exhilarating. To facilitate visual finds, try looking at objects from varying distances—move from a long shot to a closeup—and approaching from varying angles.

Left: This free-flowing pattern in ice, captured by photographer Brett Weston, makes for a fanciful image. The use of black and white further abstracts the subject, reducing it to an elegant two-dimensional design.
Above: Reflective subjects provide striking possibilities for echoing nature's designs. In this example, William Clift has used the water's reflectiveness to capture a naturally symmetric dual image of shoreline trees. Other reflective surfaces to look for are mirrors, glass, and plastics.

Far left: A photograph that is purely about colors and shapes can be highly decorative. This one was created by standing at a distance from the four-story Alexander Calder stabile in downtown Grand Rapids, Michigan. The sculpture was further segmented by the photographer, who framed only a portion of it against a blue sky. Only a hint of a cloud and a building cue the viewer to the "real" setting. Objects of any size can be transformed into abstractions simply through careful framing from an appropriate distance. *Left:* Patterns can result in handsome motifs, as shown by this intriguing photo. The hard splash of red cutting through the image, the repetitive patterns of pipes, and the interaction of straight and curved lines make this closeup detail of a car vivid and almost musical. *Bottom:* Wet pavement is a wonderfully reflective surface, too, as seen in this photo by Abe Rezny. The patterns created by the shopping carts possess a strong graphic sensibility. The effect is reminiscent of avant-garde painting of the '30s.

Photojournalism

Well-known photographer Edward Steichen once said: "The mission of photography is to explain man to man and each man to himself." Steichen's sentiments underscore what photojournalism is all about—namely, a documentation of events or cultures, using the visual medium of photography.

Essentially two different methods are used in photojournalism. One encapsulates the entire event into a single telling photograph that communicates the essence of the situation. Newspapers typically rely on these kinds of images. The other method uses a series of photographs to tell a comprehensive story. This is called the photo essay, a main staple of *Life* magazine, especially during its heyday, and still a major feature of many international magazines such as *National Geographic, Stern, Geo,* and *Newsweek.*

The photo essay is not necessarily a series of sequential photographs but rather a series made during a situation or event that conveys its different aspects. W. Eugene Smith's famous book *Minamata* is one courageous example of the photo essay at its best. Smith's photos strikingly reveal the results of chemical pollution on the people of the small fishing village of Minamata, Japan. The photos show not only the crippled bodies of mercury-poisoned victims, but also the cause of the pollution—the Chisso factory—along with the quiet terrain of the fishing village. "If...my photographs could cause compassionate horror within the viewer," Smith once said, "they might also prod the conscience of that viewer into taking action."

Photojournalism influences the public. Smith's essay, for instance, generated an international investigation into the effects of industrial pollution. Indeed photographs can show us aspects of our own lives that might otherwise slip past unnoticed.

Most professional photojournalists use a light, quick 35mm single-lens-reflex camera. However, even an instant camera can record subjects to effect immediate changes. For instance, in your own community you could photograph a post box positioned dangerously at the curve of a busy highway and show the photo to the postal service administrator to initiate a change. Or a neglected pothole in the road could be photographed and the picture sent to the local council, along with a demand for repair. Or a visual

These three images are part of a photo essay documenting the Tall Ships' visit to Boston's harbor. The series provides three different views of the event to give a varied and complete sense of the experience, from the monumentality of the ships to the authentic costumes that recall bygone times.

document may be required for more immediate situations, such as a traffic accident, a violent act, or a fire.

Of course, all photojournalism does not have negative connotations. Consider documenting the local fund-raising for the senior citizen group, the boy scout outing, or the community picnic.

One key to good photojournalism is readiness. If the camera is loaded and the flash unit charged, your chances of catching fleeting moments are increased. Most photojournalists always carry a camera, keeping it constantly ready for shooting.

The second key to mastering photojournalism is understanding the situation. If you do not know anything about a subject, you cannot possibly know what is important to photograph. It's a good idea to spend some time researching and exploring your subject. Some of the best photojournalists have an insatiable curiosity which motivates them to investigate unusual situations and out-of-the-way places.

Fast reflexes are the third prerequisite for good documentary pictures. In most situations, the subjects and events change rapidly. If you want to capture them, you have to be quick.

Photojournalism also demands a certain kind of personality. An individual must be resourceful, fast-thinking, and unafraid of difficult situations. Intelligence and a basic underlying compassion for humanity are also necessary to capture moving, insightful pictures of people. The quintessential documentarian of the contemporary scene, Robert Frank, observed: "There is one thing the photograph must contain, the humanity of the moment. This kind of photography is realism. But realism is not enough—there has to be vision, and the two together can make a good photograph" (*Photographers on Photography*).

Finally, the last element in fine photojournalistic pictures is composition. Composing quickly is demanding, but with experience the process becomes instinctual.

One difficult thing to overcome in this type of photography is inertia. If intimidated by the subject, a photographer would have a hard time shooting. Early in his career Alfred Eisenstaedt, the well-known *Life* photographer, learned never to be in awe of any-

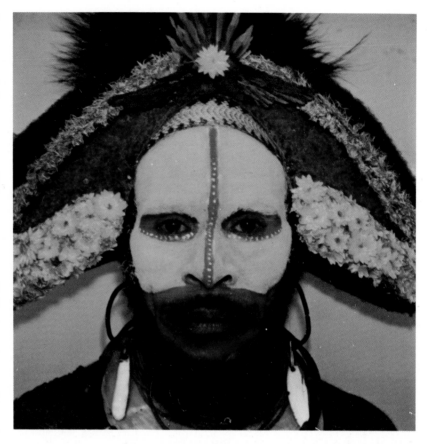

body. By keeping that credo in mind, Eisenstaedt was able to approach and photograph some of the most influential, sought-after people in the world: Roosevelt, Mussolini, and Sophia Loren, to name a few. Don't be hesitant or your pictures will betray your insecurity.

In general, when taking reportorial photographs, keep a journal with pertinent details—names of subjects, situations, dates, and times. If you are accurate, your photographs can be valuable documents. As Dorothea Lange once commented: "Documentary photography records the social scene of our time. It mirrors the present and documents for the future" (*Documentary Photography*).

Finally, be sure to carry extra film. It would be a tragedy to run out at a crucial moment during an event. Film can be changed more quickly if it is removed from its packaging and kept in a well-protected spot in your camera bag. Remember, once film has been removed from its container, its protection from dust, dirt and pressure has also been removed. So handle it with great care.

Although this photograph was culled from a series on "Man Is Art" by Malcolm S. Kirk, it also stands on its own as a documentary portrait of a New Guinea warrior. This single image conveys the full impression of that foreign culture.

Special Events

Special occasions—weddings, birthdays, graduations, celebrations, parades—can truly test a photographer's ability to take fast-action pictures, candids, formal portraits, and crowd scenes. Events happen very quickly, and life takes on a jumbled appearance. The key to making memorable pictures is simplicity and clarity. Try to get close to the subject, to create a distinct separation from the surroundings. Yet include enough details to offer a revealing clue about the setting. If photographing a birthday party or a celebratory dinner, take pictures before the plates are dirtied and the turkey is half eaten to show the table setting. If taking pictures of parades, street fairs, or flea markets, work quickly. Do not hesitate; just compose and shoot. Try to capture the mood and emotions of the moment.

Sometimes, especially for wedding pictures, you can set up special shots for more personalized, lasting mementos. Traditional wedding pictures begin at the bride's home before the ceremony. Take pictures of the bride with her mother, the maid of honor presenting the flowers to the bride, the ring bearer or flower girl with her basket, the parents alone, the parents with the bride, the bride with her grandparents, and the groom's parents and groom, if they are present. These are usually taken in a living room setting. Keep in mind the techniques for shooting portraits and groups. Watch expressions and eye direction and try to elicit a natural look. Later, during the ceremony, avoid using flash. Put the camera on a tripod and work quietly. Afterwards, take candids at the reception and, finally, try to get a picture of the bride and groom's departure.

Left: A closeup photograph of the bride's and groom's joined hands makes for a very special image evoking the essence of the ceremony. Pictures like these can be easily set up with the cooperation of the participants. *Below:* A more typical wedding picture shows the newlyweds cutting the wedding cake. The photographer chose an excellent angle to reveal facial expressions and still show the elaborately tiered cake. Flash effectively isolates the couple from a confusing background.

Left: Timing is critical when candid photographs are being taken at crowded ceremonies. In this example, the photographer had the subject turn toward the camera to isolate him from the background. The high camera angle gives the portrait a handsome impact. *Bottom left:* Children's birthday parties are full of color and vitality. Michael Pierce took advantage of the bright balloons, using them as a backdrop for this youngster's happy celebration. Notice how the birthday cake has been included in the composition, providing a wonderful remembrance of a special moment for later. *Bottom right:* Parades, circuses, street fairs, and flea markets brim with nonstop activities, people, color, objects, gaiety, and plenty of excitement. Such occasions provide terrific opportunities for instant photographers to take candid pictures and capture the joy of the day. The unusual character in this picture was marching in a United States Independence Day parade.

THE ART

We all know that art is not truth. Art is the lie that makes us realize truth—at least the truth that is given us to understand.

—Pablo Picasso
The Arts, 1923

There is a strange dichotomy in instant photography. The simplicity of using an instant camera makes it possible for anyone to take a picture; yet the complexities of its aesthetic qualities make it a challenging tool and a difficult one to master.

This section deals with the artistic side of instant photography. It is not geared to all readers and will not appeal to everyone. But for those who are inspired, it can provide exciting ideas and techniques to expand image-making possibilities using instant cameras.

In recent years, instant photography has changed in status from being merely a tool for snapshots to being widely recognized as a means of expression—an art form—accepted and shown in museums and galleries around the world. In increasing numbers, artists have been working with instant materials, seeking to understand the creative effects of instantaneity and other unique "instant" characteristics. As a result, virtually a new medium has evolved—the medium of instant photography.

The first part of the section, "The Art Portfolio," represents a sampling of instant images by international artists, showing the varying styles and concepts being explored.

The second part, "Special Effects," concentrates on hands-on techniques used by various artists to create their innovative and unconventional instant pictures. It provides exciting possibilities to stimulate and open up fresh vistas of imaginative image-making.

Rena Small

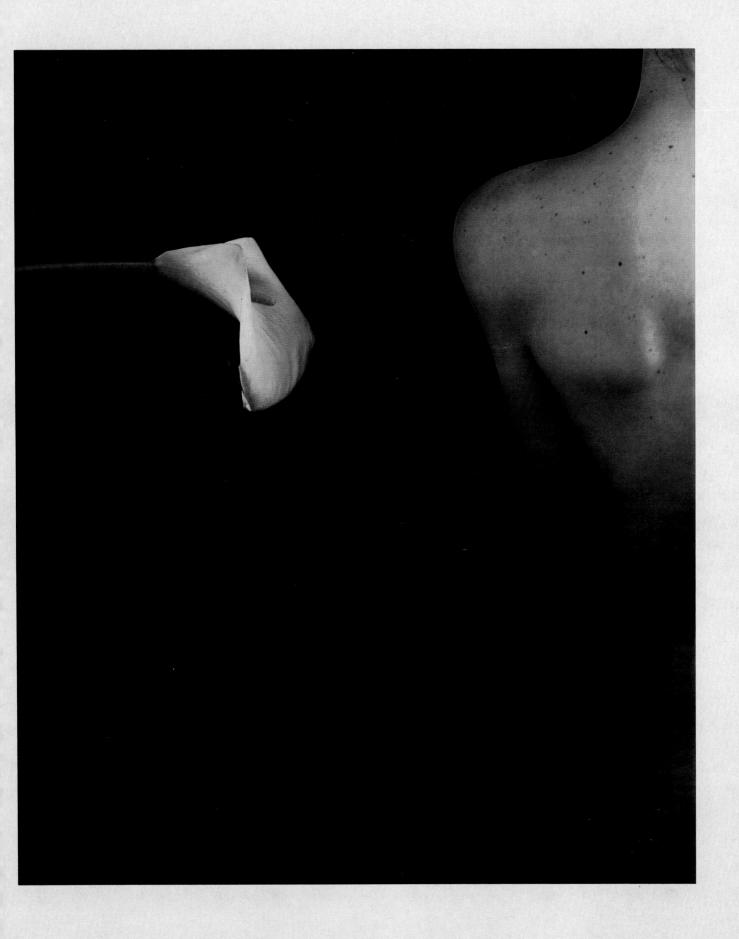

The Art Portfolio

"The Art Portfolio" represents a range of instant ideas by prominent photographers and emerging artists. Each individual brings a personal set of aesthetic understandings to the instant medium, producing disparate imagery that ranges from playful sketches to conceptual art, from erotic sensationalism to pictorialism, from documentary photography to surrealism. The scope is a direct reflection of contemporary photographic concepts.

Some artists use the instant aesthetic for its immediacy; one finished piece provides the stimulus for the next composition. Others exercise a painterly approach, akin to layering on brushstrokes—only with instants, the artist adds another photograph as part of a larger composition. Color—of fast-rising concern to the current photographic art world—takes on a multitude of characteristics in the instant form, from plastic to romantic, sculptural to reverberating, straightforward to manipulated. Some work is labored and thoughtful (owing perhaps to an artist's innate fear of vulnerability that comes from showing the viewer exactly what the artist saw through the viewfinder). Some is light and spontaneous.

Techniques vary enormously. Special lighting setups are used. Filters are attached. Prints are attacked and manipulated with paints, spoons, fingernails, and other assorted tools. And format sizes vary from Polaroid SX–70 to the large-format 20 × 24, which for many artists creates a difficult aesthetic transition as great as the leap from 35mm format to 8 × 10.

The only consistency in "The Art Portfolio" is the fact that most of the work has been done with Polaroid materials. Because of Kodak's mass-oriented marketing philosophy, Kodak instant pictures are little used in art circles (but, of course, many of the same techniques are applicable). Edwin Land, on the other hand, set the precedent for working with artists many years ago by establishing a close rapport with Ansel Adams, Edward Weston, and others. As a result, Polaroid has continued to encourage artistic explorations and, in special situations, has aided their development by supplying materials. Furthermore, Polaroid has been instrumental in displaying instant pictures before the public eye. International exhibitions have been organized to introduce a breathtaking array of instant ideas. Today instant photographs are part of permanent museum collections and grace the walls of galleries throughout the world.

Clearly the medium of instant photography is still evolving and there are unexplored areas to be developed. As one critic pointed out in the introduction to one of Polaroid's exhibitions: "The solutions found by a creative person always form a personal image, and the possibilities of individual photographic expression will remain as great as the number of original creative personalities who seek them." If you are reading this book, you too possess the tools with which to seek those possibilities.

Barbara Bordnick

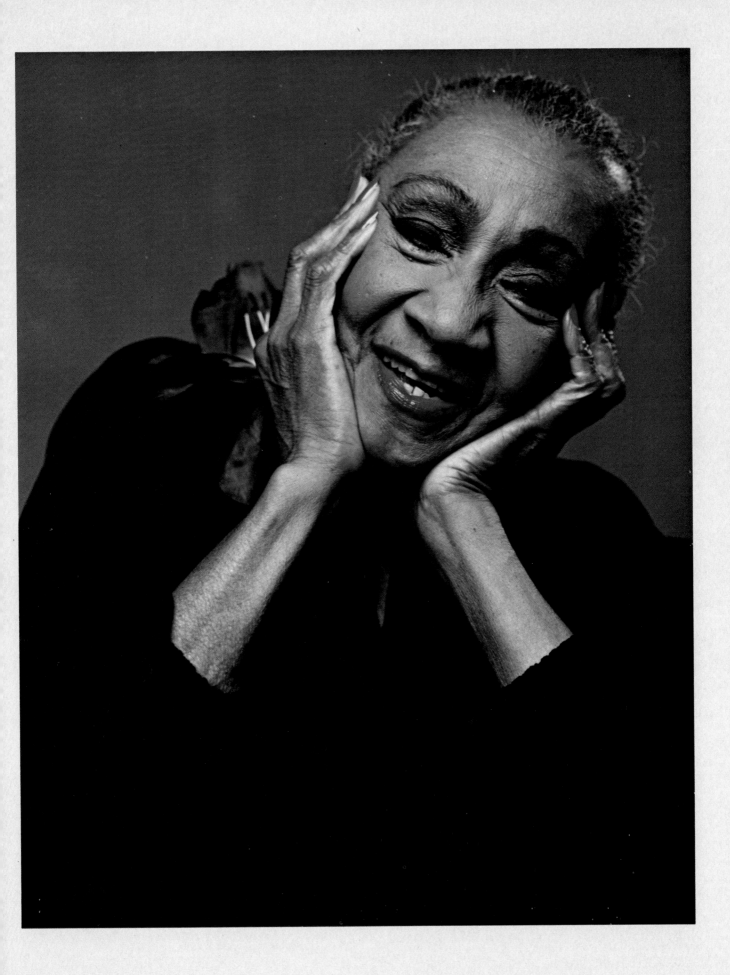

Emmet Gowin

Linda Benedict-Jones

Barbara Kasten

Antonio Strati

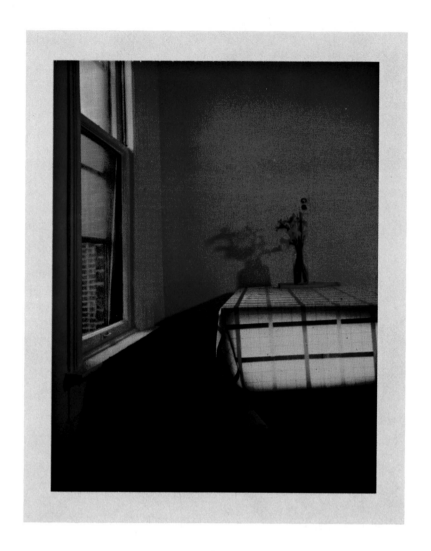

Lorie Novak

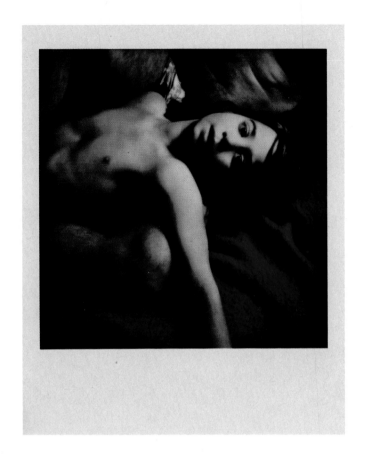

Kelly Wise

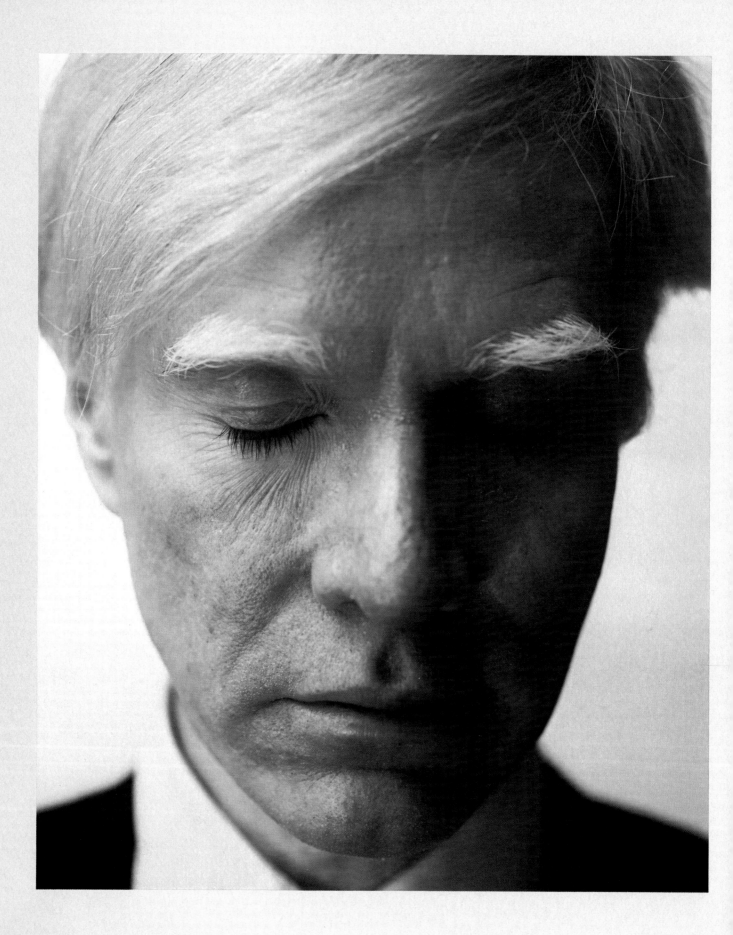

Andy Warhol

Lucas Samaras

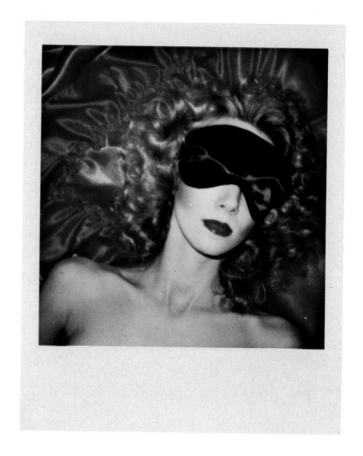

Dan Rodan

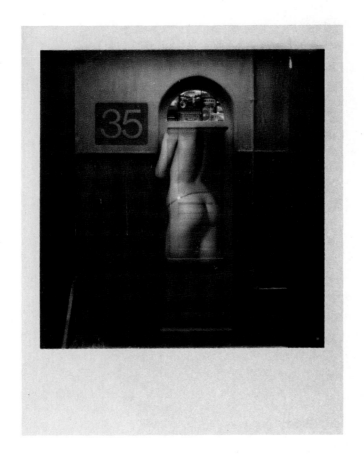

Sam Haskins

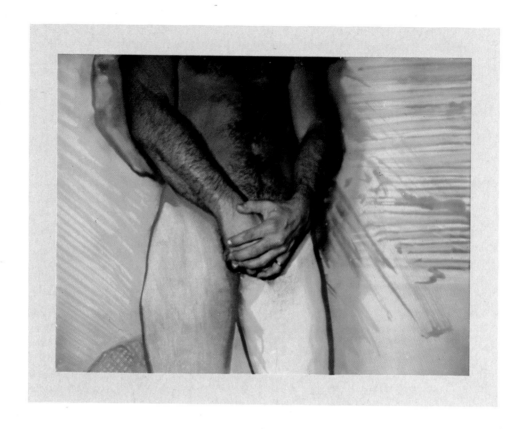

Luciano Franchi de Alfaro III

Umihiko Konishi

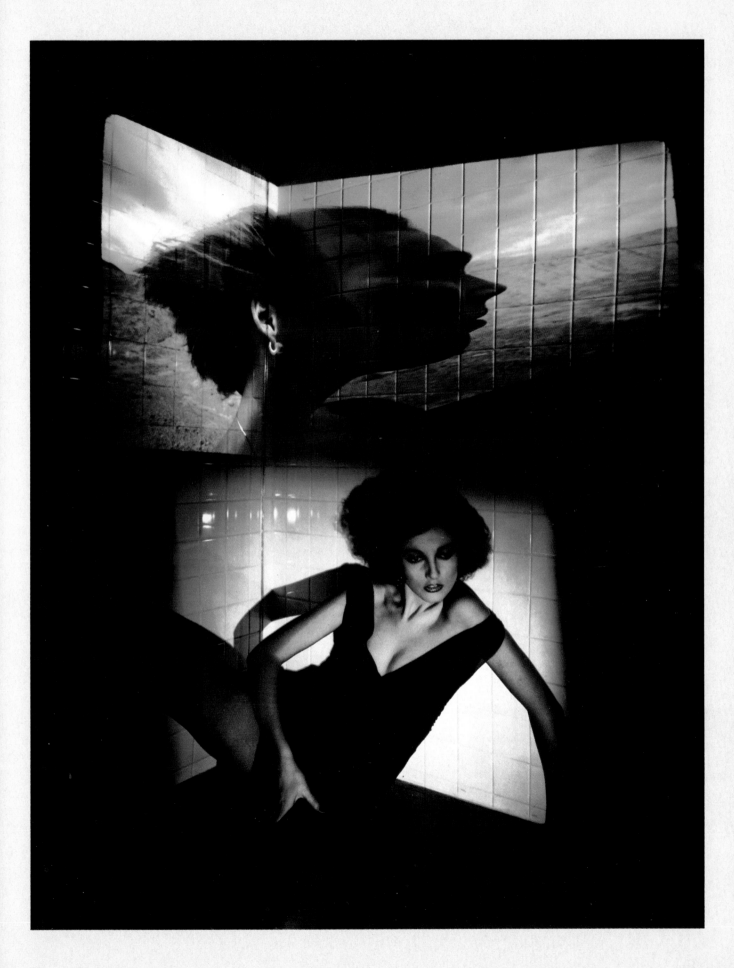

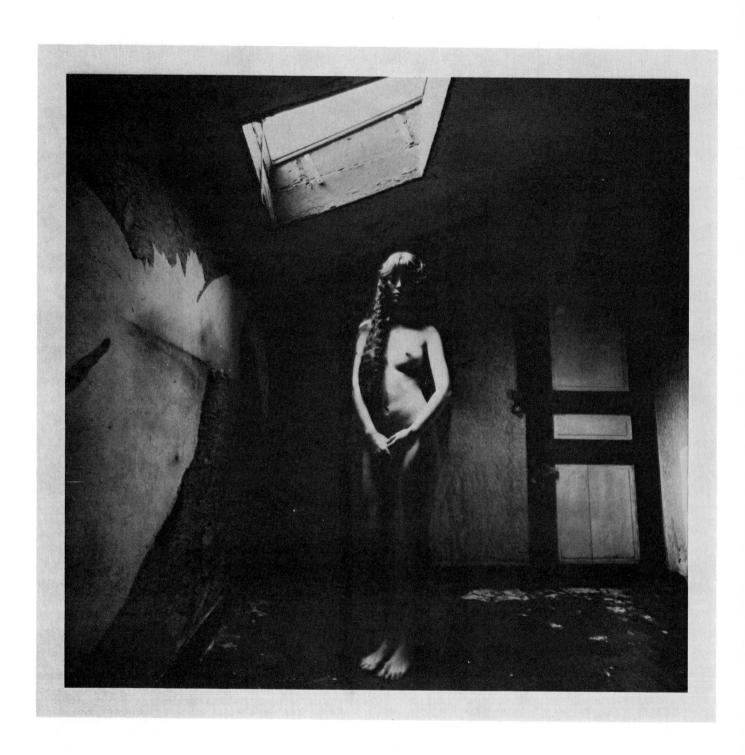

Jean Loup Sieff

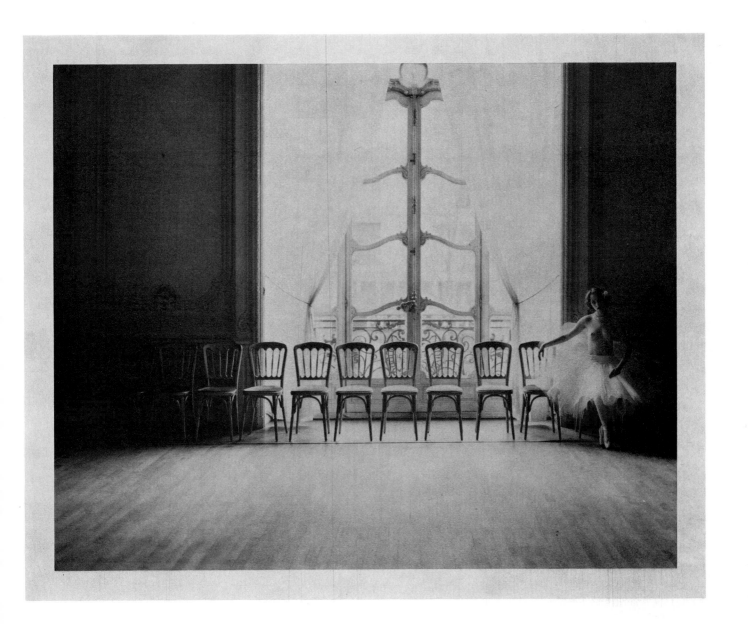

Sarah Moon

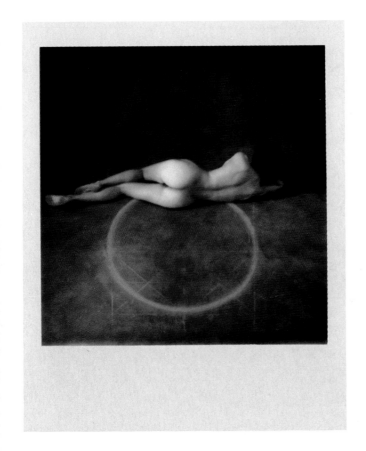

Kenda North

Christian Vogt

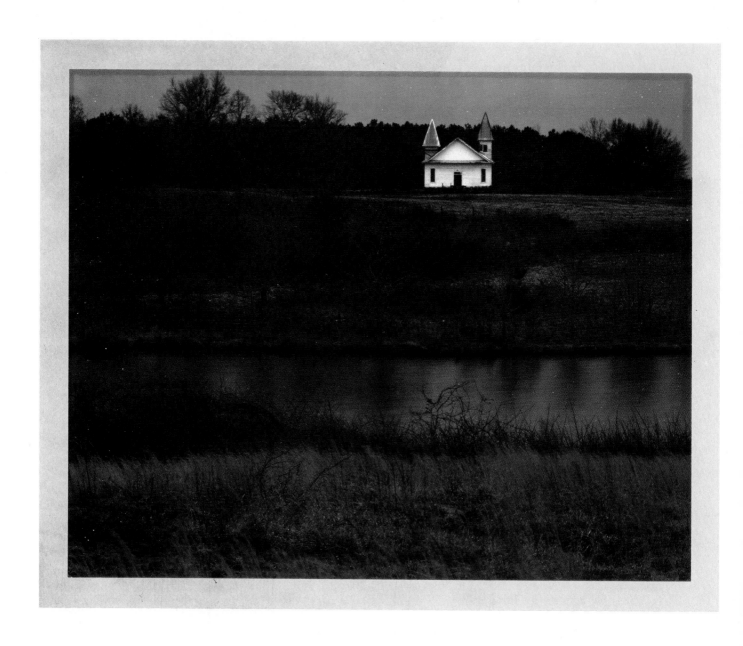

Reinhart Wolf

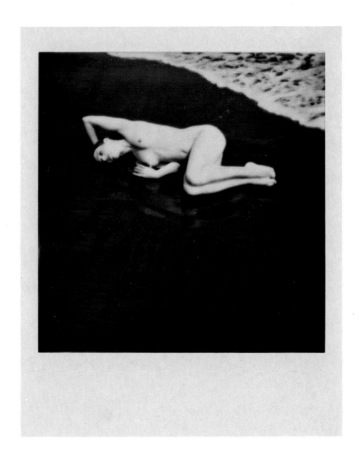

Pete Turner

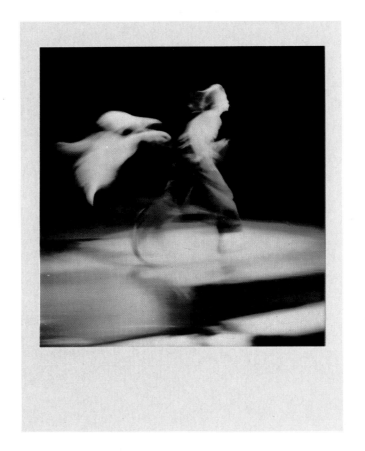

Terry Walker

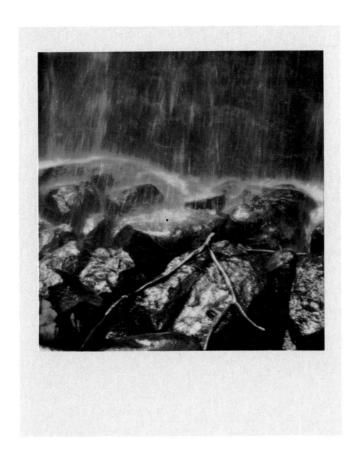

Ansel Adams

Bruno Joachim

Ulrich Mack

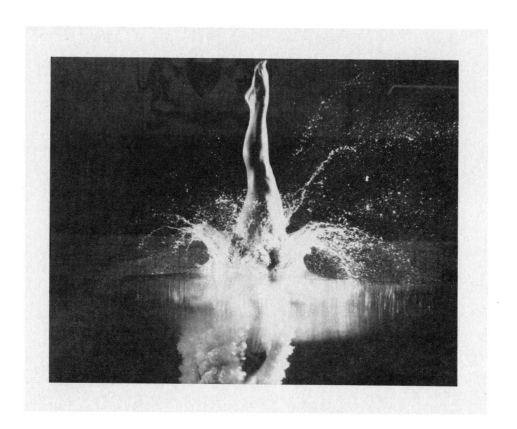

Harold Edgerton

Christopher James

The Creative Process

Letting go is probably the most difficult part of the creative process. People tend to cling to typical ways of doing things. For instance, many assume that taking a portrait requires making a straightforward frontal picture of someone to show a full view of the subject's face. But a portrait can be interpretative. An aged woman might be portrayed by a closeup of her gnarled, arthritic hands, a ballerina by her elegant profile emphasizing a long graceful neck. A creative individual lets go of traditional ways of doing things and looks for unconventional approaches, striving to see the familiar in a new light. In the classical sense, creativity is the ability to give up old ways to embrace new ones.

You may wonder, however, why it seems that some people are flooded with picture ideas while others struggle to find something interesting. Often the key is not to struggle but to relax and allow ideas to surface. Ideas are plentiful, but recognizing them is sometimes difficult. We get ideas all the time: while we stroll down the street, while we read, while we sleep. What is important is to be responsive to the ideas and to remember them. Jot them down if necessary.

You can help stimulate ideas by fooling your senses to create a new visual environment. Decide to take only closeup pictures of objects in your surroundings, or only distant pictures. Try unusual angles such as photographing from a worm's eye view. Combine objects of various sizes or colors. Use colored lights to alter impressions. Set up thematic projects for yourself by choosing a topic of interest to you: music, humor, people having fun, or sports.

There are two basic approaches to creating images: *taking* pictures and *making* pictures. A photographer who takes pictures searches for moments that catch the eye. Subjects are hunted much in the way a hunter, armed with a loaded rifle, goes out to stalk his prey. He never knows what he will come back with but sets out with a good idea of what he's looking for. When the quarry is spotted, he responds immediately. The results are unpredictable, since there is no way of knowing precisely what might present itself in front of the camera during the photographer's travels. But of course, the final choice is the photographer's.

Making pictures is a more internalized approach. The photographer decides beforehand what he or she wants to put within the frame and then sets about to arrange the elements. The process may vary from setting a stage to manipulating the print to painting or collaging. Essentially, the frame of the photograph becomes a window to the artist's inner world. The photograph is conceptualized in the mind and then reproduced in the photograph to create a new reality. As Paul Klee remarked in *The Diaries of Paul Klee*, "Art does not reproduce the visible, rather makes it visible."

Most often the reality created by artists is one that reflects the intangible. Fear, anxiety, depression, loneliness, frustration, joy, terror, confusion are some of the emotions which motivate artistic compositions. Inner feelings are conveyed in a visual way. For some, the process is almost a gestalt experience. Visualizing the problem lessens the burden. The relief is similar to that which comes from sharing the weight of a problem by confiding in a friend.

Ideas for conceptual pictures derive from deep-seated experiences and emotions. To tap these concepts, photographers pay a lot of attention to dreams, fantasies, and everyday concerns. We all have concerns and interests, but it takes time and patience to understand what some of them are. Usually, they can be discovered through conversations with friends, in private thoughts, and in unconscious manifestations such as dreams. To develop conceptual ideas, trust yourself and your feelings and let go.

Instant photography helps release the creative juices by sparking ideas as images emerge. In addition, the exchange between the photographer and the model becomes in itself a creative experience.

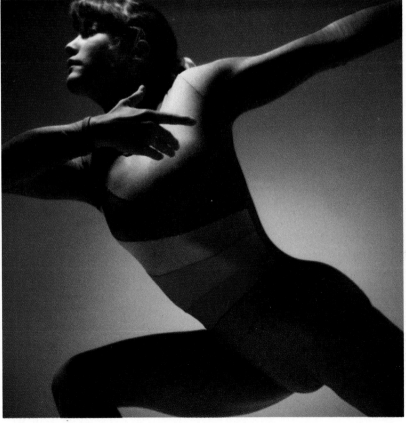

In this example, the photographer has had an ongoing artistic interaction with the young gymnast to develop the effects that satisfy the imaginative talents of both artists. The instantaneity of the medium is a decided advantage for seeing, reacting, and evolving the right moment.

Special Effects

Everything is art.
—Man Ray
Dialogue with Photography

By now you should have a solid grasp of how to control the instant medium for general situations. With that knowledge filed in your memory bank, you're ready to depart from the conventional approaches and branch out into experimental territory. This section is packed with ideas and techniques successfully used by artists and is provided to encourage experimentation and risk-taking. Ultimately the challenge is to use the techniques as vehicles for reflecting your ideas, to put your thoughts into visual form, and to

have fun. Try variations. Sometimes trying one technique—and seeing the results instantly—leads to other ideas. Be careful, however, not to fall into the trap of letting technique become the idea. When that happens, gimmickry dictates and detracts attention from the intent of your picture.

Remember there is no incorrect way of doing anything. The techniques described are merely presented as guidelines, jumping-off points, to be used and expanded upon in your own way. Your successes or failures will be judged and evaluated only by yourself. So do not put any pressure on yourself; rather, reap the joys of experimental experiences and personal discoveries. In this way, you will find this section magical and rewarding.

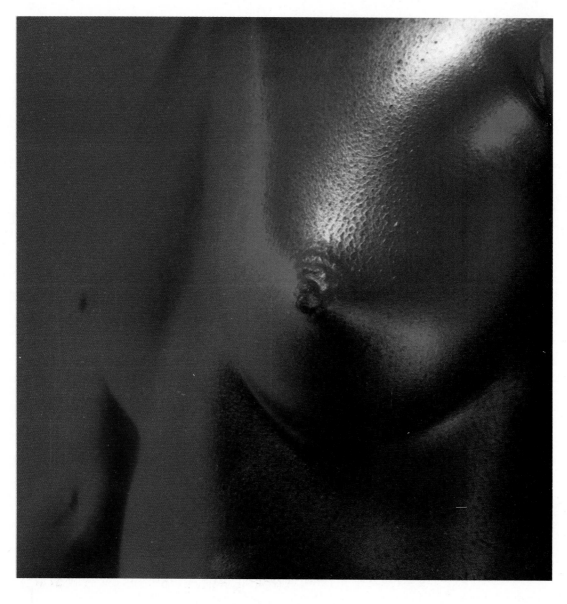

To achieve this special effect, R. R. Twarog used a gel over the light sources rather than the camera lens. By coloring the light, a photographer gains the additional control that comes from being able to pinpoint and direct colored lights onto specific areas of the subject. Twarog experimented by placing his model at varying distances from the lights. The closer the figure was placed to the light source, the more precise the coloration and delineation became; the farther away, the more diffused and softened the effect. Twarog also body painted his model with silver to add the metallic texture. The picture was taken in a studio with an SX–70 camera on a tripod.

Gels and Filters

A gel or filter can completely transform a dull picture into a wild cacophony of colors, a repetition of forms, a surreal abstraction, or a softened mistiness. Filters provide a photographer with the versatility to color correct in order to reproduce scenes with the exact light, contrast, and color rendition seen in the viewfinder, or to creatively mold light in order to evoke personal interpretations. A filter can emphasize and separate colors, alter moods, selectively permit one subject to dominate, or change contrast. Special effects filters can do even more, turning the ordinary into the extraordinary.

A gel or filter is nothing more than colored gelatin or dyed optical glass. Attached to the front of a lens, it can vastly alter light reaching the film and enable you to control values and color balance. Filters work by allowing some light rays to pass through while holding others back. Since light is a mixture of many colors, a filter can dramatically affect the color balance of a scene as we see it. The color of light that is permitted to pass through is determined by the filter's color. It allows its own color to pass through while holding back its complementary colors. A red filter holds back green and blue and transmits red. Yellow holds back blue and transmits red and green. Blue absorbs red and green but transmits blue. If you understand what a filter does, you can better decide which to choose for a particular scene. The paler the filter color, the less light will be held back and the more subtle the effect will be.

ORANGE	Transmits red Holds back green and blue	Deepens blue skies, waters. Accentuates clouds. Increases contrast. Reduces haze.
YELLOW	Transmits red and green Holds back blue	Deepens blue skies, waters. Accentuates clouds. Increases contrast. Reduces haze.
BLUE	Transmits blue Holds back red and green	Increases effect of fog and haze. Balances orange cast of incandescent lights.
RED	Transmits red Holds back green and blue	Darkens skies. Greatly increases contrast. Reduces haze.
GREEN	Transmits green Holds back red and blue	Lightens green foliage to make colored flowers stand out. Naturalizes skin tones for outdoor portraits.

Partial filtration is extremely effective for turning an ordinary landscape into a surrealistic image. To create this effect, a red filter was taped to cover only part of the lens. The image was then composed by leveling the edge of the filter to correspond to the edge of the tree line, avoiding any visible demarcation. Two different colored filters taped to meet in the center of the lens could have been used just as easily. As long as the filter edges fall within a natural line in the composition, filtration will not look obvious.

Gels and Filters

To use a gel or filter, tape it over the lens and exposure sensor. The amount of light reaching the film is diminished, but the camera's sensor automatically compensates. If the exposure sensor is left uncovered—or if the camera does not have a sensor—turn the lighten/darken control toward the lighten mark.

With time and experience, you can become very adept at using filters. Sometimes, however, it's just good fun to try a filter without knowing what will happen. The advantage of instant film is that you can quickly view the results and make immediate adjustments by changing the filter or exposure, or both.

For other variations, try special effects filters, including anything from a mist filter that simulates the impression of overcast, rainy days, to repetition filters which repeat the subject across the image in a prismatic array of colors.

The most popular filters are the UV (skylight) filters for color correction and special effects filters such as soft-focus and polarizer filters. Many photographers use a UV or skylight when shooting outdoors to cut down on blueness and reduce atmospheric haze. A soft-focus filter is often used for pictures of dreams, fantasies, romance. It softens the edges of a subject so that tones are muted and lines are indistinct. A polarizing filter is excellent for cutting glare and reflections on water, glass, or other shiny surfaces at certain angles to the sun. The degree of glare reduction is changed by rotating the filter. Before taping the filter to your camera, look through the filter and rotate it until the subject appears the way you want. Fasten the filter securely in this position to the front of the lens.

A neutral density filter is recommended for reducing light in overly bright scenes such as at the beach, on water, or in snow. This gray-colored filter can be used to shorten depth of field with cameras that have automatic, variable apertures. Since the neutral density filter reduces the amount of light reaching the film, the camera's exposure system compensates by dialing in a larger aperture (lens opening), thus diminishing depth of field.

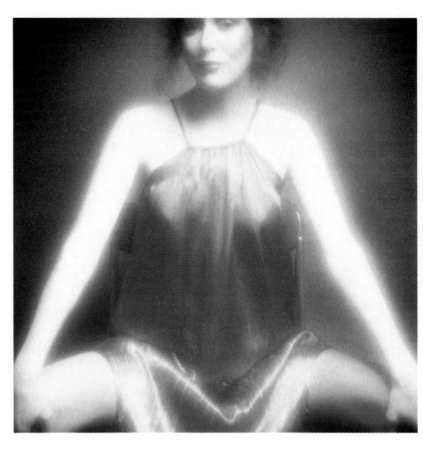

For more adventuresome and unpredictable filtration, improvise with natural filters. Screens and glass or plastic with mottled surfaces provide very soft-focus, blurred effects. (If you are using an autofocus sonar camera, use manual focus.) Tissues, silk stockings, and other fabrics stretched over the lens also work well for unusual effects. A clear piece of acetate smeared with petroleum jelly around the edges produces a soft outer edge with a sharp center. The technique is often used for model portraits.

Filters need not be fancy pieces of colored glass. As studio photographer Doug Hopkins proves with this portrait, filters can be improvised out of any old fabric. Hopkins used a scarf, soaked overnight in water—to soften the fabric—and then stretched tightly over the camera lens. The veiled glow and indistinct outlines are the result of the filter's light-diffusing capability.

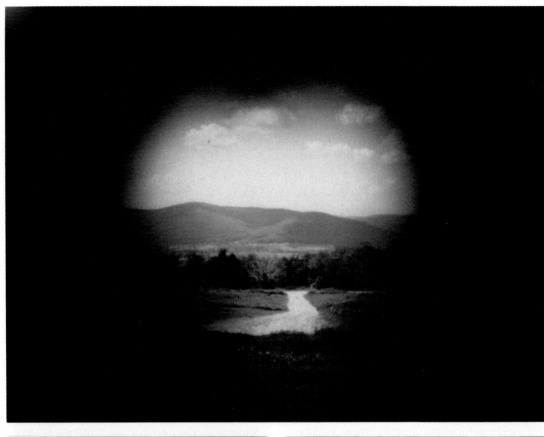

Left: Do-it-yourself filters can be fashioned to produce shaped frames of a subject. For this image, a teardrop was cut out of a piece of cardboard and taped over the lens of a Kodak Colorburst camera, which was then aimed to frame the landscape. Any shapes—hearts, circles, diamonds, squares—can be used. Below left: A spectacular futuristic effect was evoked by taping a red filter over a Tele Lens attachment on an SX–70 autofocusing camera and pointing it at a bright sun sandwiched between clouds. The lighten/darken control was kept at the normal setting so that only the very strong center portion of sunlight was recorded, throwing the surrounding sky, earth and clouds into blackness for a powerful counterpoint. Below right: A screen door provided the interesting filtration for this scene. The camera was manually focused to render the scene in a softened palette of painterly colors.

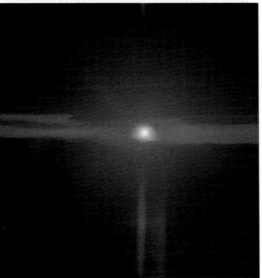

Multiple Exposures

Multiple exposures create the ultimate illusion which can confuse and baffle viewers. Not all instant cameras will readily make more than one exposure on one piece of film, but with some ingenuity and patience, you can accomplish multiple exposures with any camera.

Pack film cameras using peel-apart films are the simplest to use. Make one exposure by depressing the shutter button. Do not remove the picture. Instead, depress the shutter button a second time (or more, depending on the number of exposures you want to make). Of course, you must figure out the positioning of subjects beforehand in order to achieve the proper overlapping, and you will have to vary the lighten/darken control for each shot to get the proper tonal balance. Be prepared to experiment.

Kodak instant cameras, Polaroid Sun Cameras, and nonfolding OneStep (Button, or 1000 Model) cameras can be fooled into making multiple exposures. Open the film door and make the first exposure. If the film attempts to eject slightly from the camera—the front lip might push forward—push it back into place before making the second exposure. To make a second exposure, simply press the shutter button again. With Kodak instant cameras, close the film door before making the final exposure so that when you depress the shutter button the last time, the picture will eject and process. With the Polaroid cameras, keep the door open until you have made as many exposures as desired. When you close the door, the picture is automatically ejected. As with pack film cameras, the lighten/darken control must be varied in order to achieve the correct overall exposures.

The folding SX–70 autofocusing cameras can be rigged to make multiple exposures; however, the processes involved are liable to damage the camera's fine mechanisms. Therefore it is best to rely on the following simple method.

Put a piece of black tape over the electric eye. Just as you press the shutter button, open the film door which disconnects the camera's circuitry so that the picture will not be ejected. This makes one exposure. Now, close the film door. The print will not be ejected yet. Press the shutter button for the second

exposure. The camera will make a slight clicking noise. Wait. Your double-exposed picture will be ejected in a few seconds.

Since the SX–70 is capable of making an exposure up to fourteen seconds long, you can make use of the extended time to expose two or more subjects. You will need to work in a dark setting with a flash or strobe light. When the shutter is pressed, flash one subject with the light, then another. The bright illuminations will be recorded on the film as many times as you flash them within fourteen seconds.

Above: Fran Simoni made this amusing double exposure with an SX–70 Sonar by relying on the long-exposure capability of the camera and using pinpointed illumination to light the subject in each position. *Opposite:* Philippe Halsman created this multiple exposure called "Hypnosis" using a Polaroid pack film camera.

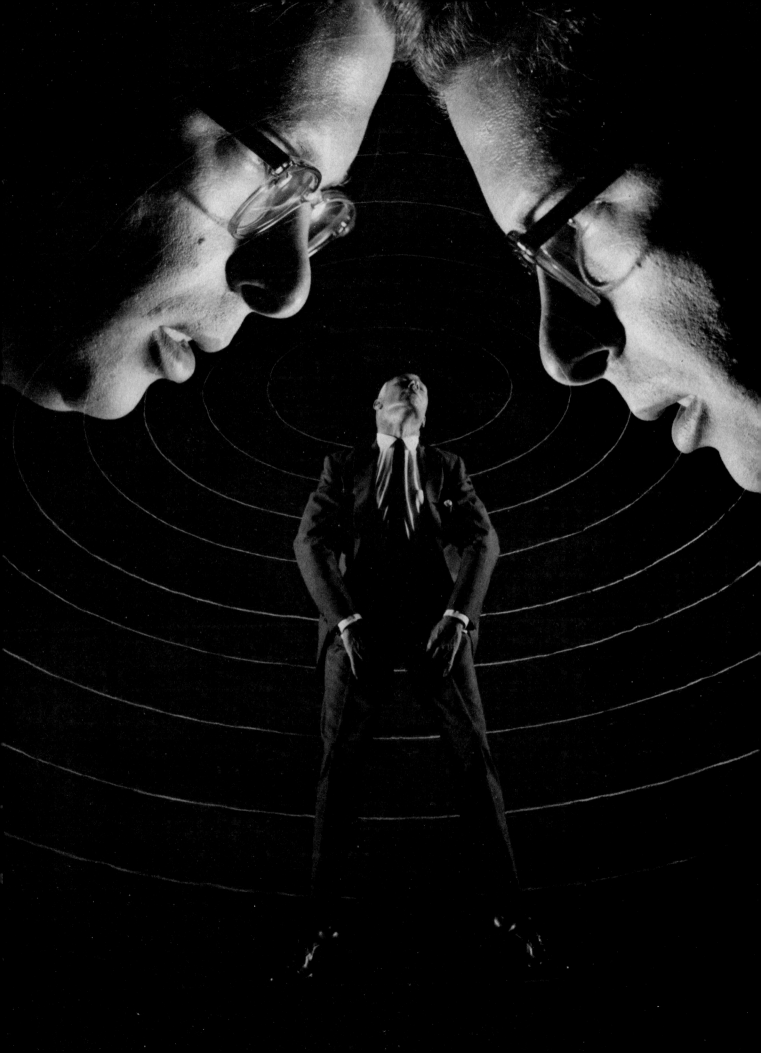

Manipulations

Altering the reality represented in an instant picture can result in the most unexpected images. There are several experimental techniques for exploring your creative side or just for turning reject prints into interesting and amazing images.

PRESSING THE EMULSION

When Polaroid's SX–70 film first hit the market, it caught the imaginative eye of quite a few artists. With piqued interest many set out to understand what the material would tolerate. In the process, they discovered that until the picture had completed development, the emulsion was soft and could be manipulated—physically shifted beneath the Mylar cover.

Soon thousands of SX–70 pictures were being assaulted, mutilated, and transformed, as illustrated by Lucas Samaras's agonized picture in "The Art Portfolio" and David Scott Leibowitz's rearranged view of Venice.

The thickly layered emulsion of the early SX–70 film could be pushed around with a blunt instrument so that dye colors were blended together or a line was stretched or an edge swirled. Tools ranged from fingernails, wooden sticks, knitting needles, and inkless pens to artist's burnishers. After the picture was taken, the artist waited about half an hour before working on the emulsion. Up to about five days, the print still could be worked on if it was reheated. SX–70 prints were seen being toasted, boiled, or placed next to hot lightbulbs.

Regrettably, the newer Polaroid Time-Zero Supercolor SX–70 Land film, the Polaroid 600 High Speed Land film, and the Kodak Instant Print films are not easily manipulated. The thinner dye layers and faster processing time render them less malleable, and the results are less exciting. However, you can still experiment and combine the technique with others for unusual effects.

David Scott Leibowitz uses dental instruments to push around the SX–70 dyes in his pictures before they completely harden. If he has waited too long and needs to soften the emulsion, he drops the print into boiling water or slips it carefully into a toaster, watching until the emulsion bubbles slightly. Then, with the instruments, he applies pressure to tiny areas of the picture at a time and, as you can see in this exquisite rendition of Venice, creates a delicate, painterly impression.

PAINTING ON INSTANTS

Painting is rarely associated with photography, and yet—applied to instant photography—it can greatly expand the photographic palette. Any instant print can be altered by the application of paints to add or remove elements or simply change existing ones.

The actual process of painting opens up an array of techniques which include varying brush sizes, using different brushstrokes, changing colors and materials. The picture of the male nude by Luciano Franchi de Alfaro III in "The Art Portfolio" shows the use of bright colors, bold and blended brushstrokes for a striking image made on Polaroid Type 58 film.

For black-and-white pictures or color peel-apart prints, use colored artist's tints, soft-colored pencils, or oil paints applied in thin coats. For Polaroid SX–70, 600, or Kodak instant prints, acrylics are best.

Some artists, like John Schwartz, are so challenged by painting on instant prints that the process has become an obsession. As a result, Schwartz has experimented with a wide variety of artistic materials and found success with airbrushing, matte spraying, and applying acrylics, watercolors with egg white, or enamels. In his work, he turns mistakes and bad film spots into advantages, sometimes purposely ruining film to create his canvas.

In this example, John Schwartz has transformed an otherwise unacceptable picture into a stunning still life creation. Using a ruined SX–70 print (with a large brown blob on the right side), Schwartz painted elements and lines onto the Mylar surface. The reality of the photographic image blends with the unreality of the painted forms for a very artful result.

Manipulations

ALTERING FROM BEHIND

The odd colors and bizarre characters in the SX–70 pictures by Marty Fumo and John Reuter were created through a technique involving the removal of the print backing. Obviously this is not a process recommended by instant film manufacturers, since the integral print contains caustic chemicals that can be harmful. Some photographers wear surgical gloves for protection.

The black backing of the print is cut away at the edges using a single-edged razor or X-acto knife. A careful incision is made to avoid marring the print surface or disturbing the frame. Once cut apart, the backing easily separates from the front, containing the positive image. A chalky substance, the titanium opacifier used to brighten the positive image, is visible. Marty Fumo washes off the substance on the front piece so that only a positive, transparent image remains. The image is placed face down on a lightbox, and then colored dyes are applied to selected areas. Sometimes Fumo scrapes away parts of the image area to change the image further by allowing more of the dye color to show through. The backing is then replaced, and the image has an entirely different appearance.

John Reuter does not wash off the white substance immediately. Instead, he lays the front image face down on a lightbox in order to make the outlines viewable so he can carefully cut and strip out parts of the image using a blade. Then he uses wet cotton swabs to clear off the titanium. The result is an isolation of part of the photographic image so that it floats within a clear piece of Mylar. Reuter then takes other materials, collected from antique stores and flea markets, and collages them onto the black spaces using acrylic gel diluted with water. When it dries, Reuter completes the image by painting the rest of the space with acrylic paint. Since all the work is accomplished from behind, the front of the image retains a smooth surface which helps it to read as a photographic image in spite of the fact that it has been quite changed.

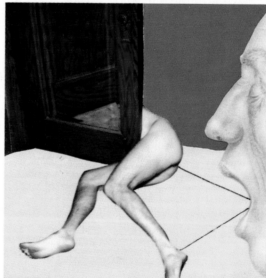

Above: Marty Fumo turns a serene landscape into a strange and curious scene by adding colors through the back of an SX–70 print. *Left:* John Reuter's complex image is the result of extensive manipulation. As Reuter comments about his purpose, "I am not looking for a specific literal result, but rather I hope to enhance, transform, or even dissolve the original claim to reality and have it become a new existence—one created through the manipulations of two-dimensional facts."

Sepia Toning

Shades of antiquity are created by toning black-and-white prints to resemble old-fashioned sepia-toned pictures. The process is easy to do and great fun. Combined with images using antique clothes and formal poses reminiscent of yesteryear, sepia toning creates a kind of photographic time capsule propelling instant photos into the nostalgic past.

Choose props and costumes that reflect the style of the period you want to suggest and use settings that add to the flavor of the time. The picture can be taken with any camera accepting Polaroid black-and-white films that require coating, such as Types 52, 57, 107, and 665.

The print should be toned immediately after processing. Use a toner such as Kodak's Rapid Selenium Toner or GAF Direct Sepia Toner. Toner should be applied to the print surface before the print is coated. This can be accomplished with a plastic misting bottle or a sponge. Hold the uncoated print by a corner over a dish or tray to catch excess toner. Cover the print surface evenly with the toner without immersing the print in toner or getting any spray on the back of the print. Most prints achieve complete toning within thirty to sixty seconds. Remove excess toner by placing the print on a clean smooth surface and wiping gently with a squeegee or sponge. Finally, coat the print with the coater included in the film box.

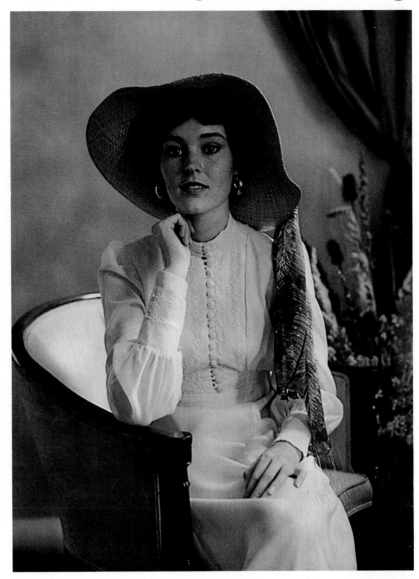

The process of sepia toning is combined with some antique props to make a picture look as if it had been taken many decades ago.

157

Collage

Variations on the usual techniques for paper and print collaging can be applied to instant photographs to make decorative and surreal creations. There are many approaches. Photographic prints can be cut into designs and shapes, then arranged and pasted on art paper or a firm backing. (This can be done with integral-type instant pictures but is not recommended because of the chemicals and dyes they contain.) Other materials—such as fabrics, wood chips, plastics—can be collaged onto any print surface to make an interesting image in relief. Or try one of the ideas illustrated on these pages.

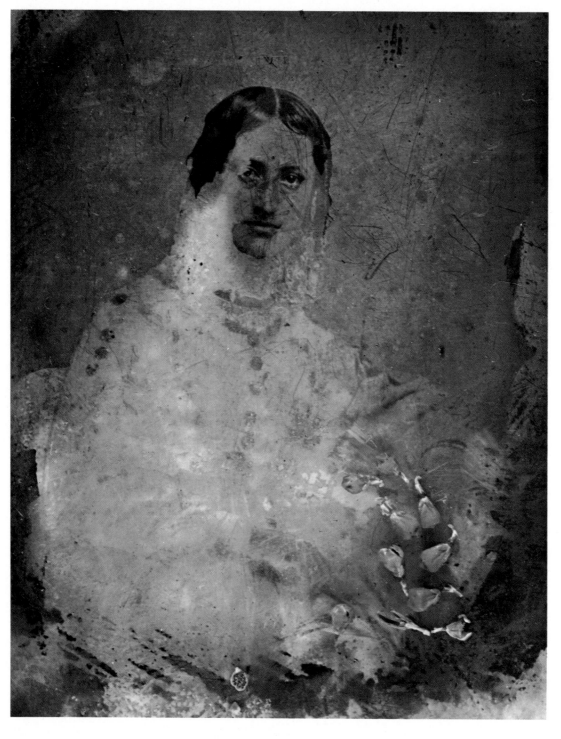

Rosamond Wolf Purcell's haunting, sinister image is a completely different kind of out-of-camera collage created by combining two different types of images and then photographing the results. Purcell selects an ambrotype—which is an early type of photograph that uses a negative over a dark surface to create the illusion of a positive print—and lays on top a Victorian illustration of an animal. The images are carefully positioned together and then photographed to produce the final effect.

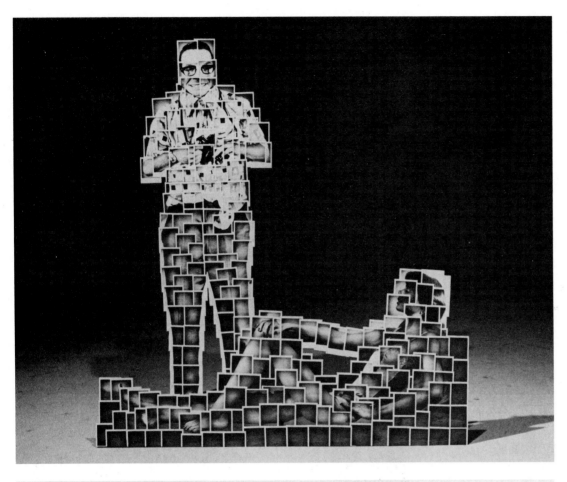

David Joyce creates life-sized, free-standing figures by collaging together SX–70 closeups of a subject. To construct his instant mosaic, Joyce photographs a small area of the model at a time, gradually covering the entire subject. The individual prints are then meticulously fitted together and fastened to a backing material to add support.

J. Michael Lesko challenges one's perception of reality by collaging one photograph onto another photograph of the same scene. The smaller square becomes an integral part of the overall recording. The effect is quite unsettling.

Photograms

An instant photogram is created outside the camera by placing objects on the light-sensitive film surface of a pack of instant film and exposing the material to light. For processing, the instant film is then put through the camera (or a film back for large-format film) so that the developer rollers can break the processing pod.

Some artists use an enlarger as the light source; others experiment with a variety of lights and color correction filters. The objects selected are up to the artist's imagination. Michael Bishop occasionally projects forms and shapes onto the film rather than placing real objects on the surface. Len Gittleman uses a variety of materials including opaque colored paper, translucent paper, and transparent colored plastics. Exposures vary, depending on the intensity of the light source and density of materials.

Above: Using assorted objects and projected images, Michael Bishop exposed Polaroid Type 58 film to make this very graphic photogram.
Opposite: This exquisite image was created by Len Gittleman using Polaroid 8 × 10 film and an enlarger as the light source for making a ten- to twenty-second exposure. A variety of colored papers and transparent plastics were arranged on the light-sensitive film and a series of trial exposures were made to achieve this soft-hued, fluid abstraction.

Projection Magic

A slide projector and colorful slides are all that is needed to create fascinating visual performances for the camera. A projection can add a strange, elongated image to a setting, as in the photograph by Umihiko Konishi in "The Art Portfolio." Or it can be tactile and textural, as in the nude projected onto a rough fabric shown on this page. Or it can be surreal, as in the creation by Jay Fedigan.

To experiment with projections, simply darken a room and project a color transparency onto a wall, fabric, canvas or even people's faces or bodies. A colorful, graphic, or highly patterned image works best. Then photograph the result. By positioning the projector at different distances from the subject, you can control the delineation of the projected image. Try a few variations. The camera may have to be steadied for a long exposure, so be prepared with a tripod or other sturdy support.

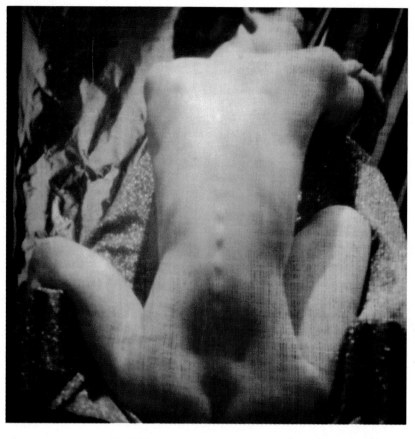

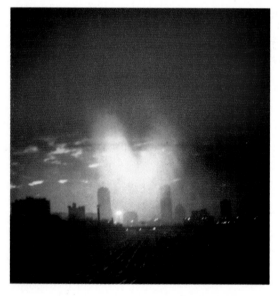

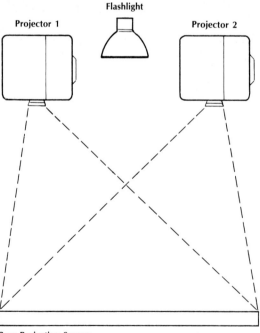

Flashlight

Projector 1 Projector 2

Rear Projection Screen

SX 70 Sonar

Above: To create this intriguing textured surface, the photographer used a coarse fabric on which he projected a 35mm slide of a nude.
Far left: Jay Fedigan's rear screen projection resulted in a futuristic-looking photograph which he entitled "How to face the end of the world...".
Left: This drawing shows the setup for a variation of projected imagery with rear-screen projection, used by Jay Fedigan to achieve the effect of his photograph. Two projectors were used; one projected a picture of a skyline, the other projected the orange color. A flashlight in the center created the peculiar highlight. The camera was positioned in front of the rear projection screen to record the total effect.

Instant Overlays

By placing a piece of material over the image area of a film pack and then inserting the film into the camera, you can create unusual, in-camera photograms that filter and mask areas of a subject. And your control over image-making is greatly expanded.

An extensive variety of materials can be used. A sheet of glass painted with daubs of clear nail polish diffuses the subject for a soft-focus impression. A heart-shaped cutout gives a romantic frame to the subject. Press type affixed to a thin sheet of lucite can add names, dates, or sayings to pictures. The possibilities are infinite.

Overlay material must be a single thickness in order to fit the tiny groove on the face of the film pack without slipping or jamming the camera. A thin sheet of glass, lucite, or flexible acetate cut to the dimensions of the film pack opening works best. If you want to enhance your subject with a special frame, cut a sheet of paper in the shape of an unusual design—perhaps a keyhole, circle, or diamond—and affix it to the translucent overlay. Then carefully tape the overlay in place over the film opening. Insert the film pack into the camera and presto! The picture emerges with the subject contained in your self-made frame.

Kodak even makes an "Instant Overlay Printing Kit" sized for Kodak Instant Print film. The kit includes clear acetate overlay masks and several sets of letters and numbers to personalize your pictures with names, dates, locations, or captions.

Another imaginative application has been devised by Lou Polett of Fun-Foto in Phoenix, Arizona, who has produced specialty overlays with sayings, expressions, or company logos. His self-proclaimed "nutty invention" is being used by real estate offices, insurance companies, and at conventions for superimposing messages onto on-the-spot pictures. It's a great idea for restaurants and resorts, too.

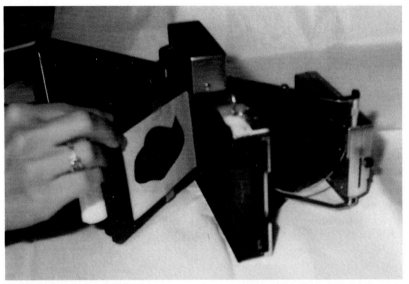

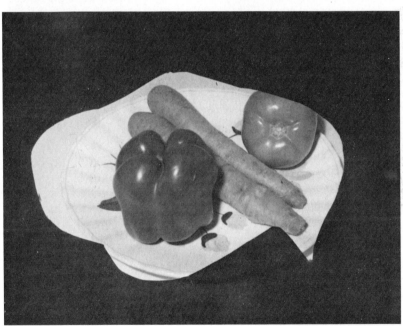

Top: A thin sheet of acetate is cut to the size of the image area on peel-apart pack film and fitted with a paper cutout. The overlay with cutout is then slipped into position and carefully held in place with tiny pieces of cellophane tape. Any type of instant camera and film pack can be used. The film pack with the instant overlay is then inserted into the camera in the normal fashion. If the protective cover sheet has been removed previously, shoot off one picture since the top piece of film has been exposed to light. _Above:_ A paper mask was first designed and then attached to an acetate overlay in order to create this strange picture of a still life setup.

Sequences

As philosopher Heraclitis once observed: "You cannot step twice into the same river." Life is in a constant state of flux, moments melting into other moments. A still photograph only records one instant carved out of the continuum. Thus the sequence becomes a convenient device for adding the fourth dimension—time—to a photographic subject. A series of instants sliced out of reality can preserve a greater sense of the experience.

The sequence is hardly a new convention in photography. One of the earliest practitioners was Eadweard Muybridge, who used a rapid succession of exposures to study movement in animals and humans. Through his explorations in the late nineteenth century, artists for the first time were able to perceive the way horses gallop—with front legs always bent, never fully extended as earlier art renderings had suggested. Animal locomotion was well explored through Muybridge's photographic processes, giving the world an incisive look at human and beast in action.

The sequence is still being used today to study processes and activities. Scientists use time lapse series to document biological changes in flora and fauna. Crafts educators and technicians use it to show individual steps in making or doing something, whether making pottery or changing the oil in a motorcycle. Sports coaches use it to record a player's form and to instruct trainees on the finer points of form for diving, skiing, or running. From the moves of a soccer or basketball team to the execution of a high jump or a skater's double toe loop, action may be analyzed very effectively through time lapse series photographs.

Sequences are useful beyond mere clinical and educational applications; storytelling is another possibility. Individual photographs are taken of an unfolding situation and then, like words in a sentence, are combined to relate the whole concept—whether a child's first bicycle ride, an incident on a camping trip, or a novice sailor's error which landed him in the drink.

Sometimes the story line does not even emerge from a real situation; instead it is a fabrication of one's imagination. The mind's eye becomes the source of material for such a conceptual approach and practically anything goes.

Some sequences are not even produced at one given time. A seasonal sequence, for instance, might record one weeping willow tree during four different seasons to show the varying light and colors of nature as well as the passage of time. In order for such a sequence to work, the subject must be photographed from the exact same vantage point so that the viewer is given the same reference point each time. A personalized time sequence might involve a similar approach in setting up a self-portrait series over several months or years to make a visual diary of moments, moods, changes, and styles.

Sequences are also artistic explorations, as seen in the work of Brian Hagiwara (see "Still Life"). Hagiwara arranged inanimate objects within a composition, took one picture, and allowed that image to suggest the next arrangement of objects. The objects' colors, shapes, and forms were integrally related from one picture to the next, but the arrangements differed. In the end, three or four images were combined into a final composition: a sequence that evolved out of

In this sequence within a sequence, pictures are incorporated into pictures to create a receding repetition of geometric colors. To begin, a red fabric was photographed; when fully developed, the picture of the fabric was photographed on another piece of colored fabric. The process was continued, with pictures arranged in multiple groupings to achieve the final image.

itself, from moments created through the process of being photographed.

Panoramic scenes lend themselves perfectly to sequencing. A complete 360° view can be taken with several exposures by rotating the camera through a complete circular view. The pictures can then be mounted side by side on one long board to achieve a 360° panorama.

In setting up a sequence, decide at the outset what you want to accomplish. Are you documenting a subject, conveying a story, recording a cityscape, exploring an aesthetic interest, conceptualizing some emotion, or making a visual commentary or diary? Each motive will require a different approach. A sequence of an event will require quick reflexive shooting, while a conceptual sequence would take planning—even sketching the idea beforehand—and careful control in order to be successful. It is essential to map out the idea fully before beginning so that you can follow through on a coherent sequence.

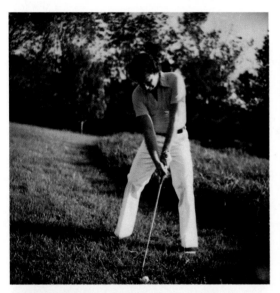
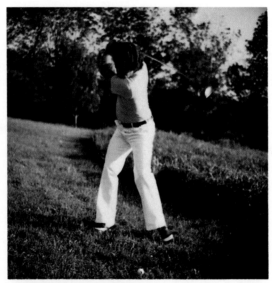
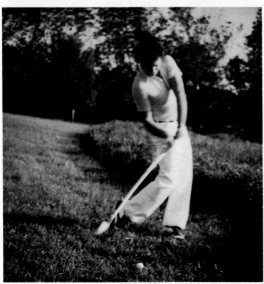
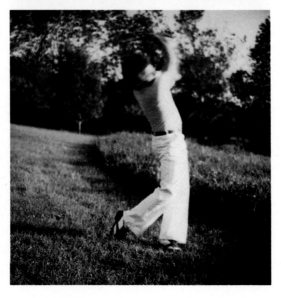

A sequence can show the form of a golfer's swing. However, since instant cameras cannot eject the pictures fast enough to take a rapid sequence of the entire motion at once, the golfer had to take several swings for the photographer to concentrate on each part of the movement, from addressing the ball to the backswing, the swing, and the followthrough. The camera was placed on a tripod with a cable release.

Lightwriting

Free form designs and elaborate drawings can be created with a penlight and your instant camera. You will need to find a dark room and a sturdy support (preferably a tripod) to steady your camera for a long exposure.

Cameras with time exposure capabilities work best for lightwriting, but others can be rigged for multiple exposures so that you can do your lightwriting in stages. (See "Multiple Exposures.") The actual length of the exposure will vary according to the intensity of your light source.

To do your writing, attach your instant camera to a tripod, place it in a dark room, press the shutter button, and move your penlight in front of the lens in the desired pattern. With the Kodak camera, open the film door to ensure a long enough exposure to record the light. Obviously, the design should be decided upon before you begin. For variations, use people or objects in your lightwritings.

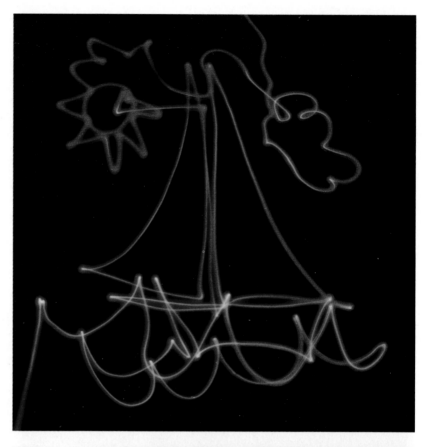

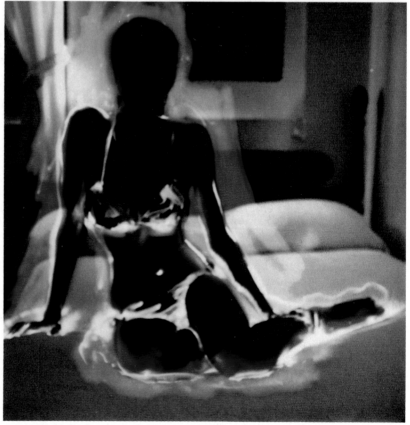

Top: Lightwriting is easy to do and can be winsome and fun. _Right:_ Gary Stubelick calls his style of lightwriting "instant neonizing." It is done by moving the penlight around the outline of a body and highlighting details of clothing. Taping colored filters over the camera lens yields even more unusual results.

Instants through Binoculars

Making instant pictures through binoculars can be an enjoyable way to record candid pictures of people without intruding on the scene with your camera. Or it can be used for catching nature's skittish creatures.

Any pair of binoculars can be used, but the more power a pair has the more compressed the space will appear in the resulting picture. Also, all pictures will be circular as defined by the binocular field of vision.

Make a simple homemade binocular rest out of a wooden box with a threaded hole cut at the bottom to fit on a tripod. Align the camera lens properly against the binoculars and press the shutter. The camera automatically sets the exposure.

The setup for shooting through binoculars includes a tripod, a homemade wooden holder to support the binoculars, and your instant camera.

Top: A picture taken from a distance with a Colorburst 50 camera reveals a simple overall view of a street. _Above:_ Equipped with binoculars and positioned at the same spot, the instant camera records a substantially different subject. The effect is similar to that achieved with a telephoto lens on a 35mm camera. Notice the extreme compression of space and the increased detail in the street sign.

Printing with an Enlarger

For those photographers who use conventional cameras and like to shoot color slides, instant printing with an enlarger is a painless and fast way to turn slides into prints and eliminate the delay of sending them to the local photofinisher. Color slides can be transformed into either black-and-white or color prints depending on the type of instant film you have on hand. All that is needed is an enlarger, instant film and camera (or film back for large-format films), a homemade easel, a color slide, and a darkroom. (A safelight cannot be used. All work with unexposed film should be conducted in total darkness.)

The enlarger should have a color head or filter drawer in which to place color compensating filters. For most tungsten light enlargers, an 80B filter should be placed in the filter drawer to balance the light for instant color film's daylight 5500°K temperature. Also needed is an easel holder to position the film pack properly under the enlarger. This can be made out of a wooden base glued with wood strips matching the size of the film pack. To achieve proper alignment of the film with the enlarger's optical system, make one end of the base slightly lower to accommodate the thicker end of the pack.

Any size instant print material can be used, from small-format Polaroid SX–70 or Kodak Instant Print film to 4×5 or 8×10 format. With the larger format instant films, a 4×5 back or 8×10 processor is needed. With the smaller sizes, only a camera is necessary for processing the film after the exposure has been made by the enlarger.

Place the slide in the enlarger's negative carrier with emulsion side up for Kodak material and emulsion side down (which is right side up in terms of viewing) for Polaroid material. (The difference in positioning is due to the way each film type is exposed: Kodak through the back of the film, and Polaroid through the front.)

To focus the slide, use an empty film pack with a white cardboard inserted to cover the image area. This acts as a kind of screen for viewing the image clearly. Focus with the lens wide open. At this point you have complete control over what parts of the slide you want reproduced. By moving the enlarger head up or down, you can enlarge and crop elements or use the entire image. When ready to make the exposure, stop the enlarger lens down to f/16. Turn off all lights. Now take the live film pack out of your camera (or for large formats, remove the safety cover) and place the pack in position with film facing up under the enlarger. Make a one-second exposure. Still in the dark, put the film pack back in the camera (or slide the safety cover back into place for large formats) and eject the picture so that processing begins. (Be sure to turn off or override any flash systems.) The room lights can now be turned on and picture development can take place normally as indicated on the film instruction sheet.

The more exposure you give the print, the lighter it will be. For a deeper colored print, use less exposure. Also special effects darkroom techniques can be used. Experiment with different colored filters placed in the filter drawer to change the color balance. Or try sandwiching slides together for even more unusual effects.

Any enlarger can be used to turn color slides into instant prints. Here an Omega Color Printmaker is illustrated with a homemade wooden holder shown on its baseboard for positioning a Polaroid or Kodak integral film pack.

The original photograph of this handsome museum in Rochester was taken with a 35mm camera on color slide film, but the final result is a lovely Kodamatic instant print. The whole process of converting the slide to a print took about five minutes.

This eerie photograph was made by sandwiching two color slides together in the enlarger and making an exposure on instant film.

THE USES

- In a small boutique, a Japanese proprietor keeps a complete inventory of merchandise with instant pictures.
- An insurance adjuster uses instant pictures to document a claim.
- A family uses instant pictures to record special personal events.
- A psychiatrist uses instant pictures as visual stimulants to reach patients more quickly in therapy sessions.
- An elementary school relies on instant pictures as an educational supplement.
- A scientist uses instant pictures to document probings with a scanning electron microscope.

Since instant cameras are handy, quick, versatile, and provide immediate visual results, the range of instant photography's uses is extensive. As you have probably gathered from the list above and earlier chapters, applications of instant pictures are as varied as life situations. In family portraits, professional photographers' studios, and scientific laboratories, instant pictures have proven valuable time and again.

This section provides a brief sampling of the many ways instant photographs have been used both personally and professionally. These ideas have already been applied successfully and are presented merely to show existing opportunities and spark more ideas for putting an instant camera to better—even perhaps profitable—use.

Family Journal

More film is used for pictures of family gatherings than for any other subject, with holidays naturally ranking highest in film usage. Instant pictures not only provide enduring records of precious times but provide an activity everyone can participate in. Family members share in the picture-taking by posing, performing, taking turns being the photographer, and almost instantaneously enjoying the results. As a bonus, pictures can be distributed on the spot so everyone receives a memento of the occasion.

I experienced the full impact of instant photography's convenience for family functions not too long ago, when my father's family was reunited for the first time in fifteen years. Equipped with two instant cameras and about fifteen packs of film, I spent the evening taking formal and candid photographs of groups and couples, and pictures of the food-laden tables. At the end of the festivity, each relative selected at least one picture to take home as a memento, and the remaining pictures were assembled in an album and presented to my cousins as a gift for hosting the party. The instant family record was appreciated enthusiastically. Instant photographs can record all types of functions—birthday parties, picnics, anniversaries, or religious celebrations.

A family album is an excellent way of organizing and preserving pictures. The Liggero family has been keeping albums for years and has amassed an almost encyclopedic collection that shows family growth, changes, travels, successes, visits, and outings. Sam Liggero likes to take pictures all the time, photographing not only special occasions, but everyday ones too. Once a week, he arranges the photographs in an album, captioning each with the date and an appropriate comment, which adds spice and memorable details.

While you may feel silly taking pictures of seemingly insignificant daily events, if you get in the habit of photographing family and friends regularly—reading quietly, dining, playing, and during special occasions—you will find picture-taking becomes a natural, spontaneous activity. Eventually you can organize the accumulation of photographs into a chronological visual journal, a personal photo history, that allows you to remember events with greater accuracy, to put your past in perspective, and to share your yesterdays with the generation of tomorrow.

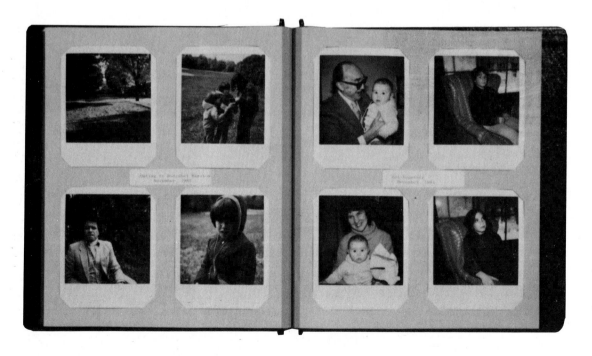

Self-Expression

Self-Image

The satisfaction of taking pictures emanates partly from a basic need to communicate. While the motivation is not always recognizable, it is compelling. Photographers can use instant photographs to exorcise their fears or convey their joys. In either case, the freedom to express ideas in pictures is liberating.

Photographs serve as a realistic mirror, allowing people to watch a personal evolution over a period of time. The functions of a photographic diary can be multifaceted. A diary can be used to follow changes or to make them. A new hairstyle can be documented as it grows in, and a decision made as to whether or not the look is satisfactory. Or a woman can try new make-up techniques and photograph the results to evaluate their merits. Clothes can be tested objectively by taking a picture of them. Or a dieter might take self-portraits as encouragement to maintain a new eating regime.

Instant pictures can accelerate self-improvement. A portrait, which reveals the way a person projects, can be used for analysis and change, if desired. For example, in a class I taught on becoming a professional photographer, one assignment required students to photograph themselves just before making a portfolio presentation to a potential client. Their photographs were insightful looks at students' self-confidence and manner of dress. By reviewing each image, the student could begin to recognize aspects needing improvement. The technique is also useful in preparing for any kind of interview or lecture.

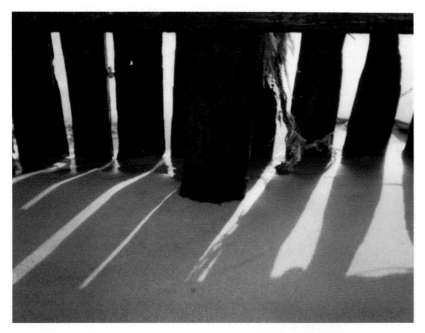

Self-portrait by Jane Tuckerman.

Diversion

One of the greatest attributes of taking pictures is the sheer pleasure it provides. In harried, stressful lives, it is essential to allow for relaxing time away from pressures. Photography can provide the needed outlet.

In fact, research has shown that taking pictures may actually help reduce stress. Stress caused by work problems, social pressures, financial difficulties, and other pressures may be relieved by pursuing an activity that requires concentration entirely removed from the source of stress. Further, stress is reduced by physical exercise. And since picture-taking requires movement—walking, bending, stretching—it can actually help to neutralize some of the tension.

Entertainment

Circuses, carnivals, costume parties, and other festive occasions are ideal for instant photography booths. An enterprising instant photographer can set up clever backdrops to photograph against, or include colorful, imaginative props. Providing costume characters—pirates, clowns, or cartoon figures—to pose with customers is a terrific way of luring people in. Or antique clothes, funny glasses, canes, and hats can be used to liven up instant pictures at the fairgrounds.

For more formal events, an instant picture booth can be decorated to reflect the decor of the party. For an elegant evening gala, the booth might be decorated in red velvet and the guests invited to pose on an elaborate throne.

Interior Design

It is always interesting to use pictures to make comparisons of things as they change—and these pictures can often help you decide on the change. In home interior decorating, instant pictures are used as an aid in selecting furniture, draperies, or other accessories. A room in which a new item is desired is photographed, and then the photo is carried to the store as a visual reference to help in the selection. (Of course, it is important to keep in mind that photographic colors can differ from "real" colors. Thus a sample swatch should be brought along for color matching.)

Homeowners can also use instant pictures to make improvements in outdoor landscaping or in house remodeling. Such pictures are equally appropriate for car, boat, or furniture restorations.

Decoration

Most instant pictures are small, but can add wonderful color, design, and shape to bare walls. Grouping instants together sometimes adds visual impact. However, if you prefer large photographs, both Kodak and Polaroid (or any photo finisher) offer enlarging services, so small prints can be blown up for use as wall hangings. (For framing and matting groups of instants, refer to the section "The Display.")

Correspondence

Note Taking

Instant pictures make great letters. A snapshot of a cluttered desk is a friendly, illustrative way of saying hello to a distant friend while indicating you have been too busy to write. Pictures of children taken regularly can keep grandparents visually aware of their grandchildren's growth and changes. And kids at summer camps often find that sending instant pictures is a less painful way of corresponding with relatives than writing cards.

Vacation pictures mailed to friends and relatives instead of store-bought picture postcards give a more personalized account of your travels. Thank you notes for gifts are also given a nicer touch when you express your gratitude with an instant picture showing the gift being used.

Instant pictures are easy-to-understand visual explanations, ideal for identifying repair problems for carpenters, plumbers, and auto mechanics, as well as for initiating action on neglected neighborhood problems such as a fallen telephone cable or a dangerous pothole.

You can take vacation notes with an instant camera and get immediate assurance that the photographs have been successful. These instant pictures make a travelogue that can be invaluable for retracing the same trip in the future.

Visual notes are also useful as memory aids. Children refer to an explanatory photo sequence pinned to the kitchen bulletin board for a reminder of chores and how to do them. Or an adult's memory is aided by pictures of the items filed in the safe deposit box or the clothes left at the summer house. Visual notes on a pet can also be helpful; if the animal gets lost, you can post pictures to facilitate the search.

Instant reminders of items stored in a safe deposit box.

176

Insurance

Instant cameras provide an easy, dependable tool for recording either possessions or scenes of accidents for insurance purposes. Check with insurance agencies about specific requirements and guidelines regarding the representations needed for filing claims. Generally, the following information will be of assistance.

ACCIDENTS

Pictures should show an overall view of the scene and details of any damage. Several vantage points are recommended. (In low-light situations, be careful of flash reflections against metal surfaces. It may be better to steady the camera for hand-held exposures than to use flash, which might obscure important details.) The photographic details serve as documentation of the accident and can be important in determination of how the accident occurred and who was at fault. Most insurance companies have claims adjusters take instant photographs of damage and attach these photographs to itemized estimates of repairs. Instant pictures are desirable evidence, since they cannot be retouched in the way conventional pictures can be.

HOME INSURANCE

You can make a comprehensive inventory of all valuables in your home with an instant camera. While visual documentation is not always necessary, it can be extremely helpful, especially in case of theft. Individual items indicated on an insurance certificate should be photographed. For some items—such as a valuable vase or artwork—you should take several pictures from different angles to produce a total picture of the item for appraisals or for possible recovery in case of theft. Instant photographs of exteriors and grounds are also used for house appraisals. Fire-damaged property is photographed with an instant camera for claim records.

Commercial Photography

In both studio and on-location sites, professional photographers have become almost completely dependent on instant materials. The instant camera back has become the professional's silent partner, ensuring the success of every assignment by providing an instantaneous proof print of any setup. It is the single major use of instant films by professional photographers in all fields from advertising to portraiture.

The overriding benefit of instant materials for the professional, who mostly relies on conventional films to fulfill assignments, is its immediacy. The pro avoids wasting endless rolls of conventional film by checking photographic representations of a setup promptly. This saves a great deal of time and energy.

In a typical fashion shooting session, the photographer sets up the scene, positions the lights, readies the props, and shoots a test shot of the arrangement even before the models are in position. An instant camera back is attached to the photographer's camera, producing an on-the-spot photograph for lighting and composition analysis. If necessary, changes are made and other test shots taken until the photographer and the art director are satisfied. Models are then asked to assume positions, and several more instant pictures are taken as a final proof before conventional film is used for completing the assignment.

Besides functioning as valuable test proofs, instant pictures have fulfilled many other uses in commercial studios. Test shots, organized in easy-access files, serve as sketches for later re-creation of special studio effects and lighting setups. Instant pictures, along with written details, can be used to keep a personal models' book for convenient reference.

When developing new projects, photographers often use instant films to help visualize new concepts and approaches. Sometimes these roughed-out samples are even rushed to clients for quick approval. Photographer Marty Fumo actually sells his SX-70 prints to pharmaceutical advertisers as final versions for use in printed brochures. However, sales of instant photographs for commercial advertising print campaigns are rare. In most cases, instants are only the intermediate step in the visual process. Story

boards with instant pictures, for instance, are commonly used by ad directors and filmmakers for layout ideas.

Assistants to commercial photographers also use instant pictures. For instance, stylists use them in seeking props, clothes, and details for a shoot. Location scouters use them to report back to photographers on potential shooting sites. In many cases, when a photographer is finally on location, the assistant will make instant records of the area for future reference and potential use.

Naturally, travel photographers rely on instant pictures extensively, especially for establishing rapport with people. When they are shown a few instant pictures of themselves, strangers are usually transformed into cooperative models. Photojournalists find instants useful in exotic cultures as a speedy means of communication.

For professionals preparing a comprehensive story or book about a place, instant pictures aid on-location progress. Instants used as sketches give a photographer an immediate assessment of how the story fits together and what aspects need further documentation. Occasionally instant photographs are forwarded to editors or publishers for feedback and direction or as supportive material for proposals.

Opposite: New York fashion photographer Alan Kaplan maintains informal instant picture books for quick reference on location sites and models he has used. In each book, he adds pertinent details—lighting setups for the location books, and names of models and their agencies for the models' book.

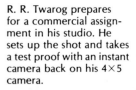

R. R. Twarog prepares for a commercial assignment in his studio. He sets up the shot and takes a test proof with an instant camera back on his 4×5 camera.

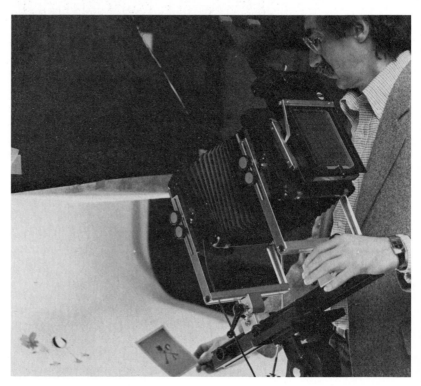

Fine Art

The instant process itself and its inherent qualities have attracted a growing number of artists and photographers. Consequently, instant photography has become an increasingly significant factor in fine art photography. Applications are widely varied.

Master photographers have used instant black-and-white materials in understanding photographic visualization. Ansel Adams, for example, has explored exquisite landscapes using various types of Polaroid black-and-white films to translate light values into tonal gradations. The immediacy of such discoveries is gratifying and stimulating for many artists.

Other imagists enamored of color have pioneered a kind of instant aesthetic with instant color materials; and unlike conventional photographs, each instant color print is a one-of-a-kind original. "The Art" section includes Polaroid SX–70 photographs by such artists as Terry Walker and Bruno Joachim who have capitalized on the unique vibrancy of the SX–70 colors to produce graphic, often lyrical images. Other artists have made personal expressions by altering Polaroid SX–70 print surfaces. Both Lucas Samaras and Marty Fumo manipulate colored dye layers of SX–70s to rearrange actual colors, forms, and shapes. John Schwartz changes the SX–70 print by painting and collaging materials onto its surface.

Still other artists have gravitated to the larger-format instant material for its exacting rendition and brilliant colors. The 8×10 format is most often used by experimental artists. More recently, the mammoth 20×24 camera has been accessible to photographers. Although the 200-pound, 20×24 camera requires four operators to move and is therefore rather awkward to use, its exquisite, detailed results are unparalleled and its availability has sparked a whole new range of uses in art and commerce.

Beyond its creative uses, the instant print has taken on grand proportions as a means of *reproducing* fine art. Polaroid designed a room-sized instant camera to record Raphael's *Transfiguration* hanging in the Vatican Museum. The purpose was to obtain an accurate life-sized reproduction that could be studied and would preserve the masterpiece. The applications of the "Camera Camera" for preserving precious works of art and documenting architectural settings are only beginning to be realized.

Polaroid's 50×60-cm "Camera Camera" is mounted on a hydraulic platform in front of Raphael's *Transfiguration* to make direct reproductions for examination by scholars and art lovers.

A direct magnification of the kneeling woman in the foreground of Raphael's painting as taken by the "Camera Camera."

Opposite: Photograph by Paul Caponigro on Polaroid 8×10 film.

Industry

Many corporations use instant picture equipment to facilitate pictorial procedures. Uses range from routine identification pictures on company passes to rather progressive ultra-high-speed instrument recording pictures for reproducing cathode ray tube (computer terminal screen) images in hard copy (paper copy).

In managerial departments, large-format instant cameras have been used for executive portraits. With instant pictures, a company officer has an immediate opportunity to accept or retake a portrait. And the instant photograph can be used for reproduction in corporate publications.

One well-known pen corporation in Germany actually used the process of making Polaroid 8×10 instant portraits as an integral part of a seminar aimed at improving executive innovation, decision making, and self-image. An 8×10 camera was set up with an instant camera back, and each executive was handed a cable release and instructed to take a self-portrait. The project aptly addressed all phases of the seminar. The novel use of instant portrait making was innovative; the immediacy required in shooting addressed the decision-making aspect; and posing in front of their peers tested the executives' self-images.

In other facets of industry, instant pictures are useful for reporting progress and efficiency, keeping inventories and records, diagnosing industrial problems, and evaluating highly technological machinery. Many available instant products are used for audio-visual presentations, graphic designs for in-house convenience, and high-volume product documentation. The Polaprinter Slide Copier is one such item available from Polaroid. It makes instant prints from 35mm transparencies and is ideal for picture libraries, manufacturer's multiple inventories, and corporate promotional departments. A print is produced in minutes without the security risk and delay of using outside photographic laboratories.

Communication, a major concern of corporate enterprises both internally and externally, is accelerated by instant photo products. Consider the MP–4 Copy Camera, a highly versatile unit used for making instant records of small products and duplications of important materials, and for modifying designs by reducing or enlarging specimens. Publishing companies use the MP–4 for copying mechanical layouts as insurance against loss of printed materials and as a way of previewing the sequence of pages in a book or magazine. Public relations firms use the camera for making camera-ready photographs for promotional pieces or house organs. Research and development departments use it as an aid in documenting and designing new products.

In recent years, a rapidly expanding field of corporate and industrial communication has been computer graphics. Instant materials have enabled communicators to generate hard-copy prints of electronic images much more quickly and inexpensively

The computer graphics hardware consists of a free-standing camera interfaced with computer terminals, a Polaroid film holder which slides into the camera to make an exposure, and a Polaroid processor for developing the Polaroid film in seconds. The entire process is economical and efficient and makes split second urgent communications possible.

Polaprinter Slide Copier
in use.

an was previously feasible. Data from video
reens and cathode ray terminals can now
e recorded with special cameras and high-
solution Polaroid instant films. Some
mera manufacturers have implemented the
se of varied formats from 8×10 to 4×5 to
X–70.

Industries have made use of the instant
omputer graphics prints. At the National
eronautics and Space Administration
NASA), scientists were able to record trans-
itted images of the planet Saturn from
ioneer 11 spacecraft using a Dunn Model
31 Camera System and Polacolor 2 film.
ther uses have included computer mapping
f nutrients in large lakes, aerial solar poten-
al surveys of urban areas, and geological
xplorations. One large business corpora-
on that relies on computers to predict
conomic forecasts records these computer-
enerated charts for presentations to
anagement. Traditional hand production of
oded graphs, charts, maps, and drawings
as been replaced by a much more efficient,
ccurate, and inexpensive means.

Corporate communica-
tions departments rely on
the adaptable Polaroid
MP–4 Copy Camera for
instant memorandums,
records, small product
documentation, quick
photos for in-house publi-
cations, and a variety of
technical requirements.

WALTHAM RESOURCES CORPORATION

BADGE NUMBER 2-6138

EMPLOYEE R. L. Roden

AREA 4

orporate identification tag.

Small Companies

Small businesspeople, from builders to caterers, company executives, foresters, interior decorators, museum directors, store owners, and travel agents, have come to rely on instant photography as a tool for reporting, recording, and promoting. The most obvious benefit of most instant cameras is that prior training in photography is not required for their use. A side benefit is that the pictures can be used immediately.

The Japanese boutique proprietor mentioned in the introduction uses his simple Polaroid camera to record newly acquired seasonal stock. He photographs each item, and as the instant picture emerges, he puts away the new stock and files the pictures in a book with notations of stock numbers and volume. Then at a glance he can tell what items he has on hand.

At a hospital in upstate New York, nurses take instant photographs of premature infants to prepare parents visually and psychologically for the way their newborn looks. Newborns being monitored with sophisticated medical equipment can appear horrifying to parents. Instant pictures can help to ease that shock.

Department stores use instant camera setups for promotions throughout the year, inviting families to have pictures taken free of charge. Interior decorators use instants to show clients different styles, accessories, and final results. Travel agents sometimes keep instant pictures on hand to convince travelers of a location's merits, which are more evident in realistic, non–brochure-type photographs. Florists use instant pictures to record flower arrangements for customer selections as well as for a visual report when flowers are sent as a gift. One conscientious florist equips his delivery staff with instant cameras so they can photograph the recipient on delivery and then forward the picture to the sender along with a bill. Several world-renowned fashion designers take instant pictures of their latest creations and even use the pictures in their portfolios.

Companies have made use of instant photography to improve morale by encouraging employees to take and exhibit pictures of family, friends, and vacations. Office problem areas have been red-flagged through instant pictures. And office gatherings, luncheons, and special events have been chronicled with instant photos, the immediate results providing a festive touch.

Real estate agents often use instant pictures of available houses in window displays in the hope of appealing to a prospective customer passing by

In high-traffic retail locations, portable instant camera setups are used to attract customers into the store. Christmas is a prime time for instant photography setups with Santa Claus.

Interior decorators rely heavily on instant pictures both to show clients samples of design concepts and to use for reference when actually designing a space.

Science and Medicine

Instant photography speeds up and facilitates scientific documentation. Instant ultra–high-speed instrument recording film and other fine-grain, instant films make possible the production of black-and-white hard-copy prints from much-relied-upon scientific hardware such as oscilloscopes and scanning electron microscopes. The hard copy provides researchers with immediate data for examination, analysis, and continual reference. Special microscope adapters are currently available for still microscopes, allowing use of small-format Polaroid SX–70 cameras for brilliant, fast-developing color prints of microscopic studies.

Well-known scientific photojournalist Fritz Goro has used the SX–70 device in his marine biology studies (see "Nature"). Photomicrography with instant films has been an aid in researching biochemical specimens, electronic chips, and microfossils. Other areas benefiting from the instant availability of photographic prints include radiometry, endoscopy, spectroscopy, astronomy, thermography, and geology.

Many scientists use a Kodak or Polaroid instant film back mounted on a view camera to record laboratory animals or experimental setups, or to make sequential photographs for studying the growth of flora and fauna or bacteria.

In medicine, instant photography has become an invaluable means of recording, educating, and diagnosing. In the area of ultrasound medical diagnostic imaging, patients are exposed to high-frequency sound waves that create visual images of internal body structures on a cathode ray tube screen. Ultrasound technology has been used in ophthalmology for providing details of minute eye structures; in obstetrics to obtain an image of a fetus when safety is a critical factor; as well as in cardiology, neurology, presurgery mapping, and for routine screening and diagnosis of cysts, tumors, and abscesses. In each situation, the cathode ray tube image is photographed directly to obtain a permanent record for patient diagnosis, physician consultation, and medical instruction. In a similar way, hard-copy prints of cathode ray tube displays are also obtainable from nuclear diagnostic imaging systems which record the function and pathology of body organs. Physicians at a U.S. vascular diagnostic center inject into a patient a radioactive solution which is assimilated by healthy or diseased tissues. Sensors placed over the heart generate a visual image of the heart tissues. The laboratory then produces hard-copy prints to support written reports of findings and for the physicians' use in diagnosing the patient.

Instant X ray systems have also proven to be extremely useful in diagnostic applications, especially for in-field situations, since the need for a darkroom is eliminated. A portable instant X ray film system actually produces instant, transparent 8 × 10 X rays on location, and is reported to render high-quality images with only twenty-five percent of the usual X ray dosage, thus increasing patient safety. The unit is particularly desirable for veterinary medicine and podiatry.

Documentation of surgical procedures has also been aided by instant materials. In one unconventional approach, a surgeon had a 35mm, single-lens-reflex camera custom-designed to accept a rotating instant back that allowed four exposures to be made on one piece of instant film. While in the operating room, the surgeon was able to make a visual representation of the several-step process involved in removing a specimen, and of the specimen itself.

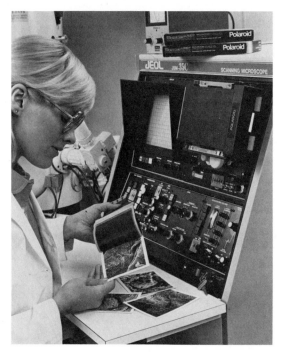

The scanning electron microscope, a sophisticated scientific instrument used for large magnifications of subjects—as great as 10× to 200,000×—is shown outfitted with a quick-loading instant pack film system for increased convenience and efficiency.

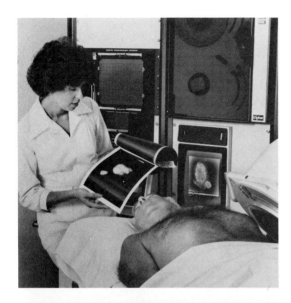

In hospitals throughout the world, it is not unusual to see instant photography systems—such as the one pictured—being used to make hard-copy prints of images generated by ultrasound and nuclear scanning cameras for medical diagnosis purposes.

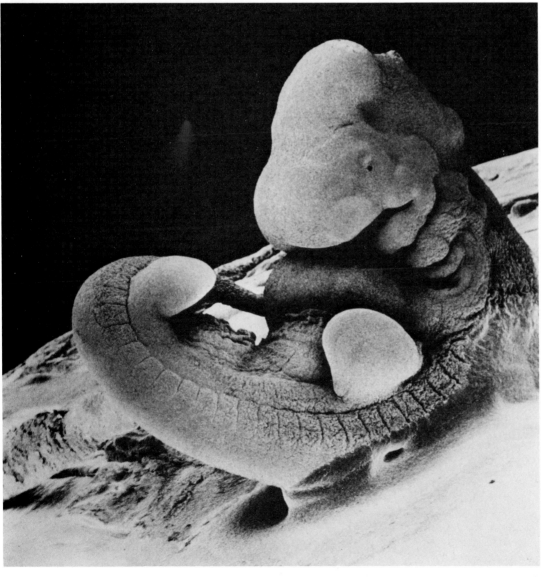

Scientist and photographer Lennart Nilsson has created rather extraordinary images through his scientific research. This striking photograph represents a human embryo.

Education

Photography schools and workshops around the world rely on the immediacy of instant materials for courses on photographic vision, composition, and techniques. Assignments can be completed and evaluated in the same classroom period. The rapport between student and teacher is intensified, and understanding of photographic principles is facilitated.

Beyond photography courses, many educational institutions use instant cameras to augment and enrich their programs. In language arts classes, students are asked to take instant pictures of special places they visit and then write stories based on the pictures. One reading consultant uses instant cameras to motivate reluctant readers; youngsters are taught how to operate the cameras and then given written instructions to read and follow. Most students delight in taking pictures and are quick to do anything that will permit them the diversion...even if it means reading. Included in the instructions is a requirement that the student mount the pictures in a book and write a brief description of each picture. Most students not only learn to read the instructions and write accompanying sentences for pictures, but take great pride in their accomplishments. The side benefit to all of this is that they also learn how to take pictures.

Primary-grade students learn the alphabet through pictures. By photographing objects resembling each letter, a teacher can present an exciting visual image to stimulate students' interest in learning to recognize letters.

One kindergarten teacher takes instant pictures of each child on the first day of school as a way of getting acquainted and as an activity in which every child can participate. The pictures are then placed on a bulletin board with each child's name printed clearly on the back. Every morning the child is responsible for turning his or her photograph to the picture side. Then the teacher is able to take attendance at a single glance.

Some teachers regularly photograph classroom activities to record students' achievements and their academic world. Pictures are a marvelous way for very young children to share their school life with parents. For older students, the pictures comprise an album reminiscent of a yearbook. In fact, some yearbook photographers use instant passport cameras for taking senior portraits.

Photography courses offered in the school curriculum are quite dependent on instant cameras. For young children, instant equipment improves eye and hand coordination. For older children, instant materials facilitate projects and problem solving. For instance, in shop courses, arts and crafts, biology and chemistry, pictures are useful for progress records and step-by-step instructions. With instant cameras a student avoids wasting time and money shooting an entire roll of film to get the few necessary pictures.

Athletic programs use instant pictures of students in action for nearly immediate review and criticism by coaches and gym teachers. In science classes, visual reminders of students' accomplishments are provided by instant photos. Language classes use pictures to evoke poems or stories. Drama classes take instant pictures to give actors immediate feedback on their ability to project a character. The pictures are also excellent for promotional publicity for performances.

Far left: Children learning photography. *Left:* Photograph taken by Tina, age 11. *Bottom:* Language symbols are taught to youngsters through instant pictures.

Learn your ABCs

Therapy

One of the most unusual yet flourishing applications of instant pictures is in the treatment of emotional disturbances and psychological symptoms. Photographs are being used to hasten communication and enhance therapist–patient rapport.

By suggesting that patients take pictures of people and things of personal importance, therapists achieve a quicker assessment of patients' concerns. The instant camera is essential for such exercises, since most patients are not trained photographers and need the instant feedback to ensure that the pictures come out. By having the patient place these pictures in order of value, the therapist gets further input regarding attitudes and problem areas.

In another application, the patient is instructed to visualize an emotion by taking a picture representing that feeling. The photograph thus objectifies the feeling and can be viewed and discussed more clearly with the therapist. The therapist can also ascertain a patient's view of the world from the way images are selected and framed. One patient might show acute depression by a repetitious choice of dark, dimly lighted subjects in isolated settings. Another patient might reveal a vitality and renewed optimism by taking colorful floral pictures, keying the therapist into the patient's progress.

Photographs serve as a reality check and allow patients a standard focus for evaluating real and imagined problems. A photograph can be a valuable discussion-generating tool and viable material for joint interpretation by patient and therapist. In some cases, the patient is much more apt to confront real feelings toward an individual he or she is having difficulty with when confronted with a realistic photographic image rather than a mental one.

In group therapy programs, patients can take photographs of one another to help explore feelings and projections about themselves and relationships with others. By discussing the images, patients become aware of body language and other unspoken aspects of behavior.

The reality factor brought into the therapy session through photographs often aids the patient in focusing on problems. The case of a fifty-two-year-old farmer suffering from heart palpitations and fatigue is a prime

Taken in an adolescent residential treatment facility by Deborah Zwick, this photograph shows a youngster examining a series of self-produced instant pictures. Instant photography is used in photo therapy for immediate feedback as a therapeutic process.

example. When his doctor found no physiological reason for his complaints, the farmer was sent to a therapist. The therapist instructed him to bring important family pictures to the second session and arrange them in chronological order. The man began with his wedding picture and described his wife as a nervous person who disliked being photographed. The second picture showed his sixteen-year-old daughter, whom he acknowledged was mentally retarded. The third picture of his son triggered tears. He explained that his son had left for college and he was sorely missing the boy. Another picture drew more tears. It was of the man's father, who had died of a heart attack a year earlier. Thus, in a short period of time, the therapist was able to establish the basis for the patient's neurosis in manifesting a heart disorder. The patient was grieving over the loss of his father and, in a sense, his son; was anxious and guilty about his daughter's illness; and harbored a strong resentment toward his wife. Pictures served as a catalyst to expose the farmer's inner thoughts. In general, family albums provide an excellent way for therapists to delve into patients' childhood experiences and relationships.

In hospital rehabilitation programs, clinics, mental institutions, and children's homes, photography has become an integral step in treating patients. In programs teaching mentally handicapped students to develop independent living skills, for instance, an instant camera is used to document a student's interrelationships in undertaking everyday chores. Pictures show students how to do various chores and then record the student's successes, reinforcing a sense of satisfaction and accomplishment. Pictures enhance communication, help to develop comprehension skills, and capture a student's performance so the student can analyze it without having to depend on memory.

Outside of formal therapy programs, individuals can use instant photography as a method of self-therapy. By making self-portraits at various intervals of time, an individual gains concrete evidence of changes and patterns. These pictures are instrumental in realizing personal behavior modification goals. As evidenced in "The Art" section, photographs also serve to release personal fears, pains, and concerns.

For a therapeutic exercise, photographic dialogue between peers in an adolescent group was encouraged. This instant photograph resulted as a nonverbal expression of a strong emotion—fear.

THE DISPLAY

The joy of taking instant pictures is surpassed only by the satisfaction of sharing them. Displaying your pictures is an exciting way to show your pictorial accomplishments and to add color and graphics to bare walls. Even more important, it is a way of protecting and preserving your photographs (provided they are not displayed in direct sunlight, which causes fading and discoloration).

Decorating interiors with instant pictures can be fun. Color pictures can be chosen to echo the style of a room or dramatic graphic ones for their personal meanings. Even if you prefer not to display your instant pictures, many different kinds of albums are available for storing, protecting, and viewing them.

This section offers ideas and techniques for presenting and storing your photographs. It is meant to further the instant picture-taking experience by showing how to care for and display the results of your efforts.

Photographs enhance interiors with color and graphics as in this home environment at Kings Grant Farm. All photographs were originally instant prints that either have been enlarged—one was made into a poster—or kept the same size and framed.

Caring for Prints

Pictures should be handled and stored with tender loving care, whether or not they are to be displayed. Too many photographers are unaware of the damaging effects of some common handling and storage practices and make the sad discovery only after their prints have curled, discolored, or faded. A few basic procedures can prolong your pictures' longevity and help avoid print deterioration.

HANDLING

From the moment prints are removed from the camera, they should be held carefully by the white border edges. Bending or creasing pictures can crack the emulsion surface or—in integral films—impede the development process. When you are photographing on location, film boxes provide acceptable protection for transporting dry prints.

Fingerprints are not a problem on integral print surfaces, as they can be removed by misting the picture surface with your breath and gently wiping with a tissue or soft cloth. Peel-apart prints, however, are marred by finger marks, especially prints that have just been coated or have not yet dried to a hard, glossy finish. With coated or coaterless prints, allow surfaces to dry for several minutes before touching or stacking. If freshly coated prints accidentally get stuck together, separate them by soaking in plain white vinegar. Wash briefly, let them dry, and then recoat.

Writing on prints can be damaging unless you take some precautions. Avoid using a pen or pencil directly on the image back, as the pressure can push through to the emulsion side on peel-apart prints, marring the surface, or break through the protective backing on integral prints, causing chemical leakage. Write only on the white edges of prints, avoiding the image area, or affix a label. Use permanent ink pens for slick-surfaced borders such as those on Kodak instant prints.

STORAGE

High humidity, high temperature, and exposure to air pollutants are destructive to prints. The ideal place to store pictures is in an atmosphere where relative humidity is below fifty percent and temperature is below 65°F (30°C). Damp basements and hot attics are detrimental to photographs, but if a choice is necessary, opt for the attic. Humidity is far worse than dry heat.

Coated prints and even integral prints can be scratched and damaged by rough handling or improper storage. Keep them in albums or individual transparent sleeves or acid-free envelopes sold for negatives and color transparencies. For easy accessibility, use sleeves that fit into looseleaf ring binders. Avoid using ordinary black paper photo albums, glue, or tape, as these contain impurities that can migrate to the image surface and cause staining or discoloration. (Refer to "Albums," "Mounts," and "Mats" for alternatives.) Prints can also be stored in archival boxes made for photographic prints.

With proper handling, black-and-white instant prints should endure as long as conventional prints. Color materials generally have a tendency to fade over a period of time. However, the metallized dyes used in most instant color products should outlast conventional film images, provided the prints are kept out of direct sunlight.

These suggested storage containers preserve and protect prints from dust, scratches, and pollutants.

Albums or photo files.

Transparent sleeves in a looseleaf binder.

Archival photographic print box.

Albums

The photograph album offers a safe and enjoyable solution to maintaining your one-of-a-kind images and can take on many different aspects. The pages can represent a cumulative flow of chronological events or a sampling of your most outstanding instant pictures. Albums can relate a story or reveal a theme such as love, children, nature, landscapes, or architecture.

Many people rely on albums to organize and keep photographs of family memoirs. Besides providing a nostalgic documentation, a family journal can be aesthetically pleasing, with pictures attractively arranged on each page. One photographer enriches his family album by writing comments that fit the sentiments of each picture. Another uses a cinematic approach, arranging his journal so that moments evolve into one another. Another photographer keeps the album opened on the living room coffee table, and as soon as pictures are snapped they immediately get placed into the album.

As an alternative, an album can be organized by "family members," with sections arranged according to which family member took the pictures. Filling the personal sections can be an enjoyable family interaction.

After accumulating a few albums, label the spine of each with dates and subject title as a reference. When buying photo albums, remember that some commercially available black paper albums can be damaging to pictures over a period of time. Stay with tested and approved albums designed for instant pictures by Polaroid or Kodak, or make your own.

Here's a simple and very effective archival album you can make: A clean, white, acid-free etching paper such as Strathmore vellum-type provides the backing on which to mount your instant pictures. White photo corners (with a neutral pH so they are acid-free) attach the prints to the backing. Depending on the size of your sheet and the size of your pictures, arrange two to four images on one page. To protect the image surfaces, an opaque vellum overlay is inserted between each page of the album. Use a hole puncher to make holes fitting a binder. Or keep loose pages in an archival photographic print box.

Larry Mach has organized his family album with a filmic eye so that moments flow into one another in picture arrangements.

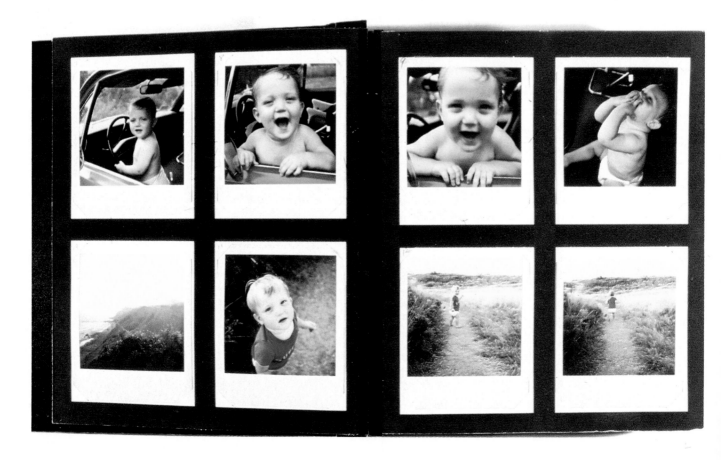

Mats

A mat offsets and highlights a photograph by providing a colored or textured paper frame around the image. Besides the aesthetic advantage, a mat offers good protection, keeping a photograph flattened and separated from the frame's glass or plastic.

Mat boards are available in many colors and sizes. Precut boards can be placed over mounted pictures to add depth and elegance. Or overmats can be made from mat boards to provide both the backing for a picture and the window to frame the image. Archival overmats, made of acid-free board, are often used for permanent storage or for museum or gallery exhibitions.

Colored materials are usually not archival but are acceptable for short-term display. The color should relate to the mood and emphasis of a photograph. A mat of similar color is effective in focusing attention on a particular object. For example, a portrait of a woman in a red cape is dramatized with a red mat; a cold-toned snow scene might be very striking with a blue mat. If the intent is to contrast the main subject of the picture, a mat of a complementary color should be chosen.

The size of a mat depends on the size of the frame and the picture dimensions. The outer measurement of the mat board should coincide with the inside dimensions of the frame in order to fit the frame's grooves properly.

The conventional approach is to cut the mat opening to the size of the image and add a 2-1/2– to 3–inch border, with a slightly wider bottom border for balance. Subjects with verticality such as skyscrapers are usually mounted in a vertical mat; horizontal images such as landscapes often look best in a horizontal mat. However, variations can work well: an 8×10 mat looks fine with a small-format Polaroid or Kodak instant print and an 11×14 mat can work beautifully with a 4×5 print. In some cases, mat openings cut to reveal the white borders of instant pictures can be desirable. Or if a print's edges are dirty or unwanted elements are to be eliminated, a mat can crop by slightly overlapping the image area. Many pictures can be combined on one mat for a composite display of family pictures or thematic subjects. Try different combinations to arrive at arrangements that are in sympathy with your images.

To make an overmat, you will need two mat boards of the same size, a mat cutter (or single-edged razor or X-acto knife), and a metal T-square or nonslip metal ruler as an edge to cut against. After measuring the size of the image and deciding its placement on the mat, carefully cut a bevel-edged window out of one mat board the size of the image area. A beveled edge is made easily with a mat cutter, but any other cutting tool can be angled at a 45° angle for the same effect. Archival mats, made of one hundred percent rag content, are preferable, since less expensive boards reveal uneven pulp contents when the edge is cut at an angle. After cutting the window, attach the two boards together either at the top or at the side. Linen bookbinder's tape is recommended. Affix the picture to the bottom mat board which is placed underneath the top mat's opening. Mount the print to the mat with linen tape.

Multiple mats can add even more separation and accent to a picture. A multiple mat is made essentially the same way—the additional mats are cut to reveal a very small edge of the mat beneath, providing an extra delineation around the print.

Two pieces of mat board are hinged together to make an overmat. The top piece has a window cut to the desired size of the image area.

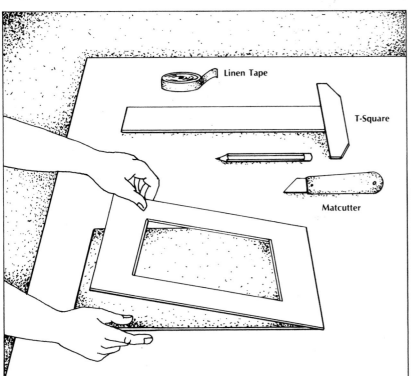

Linen Tape

T-Square

Matcutter

Mounts

Before a photograph can be framed it must be either mounted or matted on a stiff backing. Mounting materials are available in many varieties of sizes, colors, textures, and types, including mount board, plastic foam board, wood, and mat boards (refer to "Mats"). The photograph is affixed to the backing by one of three methods: adhesive mounting, wet mounting, or dry mounting.

The mount board should be selected on the basis of its enhancement of the image, unless a print is full mounted (that is, mounted with no border—standing on its own without the intrusion of the mount). Very graphic images, moody low-key pictures, and certain color prints lend themselves well to full-mounting, and are sometimes exhibited unframed. Just remember, if a full-mounted print is to be framed, leave a 3/16-inch (.76 cm) mount border since frames usually have 1/4-inch (.35 cm) grooves for the mount.

With a partial-mounted print, the edges of the mount board are exposed and become extensions of the picture. The size of the border and the placement of your print on the board become important considerations. A mount that is too large or too brightly colored can swallow up the image, whereas one that is too small or too dull can make the picture appear out of proportion or off-color. Use your judgment, keeping in mind the decor of the room in which you plan to exhibit your photograph.

CAUTION

These mounting processes cannot be undone and are not archival. However, they are simple and convenient ways of readying prints for display. When print longevity is not a deep concern, these mounting methods are acceptable. However, Polaroid SX–70, 600, and Kodak Instant Print films should *never* be dry mounted, as high temperatures involved in this process can melt protective coatings and affect the metallic dyes. Also, wet mounting will not work. Use copies of integral prints made by a copy center or a photofinishing lab for mounting and display. (When print longevity is a concern, refer to "Mats" and follow procedures for over-matting.)

ADHESIVE MOUNTING

Adhesive mounting is the simplest of all mounting procedures. It requires a spray or sheet adhesive and a mounting board to which the print will adhere. The adhesive is applied to the back of the print; the print is then affixed to the mounting board. Some commercially available adhesives dry instantly, so positioning of the print the first time around is extremely important. Use a large, clean work surface and be sure to take your time.

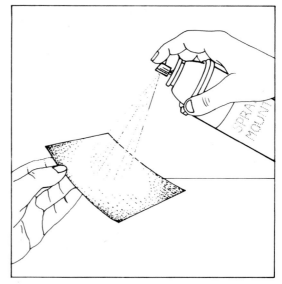

The back of the print is sprayed with an adhesive spray.

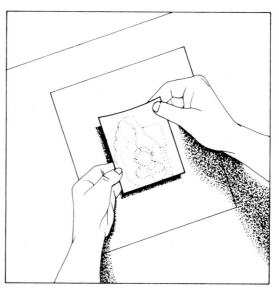

The picture is placed carefully on mount board.

WET MOUNTING

For wet mounting, a spray or water-soluble adhesive such as glue or wheat paste is needed. First, soak the print in clean water for a few minutes. Then, working on a clean surface, use a squeegee or damp sponge to press out excess water from the print. Apply a thin, even coat of adhesive on the mount board with a brush or spray can. Align the print on the board and press firmly and evenly, making sure the print is smooth. To avoid warping of the mount board, wet mount a similar-sized sheet of heavy Kraft paper to the back of the mounting board and allow it to dry.

DRY MOUNTING

This process is the most effective and neatest method for affixing a print to a mount. It requires special dry-mounting tissue which is placed between the print and the mounting board and then melted by a high temperature provided by a dry-mounting press or an iron to achieve a permanent bond.

The print is placed face down on a clean surface, and the tissue is lightly tacked to its center with an iron. The print is turned over and trimmed, together with the tissue. The print is positioned face up on the mounting board, and the tissue is lightly tacked to the board by peeling back one corner and tapping it with the iron. Then the print and mount board are protected with a sheet of clean paper and placed into a dry-mounting press. Or if an iron is being used, apply pressure from the center of the print, moving slowly outward. (Caution: If using a dry-mounting press for Polacolor prints, use a low-temperature mounting tissue and a temperature that does not exceed 180°F (82°C), and do not leave prints in the press for more than thirty seconds.)

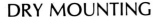

Excess water is squeegeed from the print with a wet sponge.

A thin, even coat of adhesive is applied with a brush.

Tissue is tacked to the center of the print with an iron.

Tissue is tacked to the mount with an iron.

A dry-mounting press.

Frames

Frames are available in all styles, shapes, sizes, textures, and price ranges. The frame you choose should contribute to the feeling of the print being displayed. For instance, a snappy, contemporary scene generally is complimented by a modern, shiny frame, just as a sepia-toned print with its nostalgic appearance is usually suited to an elegant antique frame.

For contemporary subjects, simple aluminum or natural wood frames of oak and walnut are most popular. Decorative antique frames provide a lovely enhancement for old family pictures or moody scenic photos. Plastic, frameless frames altogether eliminate the worry of matching prints to proper frames and can be very effective for flush-mounted prints. These are available in many types including box Lucite frames, sliding plastic frames, and Plexiglas, free-standing frames.

Unusual frames add an entirely different look to photographs. Experiment with ceramic, fabric, or enamel frames of different shapes.

Unusual frames give pictures a special touch.

Special standing frames of plastic, metal, or fabric add a decorative look to tabletops.

200

Copying

EXTRA PRINTS AND ENLARGEMENTS

Making extra copies of your favorite instant pictures is easy to do through Polaroid's or Kodak's copying service. Pictures can be reproduced the same size as the original or enlarged to make handsome displays.

Order blanks for Polaroid copy prints are packed with each film. SX–70 and 600 film blanks are on the reverse side of the cover sheet ejected from the camera. Blanks for peel-apart pack films are inside the film boxes. Kodak copy prints are available through conventional photo processing outlets.

When mailing pictures to any copy center, be sure to use a sturdy cardboard package and include a fully filled-out order blank.

Polaroid's copy service offers three sizes of enlargements for SX–70 pictures: 5×5, 8×8, and 11×11. In addition, specially made, square-format aluminum frames have been made available (in the United States only). In the same order you can have your pictures copied, enlarged, and framed. Copy service is also available for other types of Polaroid black-and-white and color films and Kodak films at photo finishers.

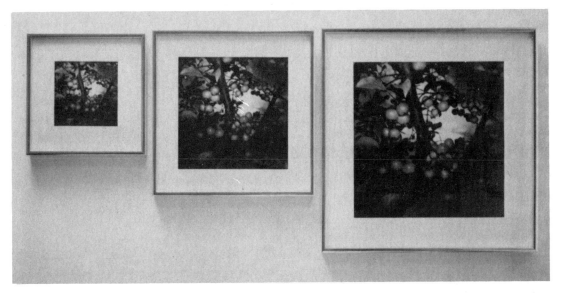

This shows the lighting setup for copying. Lights are positioned at a 45° angle on each side to shine light evenly onto the flat surface being copied. To check that the illumination is uniform, stand a pencil in the center. If no shadow is cast, the lights are properly positioned.

Instant Camera

USING YOUR CAMERA

To make copies of documents, drawings, or any other flat art, you can use your instant camera. A professional copystand would be ideal for a copying setup, but you can improvise with a tripod, a tabletop, and two daylight-balanced lights. If daylight-balanced lights (which are best to achieve "true" color renditions) are unavailable, use a color compensating filter over the lens to match your light source and balance it for daylight. Extend the tripod so the camera is extended over the tabletop, and position the lights as illustrated.

THE GUIDE
to Instant Cameras, Accessories, and Technology

This section contains a roundup of useful information about all types of instant cameras, from the technology that makes them work to how to operate them. You'll find simple step-by-step instructions for using currently available instant cameras, details on instant films, plus a listing of all kinds of accessories. Also included is a visual reference listing of professional equipment.

Cameras are divided into general categories according to model types and film used. Each category is illustrated with one specific camera as an example, but the material is applicable to other similar cameras (indicated in the introduction to each category).

Basic Cameras

FOLDING CAMERAS FOR KODAMATIC INSTANT COLOR FILM: KODAMATIC 980L

Kodak has designed the Kodamatic line of cameras with portability, better storage, and foolproof picture-taking in mind. Except for the lowest-priced model, the Champ/920, which resembles a nonfolding Colorburst 50, all Kodamatic cameras fold closed for more convenient carrying. In order to make collapsible cameras, Kodak's engineers developed injection-molded silicone rubber bellows. The bellows not only permits the camera to fold and reduces the weight, but allows a direct light path to pass from subject to film. The result is a sharper image, since the picture is not created by a series of mirror reflections as in the Colorburst cameras.

Advanced electronics were involved in creating the Kodamatics' ability to achieve evenly lighted pictures every time. Each camera is enhanced by a flash system which is made to fire whenever a picture is taken. The flash unit relies on a thyristor circuit to conserve battery energy and permit fast recycling and immediate readiness upon opening the camera. Exposure is controlled by the camera's photocells, which measure the light falling on the subject. When enough light has fallen on the film to ensure a well-exposed picture, the camera's two integrated circuits alert the thyristor circuit to stop a capacitor from sending more electrical energy.

The Kodamatic 980L is Eastman Kodak Company's top-of-the-line model for use with Kodamatic Instant Color film. It is a fully automatic camera with automatic flash, exposure control, and a unique focusing system that permits focus as close as three feet (1 m). As the shutter release is pressed, a tiny electronic preflash is emitted through an infrared filter which gives off a violet glow. The beam bounces off the subject and into the range detector at the lower left of the camera. In less than ten milliseconds, the light is analyzed and one of three focus positions of the lens is automatically selected, along with the correct aperture setting.

The flash automatically fires every time, either to illuminate scenes which are too dim or to fill in shadow areas.

Shutter release — Infrared filter — Preflash — Preflash capacitor — Integrated circuit (1) — Ambient light — Aperture blade — Integrated circuit (2) — Light from preflash — Range detector — Infrared filter

This illustration shows the functions that are activated in the Kodamatic 980L as the shutter release is depressed.

Basic Cameras

Other models in the line include the 960 and the 970L, which differ mainly in focusing capability. The 960 offers a fixed focus lens that renders subjects in sharp focus from four feet (1.2 m) to infinity; the 970L has the same fixed focus lens from four feet (1.2 m) to infinity but also provides a closeup lens which focuses two to four feet (56 cm to 1.2 m) and is used much like the Colorburst 350 closeup feature (see p. 209).

Camera Specs

✓ 100mm plastic lens

✓ Automatic flash with a range from 3 to 14 feet (1 to 4.2 m)

✓ Lighten/darken exposure control ± one stop

✓ Viewfinder viewing

✓ Variable shutter from 1/4 second to 1/150 second

✓ Variable aperture of f/11, f/16, f/27

✓ Uses four AA-size alkaline batteries

✓ Low-light indicator

Neck-strap connectors · Shutter release · Film exit slot · Preflash infrared for focusing · Flash · electronic flash · Kodamatic 980L INSTANT CAMERA · Viewfinder window · auto-focus · Bellows · Infrared filter/range detector · Lens · Light sensors

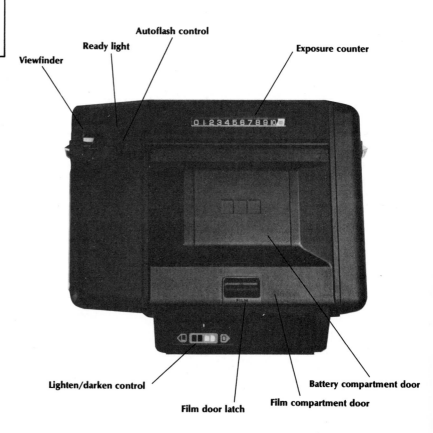

Viewfinder · Ready light · Autoflash control · Exposure counter · 0 1 2 3 4 5 6 7 8 8 10 · Lighten/darken control · Film door latch · Film compartment door · Battery compartment door

To Insert Batteries

Grasp the sides of the battery compartment door, slide it toward the left and lift. Place four fresh AA-size batteries on top of the battery strap. Match the proper positioning as indicated by the diagram inside. Close the door securely.

To Open

Unfold the camera by grasping the bottom of the camera and pushing the bellows into its locked position. Avoid touching the lens window. In the open position, the camera's autoflash control will be automatically activated and a blinking light will indicate that the flash is fully charged. The blinking light does not drain the batteries. In fact, if no picture is taken within a period of time, the flash automatically shuts off. You can turn it back on by pressing the autoflash control downward toward "reset" or by closing and opening the camera.

To Load

Holding the film pack by its edges, carefully remove the protective film wrapping. After sliding the film compartment latch up to open the film door, insert the film pack so that the blue stripe on the pack is aligned with the stripe on the camera. Close the film door and slide the latch down to its locking position. The film counter reveals the symbol ⊡. To ready the camera for the first picture, remove the black film cover by depressing the shutter button fully and releasing. The film cover automatically ejects through the film exit slot at the top. Discard it. The film counter will read 10.

Correct Holding

Hold the camera firmly, grasping it on each side. Keep the viewfinder against your eye so that all four corners of the frame are clearly visible. Keep the camera very steady as you gently press downward on the shutter release button with your index finger. For horizontal pictures, keep the camera level. For vertical pictures, turn the camera so the shutter release is on the bottom. When the print ejects at the top of the camera, remove it before shooting the next picture.

To Close

Place your thumb on the circular indication on the bellows and close the camera.

Basic Cameras

NONFOLDING CAMERAS FOR KODAK INSTANT COLOR PRINT FILM: COLORBURST 350

The Colorburst 350 is Eastman Kodak's top Colorburst instant camera. It is non-collapsible, provides a closeup feature that focuses to two feet (56 cm), and has a built-in flash. It is not substantially different from the Kodak EK–6—one of Kodak's earliest instant models—but offers additional features and improvements. Compatible models are Kodak's EK–6 and Colorburst 250.

Inside the camera's metal frame and glass-fiber-reinforced plastic body is a complex system of optics and electronics. When the shutter button is pressed, light enters the lens and is automatically measured and controlled to ensure proper exposure. The film is then transported through developer rollers to begin picture processing outside the camera.

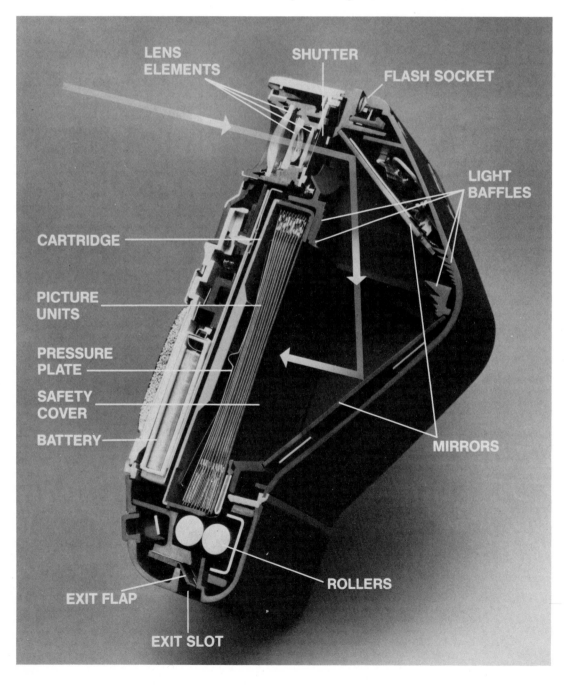

The inside of the Kodak instant camera, illustrating the light path and various internal parts for containing and ejecting film.

Light enters the lens of the camera, bounces off two angled mirrors, and is directed onto the back of a sheet of Kodak film. The exposure is made through the back of the film, opposite the finished image surface. The light is measured and controlled by an automatic exposure device consisting of an integrated circuit chip that is automatically activated when the shutter button is pressed. On the chip is a silicon photosensor that reads reflected light from the scene and controls the lens opening and shutter time for correct exposure according to the brightness of the subject. For instance, if the scene is bright, a lens opening of f/20 is chosen with a fast shutter speed of 1/300 of a second. If the scene is dim, f/12.8 is used along with as long as a two-second shutter speed. A single electro-magnet controls the shutter blade and lens diaphragm movements.

When the photographer releases the shutter button, the exposed film is advanced by a motor, turning a gear-driven, single-revolution clutch and cam, and pressed through two rollers. The rollers break an activator pod to start the processing and propel the print out of the camera, where the picture completes its development.

The integrated circuit that receives the exposure data also responds to the lighten/darken device, giving the photographer manual exposure control for special lighting situations. In addition, the circuit chip computes battery condition and activates the low-light signal indicating the need to use flash.

The focusing system in the Colorburst 350 consists of two fixed focus lenses. The normal 100mm, three-element lens, regularly in position, records subjects in sharp focus from four feet (1.2 m) to infinity. A 0.50 diopter closeup lens can be locked into place by sliding a switch to provide close-focus capability from two feet (56 cm) to four feet (1.2 m).

An integral top-mounted flash unit automatically adjusts for the proper flash output when either lens is in position. The built-in electronic flash's special circuitry allows light output up to a ten-foot (3 m) range, and recycles in ten seconds with fresh batteries.

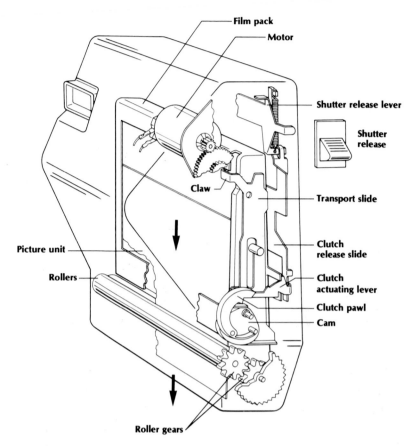

The motorized film transport mechanism.

Basic Cameras

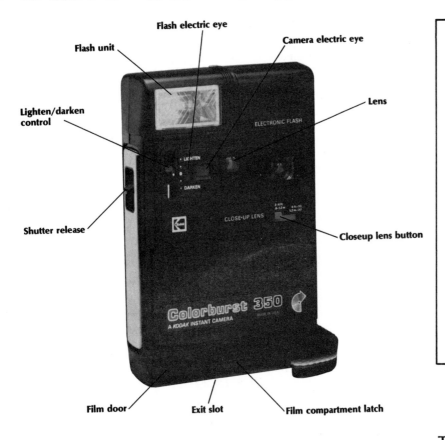

Flash electric eye

Flash unit

Camera electric eye

Lighten/darken control

Lens

Shutter release

Closeup lens button

Film door

Exit slot

Film compartment latch

Camera Specs

✓ 100mm, f/12.8 lens

✓ Built-in 0.50 diopter closeup lens focusing to 2 feet (56 cm)

✓ Built-in flash with a range of 2 to 10 feet (56 cm to 3 m)

✓ Lighten/darken exposure control ± one stop

✓ Viewfinder viewing

✓ Variable shutter from 1/300 to 2 seconds

✓ Variable aperture of f/20 or f/12.8

✓ Uses four AA-size batteries (either alkaline or rechargeable nickel-cadmium)

✓ Built-in low-light indicator

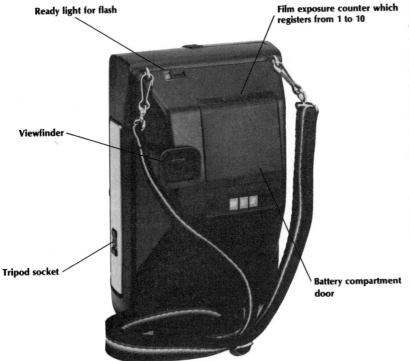

Ready light for flash

Film exposure counter which registers from 1 to 10

Viewfinder

Tripod socket

Battery compartment door

To Insert Batteries

Pull downward on the battery compartment door at the back of the camera. Insert four AA batteries as indicated by the diagram inside the compartment, making sure that the battery strap is left underneath batteries for later removal. Close door and press until it snaps securely. (*Note:* With four fresh alkaline batteries, the flash recycles for the next picture in about ten seconds and provides about one hundred flashes. However, as batteries weaken, recycle time and maximum flash distance of ten feet [3 m] diminish. With four rechargeable nickel-cadmium batteries, flash recycles in only seven seconds, provides about forty flashes, and has a slightly shorter maximum flash range of nine feet [2.7 m].)

To Load

Holding the film pack by its edges, remove the protective film wrapping carefully. Pull the paper flap in the indicated direction.

After pressing the film compartment latch to open the film door, insert the film pack so that the orange stripe on the pack is aligned with the orange stripe on the camera.

Close the film door and latch securely. The film counter reveals the symbol ⊙. To ready the camera for the first picture, remove the black film cover by depressing the shutter button fully and releasing. The film cover automatically ejects through the film exit slot. Discard it. The film counter will read 1.

Correct Holding

Hold the camera firmly, keeping fingers clear of the lens, viewfinder, and film exit slot. Elbows should be closely tucked against the body for maximum support. The viewfinder eyecup should rest against your eye so that all four corners of the frame are clearly visible. Keep the camera very steady as you gently squeeze downward on the shutter release button with your index finger.

(*Note:* If a red light flashes in the viewfinder as you partially depress the shutter, the camera is indicating that the light is too dim to provide a good picture. The flash should be turned on. Refer to "Exposure" in the text section of "The Tools" for more information.) When the button is released, the print is ejected from the camera. Handle the developing picture carefully by its edges.

For vertical pictures, grasp the camera firmly in the normal fashion, then turn 90 degrees in a clockwise direction. Keep your left elbow close to your body for extra support to avoid camera movement.

To Take Closeups

For subjects positioned between two and four feet (56 cm and 1.2 m) from the camera, slide the blue closeup button to the right until it clicks into place. Then operate the camera normally. After the picture is taken, the closeup control automatically returns to the normal position. If the next subject requires a closeup, reset the closeup button.

To Use Flash

When a red light appears in the viewfinder indicating too little light for proper exposure, slide the built-in electronic flash to the right until it clicks into place (Figure 1). Wait for the ready light to blink at the back of the camera, indicating that the flash is fully charged. (Refer to "Exposure" in the text section on "The Tools" for more details on taking flash pictures.)

To Remove Empty Film Pack

When the film pack is completely used, the exposure counter reads 0. Open the film compartment door and pull the film pack extractor to remove the empty pack (Figure 2).

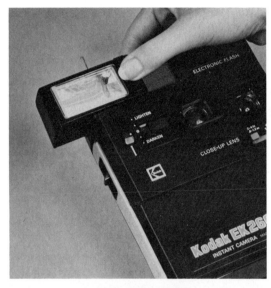

Figure 1.

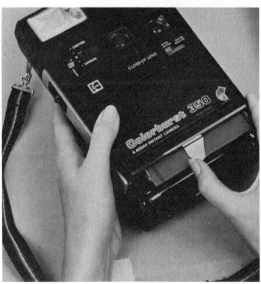

Figure 2.

Basic Cameras

FOLDING SINGLE-LENS-REFLEX CAMERAS FOR POLAROID SX–70 TIME-ZERO FILM: POLAROID SX–70 LAND CAMERA

The unique feature of the SX–70, setting it apart from any other instant camera, is its single-lens-reflex (SLR) system and its capacity to fold flat. SLR refers to the viewing system, which is the most advanced of any instant camera. Unlike most instants, which have a separate viewing lens, the SLR camera has only one lens which, through an arrangement of mirrors and optics, projects the exact image framed by the lens into the viewfinder. Thus the photographer sees precisely what the camera sees and can very accurately compose the picture.

To accomplish this innovative design, Polaroid evolved a complex system of aspheric optics and mirrors. Light enters the camera's lens and is reflected by a viewing mirror down onto a Fresnel mirror which sends the beam back to the viewing mirror, through the viewfinder opening, to the aspheric viewfinder mirror which reflects the light through the viewfinder lens to the eye (as shown in the illustration).

When the electronic shutter button is pressed to make the exposure, several functions occur. The shutter, opened for viewing, closes. The motor drives the viewing mirror up against the back of the camera and in doing so reveals the "taking" mirror on its reverse side. The shutter opens to take the picture. The light passes through the camera lens and is reflected from the taking mirror to the film, while the electric eye measures the light and directs the shutter to close at the proper moment for correct exposure. Finally, the motor turns gears to move the exposed film through the rollers, breaking the developer pod of chemicals to begin development and expelling the

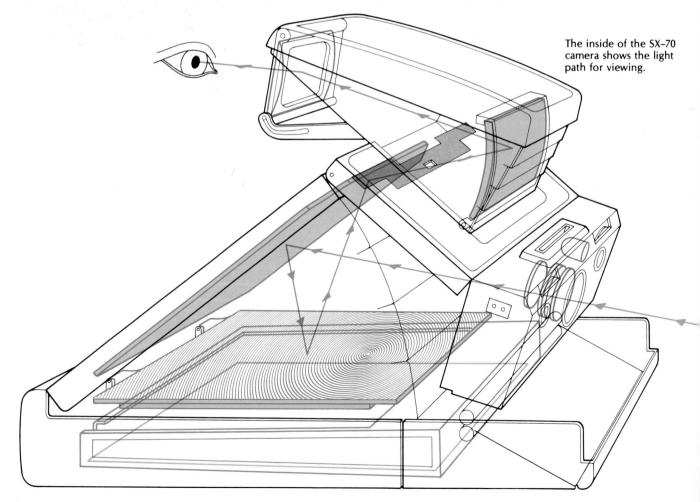

The inside of the SX–70 camera shows the light path for viewing.

picture from the camera. The motor simultaneously lowers the taking mirror to replace the viewing mirror in preparation for the next picture.

The automatic exposure system is governed by a photodiode for available-light situations. The lens opening and shutter speed are controlled by the movement of two blades, with variations of lens openings from f/8 to f/70 or more and shutter speeds from 14 seconds to 1/180 of a second. For flash situations, the lens opening is set according to the focusing distance.

The 116mm lens is capable of close focusing to 10.4 inches (25 cm), the closest distance obtainable with any instant camera without accessories.

The power for all the camera's motor operation and electronic functions is derived from a unique six-volt planar Polapulse battery integrated into every SX–70 Time-Zero film pack.

Sleek and compact, Polaroid's SX–70 Land Camera incorporates highly sophisticated technology into a body that is handy to carry and simple to operate. The basic guidelines for using the Polaroid SX–70 Land Camera can be applied to all folding models.

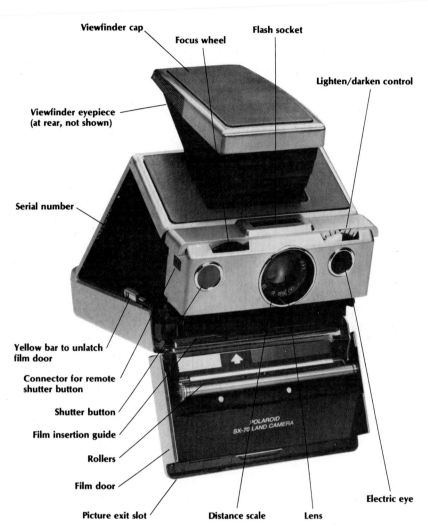

Camera Specs

- ✓ Through-the-lens viewing
- ✓ Automatic exposure control
- ✓ Focus from 10.4 inches (25 cm) to infinity
- ✓ Four-element, 116mm glass lens
- ✓ Variable aperture from f/8 to f/74
- ✓ Variable shutter from 1/180 to 14 seconds
- ✓ 1.5 seconds to eject a picture
- ✓ Built-in low-light indicator (a red light flashes)
- ✓ Lighten/darken exposure control
- ✓ Powered by a high-energy battery contained in each film pack
- ✓ Flash range between 10-1/2 inches (25 cm) and 20 feet (6 m)

Basic Cameras

To Open

Hold the camera firmly in your left hand. Your fingers should tightly grasp the metal sides. Hold the small, grooved end of the viewfinder cap with the index finger and thumb of your right hand and pull upward.

Continue to pull upward until the cover support (arrow) is perpendicular to the metal base and locks securely, keeping the camera in the open position (Figure 3).

To close the camera, unlock the cover support by pressing it in the direction of the arrow printed on its side, which will be toward the back of the camera. Then press down on the viewfinder cap until the camera latches on both sides.

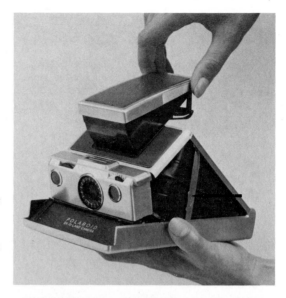

Figure 3.

To Load

To insert film into your camera, press downward on the yellow bar at the right side of the camera. The film door should open automatically. If it does not, a light touch on the side of the film door should release it. Never use force (Figure 4).

Hold the film pack by its edges, being careful not to put any pressure on the middle of the pack, which can cause damage to the film. The cardboard cover sheet is color coded with a large strip of blue, then a white arrow in a black field, and a small patch of yellow. The camera has the same codings on the ridge below the film compartment to show you exactly how to insert the film pack. Push the pack all the way in until a thin strip of plastic at the end of the pack snaps open.

Close the film door. The camera will automatically eject the protective cardboard covering. Be sure to keep fingers out of the path of the exit slot. The film counter will now register 10, and you can take the first picture.

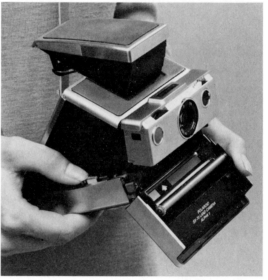

Figure 4.

Correct Holding

Support the camera by holding it firmly in the palm of your left hand. Be sure your fingers clutch only the metal sides and not the soft rubbery center area or you'll interfere with the camera's inner workings and inadvertently blur your pictures. Curl your right hand into a fist except for the index and thumb fingers, which should form a pinching grip. The thumb rests against the indicated space ◖ behind the shutter housing (Figure 5).

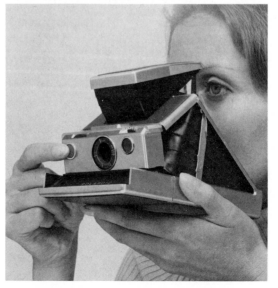

Figure 5.

The index finger is in position to press the shutter button. Keep other fingers away from the front of the camera to avoid blocking the film exit slot.

Keep arms tucked close to the body. Squeeze the shutter button gently. Do not jab at it or your pictures will be fuzzy. If a red light appears in the viewfinder as you partially depress the shutter, the camera is indicating that the scene is too dim to produce a properly exposed picture (see "Exposure" in the text section on "The Tools" for how to compensate).

To Focus

Position your eye about one inch (2 cm) from the viewfinder eyepiece. You should be able to see all four edges of the viewfinder frame. If you can't, move the camera slightly until you do. Use your index finger to turn the focusing wheel until the image looks sharp. Roll the wheel very slightly back and forth until you are certain that your main subject is as sharp as possible. You can see in the viewfinder precisely what is in focus. However, there is one exception. On very bright days with the camera focused on an object fifteen feet (4.5 m) away, everything from about eight feet (2.4 m) to infinity will be in focus but the viewfinder image may not show this wide focusing field.

Split Circle Aid. Some SX–70 models provide an aid to focusing in the form of a split circle in the center of the viewfinder. To use, place the split circle over a vertical line on your subject and align the vertical. Turn the focusing wheel until the line is solid, at which point the subject will be in proper focus. Once the subject is sharp, you can reframe your picture for the best composition, but do not change your distance from the subject or you will need to refocus.

Sonar Autofocus. Most SX–70 models have an autofocus feature that permits the viewer to point the camera at the subject, press the shutter button, and get a properly focused picture automatically. These cameras use a sonar device that emits sound waves that travel to the subject and echo back into a tiny electronic computer in the camera. The distance is calculated by the computer, which measures the speed at which the sound travels to the subject and back to the camera. The computer then signals a motor to move the lens to the correct setting. This occurs in less than one-third of a second. To use, bring the camera to your eye and slightly depress the red shutter button, which will allow you to preview your image and compose. Do not put too much pressure on the button at this point or you will release a picture prematurely. You will be able to see what objects are in focus and what is out of the range of the camera. When you are ready to take the picture, squeeze the button the rest of the way. Be sure to keep the camera steady.

Manual Focus. Certain subjects pose problems for the sonar autofocusing device. For instance, you cannot shoot through glass, since the sonar will bounce off the glass surface and focus on it rather than on the subject beyond it. In such situations you will need to disengage the autofocus feature and set the camera on manual focus.

To do so, push the bottom edge of the focus switch (the lever just above the focus wheel) until it clicks down. A red line appears at the top of the switch, indicating that you have disengaged the sonar mechanism. Use your index finger to turn the focus wheel until the image appears sharp in your viewfinder. To reactivate the sonar device, press the top of the switch back into its original position.

The Distance Scale. In dim lighting or in other situations where focusing may be difficult, you can use the distance scale on the lens as an aid to focusing on all SX–70 cameras. (With the SX–70 autofocusing cameras, you can use this technique in the manual setting only.)

Estimate the distance from subject to camera and turn the focus wheel until the line alongside that approximate distance is aligned with the mark on the lens housing. In the illustration, the lens is set on a subject five feet away. Notice how the line next to the number is aligned with the line on the lens housing.

Basic Cameras

Selective Focus

In some circumstances, you might want to use selective focus. Let's say you want the near object in focus and the middle-range objects blurred. You would think the only way to accomplish this would be to position the near object in the center of the frame to get it in proper focus. This is true for focusing, but you need not take the picture at that point.

To use selective focus, place the object you want sharply focused in the center of the frame where the sonar device focuses accurately. Press the shutter partway to engage the sonar unit so that focus has been achieved (as you can see in the illustration, focus is on the cheese and crackers).

Keeping your finger pressed very lightly on the button, you can maintain that focus and shift the camera slightly to recompose the picture for a more balanced composition. In this example, the cheese and crackers have maintained their focus, while the distant objects—the wine glass, bottle, and potted plant—are included but as blurry, less-important elements in the composition.

Handling the Film

After you press the button, the developing picture is ejected from the film exit slot. Remove it by handling the white borders carefully. Do not bend or squeeze the picture or development can be affected adversely.

Accessories

Remote Shutter Button

The remote shutter button plugs into the two-pronged socket on the right side of camera and is used in place of pressing the shutter release. It is often used to prevent camera shake when the camera is mounted on a tripod.

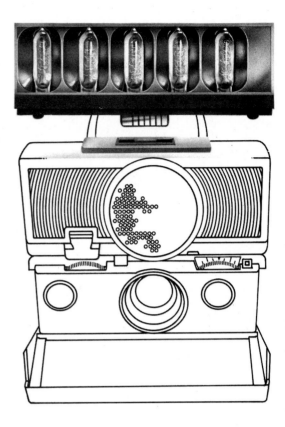

Self-Timer

The unit slides into place over the existing shutter button, fitting into the two prongs on the right side of the camera. The unit's dial is then turned toward the left, the red button is pressed, and fifteen seconds later the picture is taken. The self-timer is great for self-portraits or group shots that include the photographer.

FlashBar

Individual FlashBars, good for ten flashes each, are available for the SX–70. (Also for the Pronto, and OneStep cameras.)

Polaroid SX–70 Tele/1.5 Lens

The Polaroid SX–70 Tele Lens snaps onto the front of the camera and enlarges the subject by fifty percent. It is useful for bringing distant subjects closer, for a change in perspective, and for portraits.

Without Tele Lens.

With Tele Lens.

Basic Cameras

Polatronic Electronic Flash

To assemble, slide the flash bracket onto the bottom of the flash unit. Then place the camera bracket onto the bottom of the camera, tightening the screw into the camera's tripod mount. Insert the flash bracket into the camera bracket and lock the lever. Plug flash cord into the slit at the top of the camera.

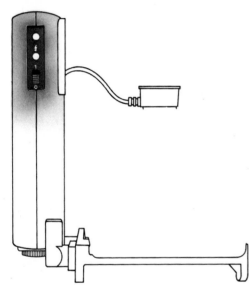

To use, turn switch to "On" and wait for green ready light, which should take less than ten seconds to appear. (If it takes longer than thirty seconds, replace batteries.) Press test button only if you want to see if flash is firing or to judge recharge time.

Flash Director

Use flash director for closeups with flash on the SX-70 camera—from 10.4 inches (25 cm) to 2 feet (56 cm). Slide over the front of the flash unit to diffuse light for more even illumination.

CU-70 Closeup System

A highly sophisticated accessory for folding SX-70 Land Cameras, the CU-70 Photographic System is used for enlarging subjects up to three times life-size. To use the system, you must choose the lens assembly of desired magnification (the unit is equipped with three lenses—for 1×, 2×, and 3× magnification), along with a corresponding frame which places the camera at the correct distance from the subject and outlines the area included in the photograph. A Polatronic Flash is attached first. (See "Still Life" for an example of a picture taken with the CU-70 Closeup System.)

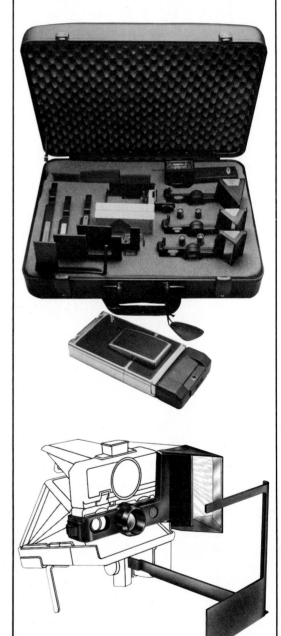

NONFOLDING CAMERAS FOR POLAROID SX–70 TIME-ZERO FILM: POLAROID TIME-ZERO ONESTEP LAND CAMERA

Polaroid's OneStep is the most popular and simplest to use of all the cameras in the Polaroid line. It requires no focusing and renders sharp pictures of subjects from four feet (1.2 m) to infinity. Noncollapsible, the OneStep is ready for picture-taking at any instant. The photographer merely frames the subject and presses the shutter button. The Model 1000 and Button cameras are similar to the OneStep. All nonfolding cameras have a viewfinder viewing system in which the lens taking the picture is separate from the lens used to view and frame the picture. Thus there is a slight difference between the final picture and the composition as seen in the viewfinder.

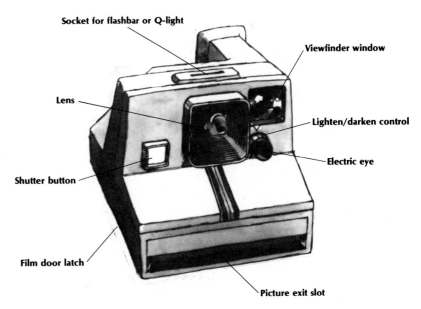

Socket for flashbar or Q-light
Viewfinder window
Lens
Lighten/darken control
Electric eye
Shutter button
Film door latch
Picture exit slot

Camera Specs

✓ 103mm f/14.6 lens, prefocused from 4 feet (1.2 m) to infinity

✓ Automatic exposure control

✓ Variable shutter from 1/125 to 1 second

✓ Fixed aperture at f/18 (at f/14 in flash mode)

✓ Slot for Pronto! tripod mount

✓ Lighten/darken exposure control

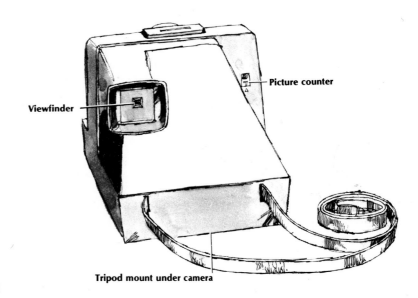

Picture counter
Viewfinder
Tripod mount under camera

To Load

To put film in, press forward on the film door latch until the film door drops open. If the film door sticks, apply very light pressure downward, holding the sides of the film door. Never use force.

Hold the film pack by its edges. Do not put any pressure on the middle of the pack or you may cause damage to the film. The cardboard cover sheet is color coded to correspond to the markings below the film compartment indicating proper loading. Push the pack all the way in. Close the film door. The camera will automatically eject the

Basic Cameras

protective cover to be ready for the first picture. Be sure to keep fingers clear of the exit slot. The film counter will now register 10.

Correct Holding

Unlike the palm-under-camera position recommended for both SX–70 Land cameras and popular 35mm single-lens reflexes, the OneStep is best supported by holding the camera as shown (Figure 6). Clutch firmly on the left side, with fingers clasped over the viewfinder housing and your thumb resting underneath the camera for support. Position the index finger of your right hand on the shutter button, the thumb below the picture counter. Keep the rest of the fingers curled and out of the way of the film exit slot.

Figure 6.

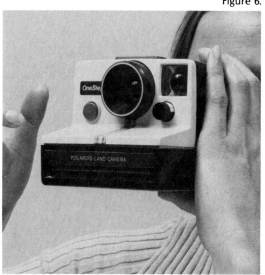

To Take the Picture

Position your eye close to the viewfinder eyepiece. You should be able to see all four edges of the viewfinder frame. Keep arms tucked close to the body. Squeeze the shutter button gently. Keep fingers out of the path of the film exit slot. When the developing picture is ejected, handle it carefully by the white borders until development is completed.

To minimize camera shake if light on the scene is not bright, look for stationary objects to lean on for extra support.

Subjects positioned from four feet (1.2 m) to infinity are all sharply recorded by the OneStep's prefocused lens.

Accessories

FlashBar
See under Polaroid SX–70 Land Camera.

Self-Timer
The self-timer snaps over the shutter button. Turn the dial until it stops. Press the red button at the rear of the unit; fifteen seconds later the shutter is activated, and the picture is taken.

Cable Release
The cable release is plugged into the two prongs on the side of the OneStep self-timer. It is used instead of pressing the regular shutter button for a smoother, gentler shutter release.

Tripod Mount
The tripod mount fits onto the bottom of the OneStep so that a standard tripod can be used.

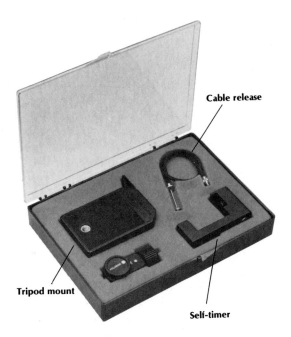

Cable release

Tripod mount

Self-timer

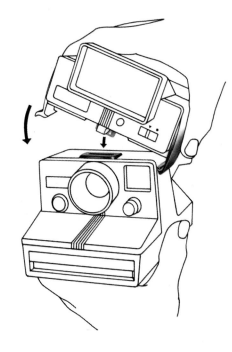

Polaroid Q-Light
To snap the Polaroid Q-light onto the camera, place the left locking tab over the ridge on one side of the camera. Slip the blade into the FlashBar socket, and latch the other locking tab in place. (Lift out and up on one tab to release.) To operate, turn power switch to "On" and wait for ready light. To test flash, press ready light; flash should fire. The lighten/darken control can be used in difficult lighting situations.

SUN CAMERAS FOR POLAROID 600 FILM: <u>POLAROID 660 AUTOFOCUS INSTANT LAND CAMERA</u>

The 660 is a fully integrated electronic strobe camera with light-managing capability blending available light with strobe light to achieve well-exposed pictures in any lighting situation indoors or out. Combining electronics, optics, photographic film, and improved battery technology, the inter-active system manipulates digitized information received and stored in its electronic network to make as many as forty-two function decisions in milliseconds. Pressing the shutter button initiates a sequence of operations activating light measurement, sonar focusing, exposure computations, and ejection of the print.

The electronic intelligence is accomplished by a photocell which detects and samples incoming ambient light as the shutter blades begin to open to make the exposure. The presampling is instantaneously evaluated and the light measured to determine the appropriate flash mode for dim or bright light. Outdoors in daylight, when ambient light levels are brightest, the light-blending facility balances 75 percent ambient illumination with 25 percent strobe fill light. As the ambient light level dims, the camera automatically increases the percentage of light added by the strobe. In extremely low light, the strobe is signaled to operate in full-flash mode. The same electronic chip—the system consists of six chips in all—that monitors the light and calculates the needed fill-strobe light also directs the shutter to close at the correct moment.

The electronic circuitry storing camera-to-subject distance—determined by the sonar ultrasonic ranging device—also controls the focus position of a four-lens disc located behind the 660's 109mm lens to create a double-element lens for each of four focus positions: 2 to 3.5 feet (56 cm to 1 m); 3.5 to 5.5 feet (1 to 1.7 m); 5.5 to 13 feet (1.7 to 3.9 m); and 13 feet (3.9 m) to infinity. The precise distance is stored in the electronic memory and used to calculate the proper lens opening ranging from f/10 to more than f/32.

Top of the line in the 600 series, the 660 Autofocus is the "everything" instant camera with autofocus, autoexposure, and light-blending operations. Pictures taken with the 660 have a natural look, as if illuminated by sunlight; hence the name Sun Camera. Polaroid 600 film, combining innovative film and battery electrochemical and mechanical sciences, is used with this system. Other current models in the 600 line are the Sun 640, the Sun 650, and the Amigo 620.

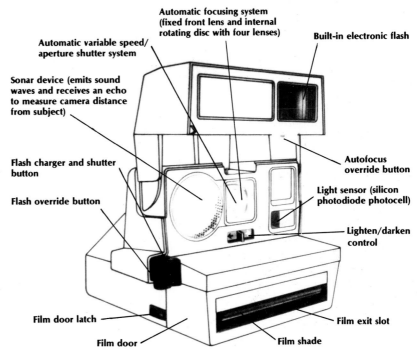

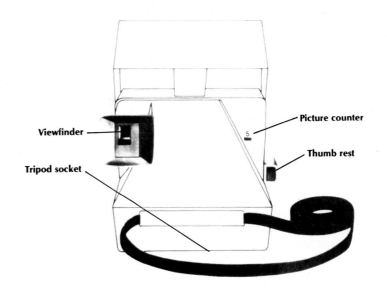

Basic Cameras

Camera Specs

✓ Fixed, 109mm front lens combined with a four-lens rotating disc to cover four focus zones: 2 to 3.5 feet (56 cm to 1 m); 3.5 to 5.5 feet (1 to 1.7 m); 5.5 to 13 feet (1.7 to 3.9 m); and 13 feet (3.9 m) to infinity.

✓ Autofocusing with the sonar echo-ranging system to as close as 2 feet (56 cm).

✓ Automatic electronic shutter system with speeds from 1/200 to 1/3 of a second calculated for optimization with automatic aperture and flash.

✓ Automatic aperture with a range from f/10 to f/45 without flash; with flash from f/10 [at maximum flash distance of 14 feet (4.2 m)] to f/52 [at minimum distance of 2 feet (56 cm)].

✓ Integral strobe for proportional fill flash in ambient light. Operates for all exposures unless manually turned off. Ranges from 2 to 14 feet (56 cm to 4.2 m) with a five-second recharge. Follow-focus method of flash exposure (distance measured is stored in electronic memory and used to calculate aperture).

✓ Silicon photodiode receptor determines balance of light for proper illumination and signals for flash to fire for full flash or partial fill flash depending on a subject's lighting.

✓ Lighten/darken control varies exposure ±3/4 stop

✓ Tripod socket

✓ A 6-volt, high-energy battery is contained in each film pack to power the camera and electronic flash.

To Open

To ready camera for operation, raise the electronic flash unit by grasping the sides and swinging up until it clicks into position (Figure 7). The lens and other camera mechanisms are now revealed.

To Load

To insert film, press forward on the film door release latch until the door swings open. Hold the film carefully by its edges, being careful not to put any pressure on the middle of the pack. The cardboard cover sheet should face upward. It is color coded to show you exactly how to insert the pack into the film compartment. Push the pack all the way into the camera. Close the film door. The camera automatically ejects the protective cardboard covering. The film counter will now register 10, and you are ready to take the first picture.

Correct Holding

The 660 camera is best supported with a grip similar to that used for Polaroid's nonfolding cameras. Clutch firmly on the left side, with fingers of the left hand clasped over the viewfinder housing and your thumb fixed underneath the camera for support. The index finger of your right hand is positioned on the shutter button, your thumb placed on the thumb rest. Keep other fingers curled and out of the way of the film exit slot. Keep arms tucked close to the body.

To Take the Picture

Before the camera is ready for picture-taking the flash must be charged, since the camera functions with flash for light blending. Press the red button partially and hold until the red light in the viewfinder goes off, indicating that the flash is fully charged. Compose in the viewfinder, hold the camera steady, and gently press the red button the rest of the way. The camera automatically ejects the picture.

Figure 7.

To Focus Manually

Certain subjects, like glass, pose problems for the sonar autofocusing device. The sonar sound waves bounce off the glass surface and the focus is computed on it rather than on the intended subject beyond. To disengage the autofocus feature—and use the camera on manual focus—hold in the autofocus override button and press the flash override button to take the picture (Figure 8). (See below, "To Take Nonflash Pictures.") However, subjects must be more than 12 feet (3.7 m) away.

Autofocus override button

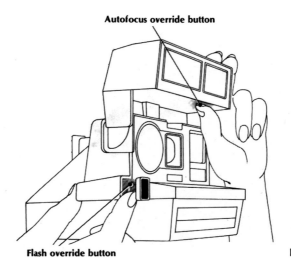

Flash override button

Figure 8.

To Take Nonflash Pictures

Fill-in flash is sometimes undesirable when you prefer a silhouette or the shadowy effect of underexposure. To stop the flash from firing, use the flash override button. Slip your index finger behind the shutter button and press back on the thin plastic lip when you're ready to take the picture.

Basic Cameras

POLAROID PACK FILM CAMERAS FOR POLAROID PEEL-APART FILM: POLAROID EE 100 LAND CAMERA

The EE 100 is among the most popular of the pack film cameras. It uses several types of Polaroid black-and-white and color films in rectangular and square formats, including Types 108, 88, 668 (professional) in color; Types 107, 87, 667 (professional) in black and white; and Type 665 in black and white (positive/negative). Peel-apart film may seem more cumbersome but is considerably more versatile when it comes to varying films from black and white to color or changing format size from square format to rectangular format. A special benefit is the availability of Polaroid's PN (positive/negative) film, which provides a usable negative (for making enlargements) in addition to a print. The EE 100 is collapsible, lightweight, and inexpensive. Some of the other pack cameras differ in that they are not collapsible and require cocking of the shutter to take a picture. The EE 100 is identical to the Reporter camera.

Camera Specs

- ✓ 114mm lens, prefocused from 3 feet (85 cm) to infinity
- ✓ Automatic exposure control
- ✓ Variable shutter from 1/500 to 1 second
- ✓ Fixed aperture at f/9 for color or black-and-white extended range, f/60 for black-and-white
- ✓ Extended range shutter
- ✓ Lighten/darken exposure control
- ✓ Tripod mount
- ✓ Flash range from 4 to 12 feet (1.2 to 3.6 m) with Hi-power cubes, 4 to 8 feet (1.2 to 2.4 m) with regular cubes

To Open

Depress the cover release in the top center of camera. Lower cover until side supports lock into the open position. To close, press back on both side supports and latch the cover securely.

To Load

Away from direct sunlight, open the camera back by unlatching the thin metal bar. Press forward on it.

Hold film pack by its edges and insert. Check that white tabs are not caught in any way as you close the camera back.

Latch the metal lock to secure the camera back in the closed position. The black film cover sheet should protrude. Remove it by pulling it straight out of the camera while holding the ring handle.

To Set the Controls

Set the film selector according to the setting indicated on the film's instruction sheet. Type 88, for instance, should be set at 75 (color), Type 107 at 3000 (black and white); 3000 ER is used for Type 87 or Type 107 in existing, low-light situations.

Calculate the distance from subject and set distance scale accordingly. Simply turn the ring surrounding the lens until the appropriate distance is beneath the arrow symbol.

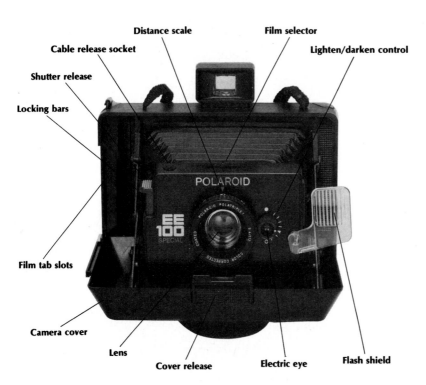

Distance scale · Film selector · Cable release socket · Lighten/darken control · Shutter release · Locking bars · Film tab slots · Camera cover · Lens · Cover release · Electric eye · Flash shield

Correct Holding

Hold the side of the camera firmly with your left hand. Position your right index finger on the shutter release button; your right thumb should rest beneath the camera for support. Arms should be tucked close to the body.

Proper Framing

The camera's viewfinder has a white rectangular frame with two notches toward the right side. All four corners of the frame should be visible so that you can use them as framing guides. If you have trouble seeing any corner, move the camera slightly until you do. The two notches are for square-format framing when you are using Types 88 and 87 film.

Frame for rectangular format.　　Frame for square format.

To Take the Picture

Keep the camera steady and press the shutter release. Hold it down until you hear a second click, indicating that the picture has been taken. Hold the ring handle as you did to remove the film cover sheet and pull the white tab completely out of the camera. A yellow tab with arrows will appear. Pull slowly and evenly on the yellow tab until the film is removed completely. Begin timing development (the specific time is indicated on the film instruction sheet).

After development time has elapsed, peel the print away from the negative, beginning at the yellow tab. Unless using positive/negative film, throw away the negative. Coat the print at this point if indicated for your film type.

Battery Check and Change

To check the battery, remove any film and set the film selector to 75. Cover the electric eye with your hand and aim the camera at a bright light. Depress and hold the shutter release. You should hear a click. Uncover the electric eye. If you hear another click, the batteries are good. If not, change to fresh batteries. To do so, open the camera back. Pull down on the plastic bar holding batteries in place at the bottom. Remove old batteries and insert new ones as shown on the battery compartment. Then close the plastic finger grip.

Accessories

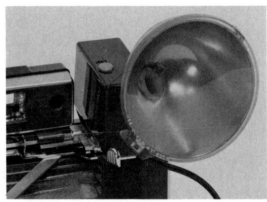

Flashgun
For 100, 200, and 300 series cameras, use flashgun with M-3 clear bulbs.

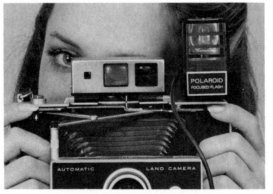

Focused Flash Unit
For use on 400 series cameras, the focused flash uses Hi-Power or flash cubes. Rotate the cube after each shot by pushing the lever on the unit.

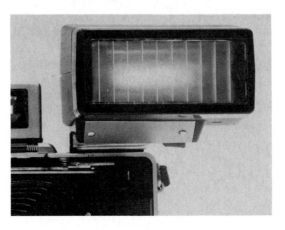

Electronic Flash Unit
For the Model 360 camera only, the electronic flash must be turned on and the ready light must be blinking before you take each picture.

Film Technology

This section provides an in-depth overview of the newest integral-type color instant films and how they work. In reading the material, do not worry about understanding all the technical jargon but simply try to get a sense of film characteristics and the amazing chemical reactions that occur each time an instant picture is taken.

The earliest instant film to come into existence was Polaroid's roll film, which produced a sepia-toned print. It was a one-step dry process that transferred a developing negative to an image-receiving sheet. A reagent, which included both a silver halide solvent and a developing agent, was used to form a positive, silver image suitable for viewing. The two sheets were sandwiched together, with a pod at one end containing the reagent. After the exposure was made, the sheets were pressed through rollers, breaking the pod and spreading the reagent evenly to begin development. After a specified processing time, the sheets were peeled apart. The later developments of Polaroid black-and-white peel-apart pack film, and color peel-apart pack film—available currently—are also based on this early one-step transfer process.

Little more than a decade ago, Polaroid introduced an entirely new concept in film chemistry, a self-processing instant color print film capable of full development outside of the camera in ambient light. Referred to by Dr. Land as "absolute one-step photography," this integral film—the first SX–70 film—revolutionized instant photography.

Today a variety of black-and-white and color peel-apart films are available from Polaroid. In addition, several major integral color print films are being marketed by Polaroid, Eastman Kodak, and Fuji Photo Film. These represent the most sophisticated innovations in film technology. While differences exist among the integral systems, they basically use a film sandwich of sensitized emulsions and chemicals, exposed by an image passing through a cover sheet.

INTEGRAL COLOR PRINT FILM

The miracle of the integral color print film is that the picture is developed fully outside of the camera with processing contained within the print's own ejected package in a kind of instant darkroom. The developing picture is unaffected by light, and its emergence is clearly visible.

In order to understand the process, you must first grasp the basic principle of subtractive color. Primary subtractive colors (cyan, magenta, and yellow) are formed by subtracting one of three primary additive colors (red, green, and blue) from white light. For magenta to be produced from white light, green has to be removed. A magenta dye allows only blue and red light to pass through and blocks—or removes—green. A yellow dye holds back blue and allows red and green to pass through to form yellow. Integral film is composed of three layers of light-sensitive emulsions; one records the blue content of the scene, another the green content, another the red content.

The second basic principle is the reversal process in which unexposed grains of silver halide in the three emulsion layers (red, blue, and green) of the film are developed by complementary-colored dyes to produce the final image. The film unit consists of three color-sensitized silver halide layers, three dye developer layers, a negative base, an acid polymer layer, a timing layer, and an image-receiving layer that accepts the positive image, visible from above.

Light from the scene enters the film and exposes certain silver halide crystals within the appropriate color-sensitive layers, immobilizing specific dyes. The film is pressed through rollers as it ejects from the camera, and a pod containing a thin layer of developing reagent/activator is broken. A transparent plastic layer seals the picture from the top. The reagent/activator forms an opaque layer (which becomes the backing) to protect the negative layers from further light (this allows the picture to be processed in ambient light). The reagent/activator also permeates the negative layers to initiate the transfer process. The alkali of the reagent/activator releases the metallized dye developers positioned next to each complementary-color-sensitive silver halide layer: a yellow dye developer reacts next to a blue sensitive layer; a cyan dye is next to a red layer; a magenta next to green. The color dye and silver halide developing agent unite to effect a color transfer from negative

to positive. The unexposed silver halide crystals help determine which dye developers will migrate through the negative to the positive. If, for instance, the film is exposed only to red light, the yellow and magenta dye developers will transfer to the positive. The cyan dye will be halted in its migratory path to the image-receiving layer by the red-sensitive silver halide layer. As the alkali of the reagent/activator reaches the polymeric acid layer, the process is stabilized. As the dyes reach the image-receiving layer, the positive image is fixed and viewable.

The major difference between Polaroid and Kodak integral films is the exposure process. Polaroid's film is exposed through the top clear plastic layer: the light strikes the color-sensitive silver halide emulsion layers and a reagent activates the processing in which dyes migrate to the image-receiving layer to form the positive image. Kodak's film is exposed through the backing layer: activator fluid penetrates and develops the color-sensitive emulsion layers of the integral imaging receiver. The positive image appears on the side opposite where the light entered.

Another significant difference is in the film pack itself. Polaroid's film pack is equipped with a unique flat, high-power planar battery designed to power the camera's electronics. With each new pack of film, the camera is given a fresh battery. Kodak's camera is powered by four AA-size batteries inserted into the camera itself.

Kodak instant film during activator spreading. Notice how the exposure is made through the back of the Kodak film and processing passes through the layers to the top surface, the image-receiving layer, which becomes the viewing direction.

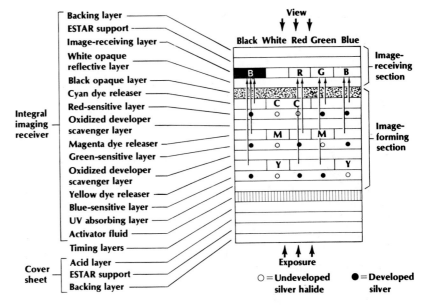

Polaroid SX–70 film during exposure. Notice the red light is transmitted through the plastic cover to the appropriate color-sensitive silver halide layer.

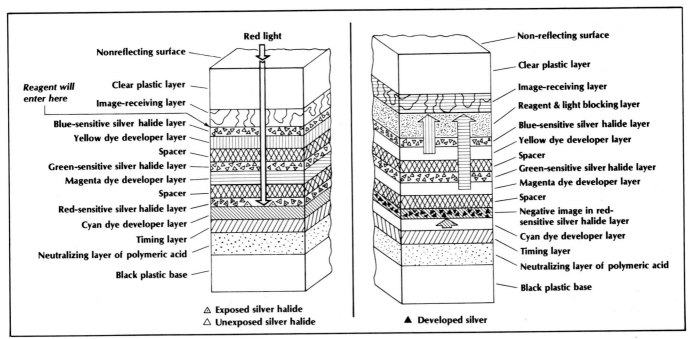

Polaroid SX–70 film during reagent spreading. Notice how the color dye layers are positioned below their complementary-color-sensitized layers. Processing migrates up through the layers, with dyes finally reaching the positive image-receiving layer. This cross-section shows exposure to red light only.

Professional Equipment

PROFESSIONAL CAMERAS AND ACCESSORIES

Many professional photographers, scientists, engineers, and industrial technicians have come to rely on instant materials for a multitude of purposes. Here is a compilation of the professional cameras, accessories, and films that are currently available.

Kodak Instant Film Back

The film back fits on the back of 4×5 press and view cameras and uses Kodak Instant Color Print film in its regular ten-exposure packs.

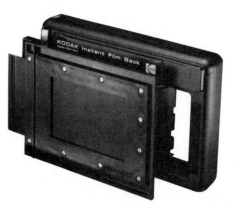

Polaroid 4×5 Land film Holder Model #545

The Polaroid back fits into a 4×5 press or view camera and uses Polaroid individual film packets.

Polaroid 4×5 Land Film Holder Model #550 (not pictured)

This is similar to the above film holder except that the pack film system uses eight-exposure 4×5 pack film and is especially suited for high-volume applications.

Polaroid CB-70 Camera Back

The CB-70 camera back is adaptable to a variety of scientific instruments and camera equipment by OEM (Original Equipment Manufacturers). The back is designed to use SX-70 color print film.

Film Back for 35mm Cameras: ProBack by Forscher

Professional Camera Repair in New York has produced a pack film back for the Nikon, Canon, Leicaflex, and other 35mm cameras. The device allows for two full-frame 24×36-mm exposures, side by side on Polaroid 3-1/4×4-1/4-inch (8.3×10.8 cm) pack film.

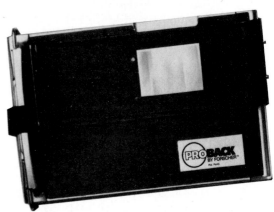

8×10 Land Photographic System

For use with 8×10 cameras and instrumentation, this system allows the user to make 8×10 color prints and overhead transparencies in instant picture format. The film holder fits most 8×10 cameras. The automatic processor provides processing of 8×10 prints and overhead transparencies.

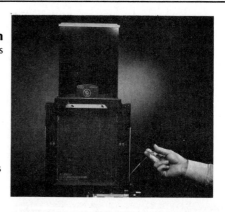

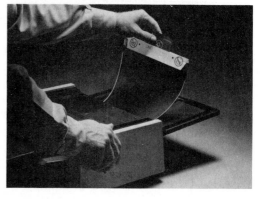



Polaroid 600 SE

This is a professional pack camera with interchangeable lenses. It accepts 3-1/4×4-1/4 (8.3×10.8 cm) film packs, including Type 665 black-and-white positive/negative film, Type 667 coaterless 3000 speed black-and-white film, and Type 668 Polacolor 2 Land print film.

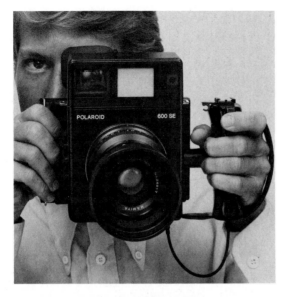

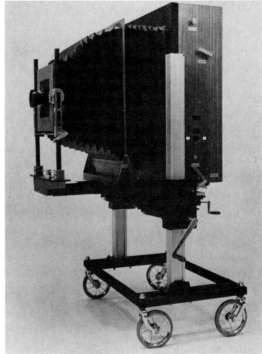

MP-4 Land Camera

A multifaceted unit for copying, photomacrography, and photomicrography, the MP-4 offers numerous optional additions such as variable focal length lenses, microscope adapter, and macro extensions.

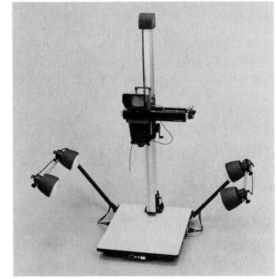

Polaroid 20×24 Land Camera

A very large format instant print camera using Polaroid's Polacolor ER film, this camera is for use at designated Polaroid studios only.

Polaroid CU–5 Close-Up Land Camera System

The Polaroid CU–5 Close-Up Land Camera System is employed by professionals for closeup photographs in science, medicine, dentistry, law enforcement, horticulture, and many other fields. Two camera bodies that accept Polaroid Land Pack film can be used: one for 3-1/4×4-1/4-inch pack films; one for 4×5 pack and sheet films. The lenses, frames, power supply, etc. are separate components that are attached to the camera body. The setup has the capability of reproducing from one-quarter life-size to ten times life-size.

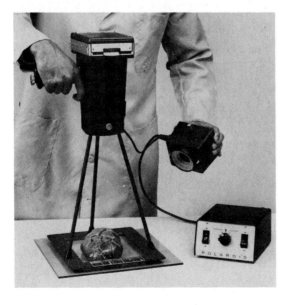

Polaroid Microscope Adapter

For photomicrography, a microscope adapter is available for use with any Polaroid SX–70 camera. The setup is demonstrated here by scientific photojournalist Fritz Goro.

Professional Equipment

PROFESSIONAL COLOR FILMS
Polacolor 2

A peel-apart general purpose color print film producing fade-resistant colors, it has limited exposure latitude and is not recommended for extreme lighting conditions of great contrast. It is available in several types, including the following:

Type 668. This is a 3-1/4×4-1/4 (8.3×10.8 cm) pack film with an ASA rating of 80. Balanced for electronic flash and for optimum rendition of skin tones, it is available in an eight-exposure pack.

Type 58. This is a sheet 4×5 format with an ASA of 75 and a processing time of sixty seconds. It is balanced for daylight and electronic flash, but can be used with tungsten lighting.

Type 808. An 8×10 sheet format with an ASA rating of 80, it is balanced for daylight and electronic flash and can be used with tungsten lighting.

Polacolor ER

This more recent peel-apart film offers better exposure latitude and more accurate colors than Polacolor 2, with an increased exposure range extending over 5½ f-stops. It has an ASA of 80 and is balanced for daylight and electronic flash. With filtration it can be used with tungsten lighting. Standard development time at 75°F (24°C) is sixty seconds. Several types are currently available:

Type 669. This is a 3-1/4×4-1/4 (8.3×10.8 cm) pack film with eight exposures per pack.

Type 559. This is a 4×5 pack format with eight exposures per pack.

Type 59. This is a 4×5 sheet format Polacolor ER film.

Type 809. This is an 8×10 sheet format Polacolor ER film.

PROFESSIONAL BLACK-AND-WHITE FILMS
Polaroid High-Speed 4×5 Land Film Type 57

A 4×5 sheet format with an ASA of 3000 and a processing time of fifteen seconds, this film is for general purpose uses.

Polaroid High-Contrast 4×5 Land Film Type 51

This 4×5 sheet format film has a sensitivity to blue light only and can be used at ASA 125 in tungsten light or at ASA 320 in daylight. It is designed for reproducing line art.

Polaroid Polapan 4×5 Land Film Type 52 and Type 552

Available in 4×5 size, both are rated at an ASA of 400 and offer a wide tonal range and superb detail. Type 552 is the newer film introduced in a pack format with a processing time of twenty seconds at 75°F (24°C). Type 52 is a sheet format and has a processing time of fifteen seconds at the same temperature.

Polaroid Coaterless Land Film Type 667

This is a 3-1/4×4-1/4 (8.3×10.8 cm) size professional high-speed pack film. It is rated at 3000 with a development time of thirty seconds.

Positive/Negative Films: Polaroid 4×5 Land Film Type 55 and Land Pack Film Type 665

These films produce a positive and a negative simultaneously. Type 55 is a 4×5 sheet film with an ASA of 50; Type 665 is a 3-1/4×4-1/4 (8.3×10.8 cm) pack film with an ASA of 75. Standard processing time is twenty seconds.

Glossary

Aberration: An inherent flaw in the lens resulting in a distorted or less sharp image.

Activator pod: A sack of chemicals fixed to one end of an instant film sandwich and broken by developer rollers to begin the development process.

Additive synthesis: Method of producing full-color images by mixing the additive primaries of red, green, and blue light.

Ambient light: Existing light in a scene indoors or out.

Aperture: Opening behind a lens which permits light to pass through and expose the film. The size of the opening, designated by an f-number, determines the brightness of the picture. The larger the f-number, the smaller the opening.

Artificial light: Illumination by sources other than daylight including incandescent light, fluorescent light, photofloods.

ASA: A standard rating of film speed established by the American Standards Association. A high ASA value indicates a high-speed film more sensitive to light than one with a low ASA number. ISO speed, established by the International Standards Organization, is comparable.

Aspheric: Curved in a complex shape that is not a part of a mathematically perfect sphere. A piece of plastic or glass is usually molded (not ground) in this form to be used as an element of a lens.

Atmospheric perspective: Haze or fog created in the distance of a scene by fine particles suspended in the air diffusing the light.

Autofocus: A feature in a camera that automatically adjusts the lens to the correct setting for the camera-to-subject distance.

Automatic camera: A camera with exposure controls that measure the light and adjust the camera's lens opening (aperture) and shutter speed for correct exposure.

Available light: Illumination existing in a setting; any light not added by the photographer.

Backlighting: Illumination from behind a subject, creating a dramatic contrast and occasionally a silhouette.

Bellows: A pleated extension that joins the camera body to the lens. Common in large-format cameras and some small-format cameras.

Bounce flash: A procedure of directing flash at a wall or ceiling to soften the light reflected onto the subject.

Cable release: A thin cable which attaches to the shutter button and is pressed on its plunger at one end to trip the shutter. Used for reducing camera shake, especially when the camera is mounted on a tripod.

Cast: A color shift giving an image an unnatural look.

CdS cells: A photosensitive cell used for measuring light in many built-in exposure meters.

Chiaroscuro: Arrangement of light and dark elements in a picture, usually expressing a subject's three-dimensionality and often formed by modeling light.

Close-up lens: A supplemental lens that attaches over the existing lens to magnify the image.

Color balance: The true rendition of colors from a given scene. Most instant films are balanced to produce accurate reproductions in daylight or with daylight-balanced flash.

Color correction filters: Filters used over the camera lens to correct color shifts caused by illumination from artificial light sources.

Color reversal film: Film resulting in direct color positives (slides or transparencies).

Complementary colors: Two colors that combine to produce white light. Cyan, magenta, and yellow are complementaries of the primary colors red, green, and blue, respectively.

Compound lens: A lens made with two or more elements.

Computer flash: Flash with built-in sensor that evaluates flash reflecting from the subject and determines the proper exposure. The Polaroid 600-system cameras rely on a computer flash for light mixing.

Contrast: The range of tones in a print. Pictures with deep blacks to white are considered contrasty; gray-toned prints are "flat."

Cropping: Usually refers to darkroom printing when only a portion of a negative is enlarged in order to leave out unwanted areas. Also refers to in-camera cropping, or leaving out unwanted parts of a scene by eliminating them from the viewfinder frame.

Daylight film: Color film balanced for use in average daylight (about 5500 Kelvin) and with electronic flash and blue flashbulbs.

Depth of field: Distance range of sharpness extending in front of and behind the point of focus on the subject, usually determined by the size of the lens opening (the larger the opening, the shallower the depth of field) and the distance from lens to subject.

Developer: A chemical substance which acts on the latent image to produce a positive, viewable image.

Diaphragm: A system of adjustable blades which forms the lens opening (aperture).

Diffusion: Light scattering which softens an image. Can be caused by bounce lighting, atmospheric perspective, or filtration.

DIN: Deutsche Industrie Norm, a film speed rating system widely used in Europe.

Diopter: A measurement of the strength of a supplemental lens, noted in meters.

Double exposure: Superimposition of one image over another on the same frame of film.

Drying marks: Water marks on film caused by uneven drying. A wetting agent helps to eliminate drying marks.

Dry mounting: A process of affixing a print to a mounting board using a special heat-sensitive tissue that melts, forming a bond between the print and board.

Electric eye: A photosensitive cell system which measures the light in a scene.

Electronic flash: An artificial illumination relying on a high-voltage electrical discharge passing through a gas-filled tube.

Emulsion: A light-sensitive photographic material capable of receiving an image.

Enlargement: A print larger than the original image.

Exposure: The amount of light acting on a light-sensitive emulsion, controlled by the image brightness (determined by the aperture) and the length of time the light

strikes the emulsion (determined by the shutter).

Fill flash: Supplemental lighting used to illuminate shadows for a more balanced, less contrasty picture.

Film speed: The measure of a film's sensitivity to light, usually based on ASA, DIN, or ISO ratings.

Filter: A colored glass, gelatin, or translucent material used to hold back a specific color of light in order to alter the resulting image. A filter is placed over a lens or light source.

Fixed-focus lens: Lens permanently set to a given distance. Offers a wide depth of field, often keeping subjects in focus from four feet (1.2 m) to infinity. Usually found on simple cameras.

Flare: Light reflected in the camera from the lens elements, or diffused from scratches or moisture on the lens surface, resulting in irregular light marks on the picture or a general loss in image contrast.

Flat lighting: Illumination lacking contrast and producing little or no shadows.

Floodlight: A typical artificial lighting device used in studios to provide even lighting. Uses a high-wattage lamp in a reflector.

f-number: Measurement indicating the diameter of the lens opening (aperture). As the steps (or f-stops) become higher, the lens opening becomes smaller, allowing less light to pass through. When an exposure control is moved one f-stop toward lighten (lowering the f-number), the lens opening is made larger, letting in more light; moved a stop toward darken (increasing the f-number), the opening becomes smaller.

Focal length: Distance between the optical center of a lens focused at infinity and the film plane, indicated in millimeters.

Foreshortening: The compression of space resulting in a distorted impression of depth. Occurs with a longer focal length lens such as Polaroid's Tele Lens accessory.

Format: Refers to the dimensions of an image recorded on film by a particular type of camera and the resulting print or negative size.

Fresnel: A surface made up of concentric circles with convex shapes, usually incorporated into lenses or mirrors to produce even brightness.

Frontlighting: Illumination of a subject from a light source shining from the direction of the camera.

Full flash: An operation of an electronic strobe system in which the light output is at maximum capacity.

Gradation: The tonal range in a picture; the gradual changes in density of tones or color.

Grain: The silver or dye particles making up the image of black-and-white or color prints. High-speed (fast) films usually result in larger particles and grainier pictures.

High-key image: An image containing mostly light and middle tones and no dark tones.

Highlights: Brightest areas of an image.

Hue: Slightly differing characteristic of a color in terms of its wavelength or place on the color spectrum.

Image plane: Plane inside a camera on which the film is flattened to accept a sharply focused image.

Incident light: Illumination that falls onto the subject rather than reflecting off it.

Infinity: Symbolized by ∞; extending indefinitely into the distance.

Integral film: A complete film able to receive an exposure, process a positive image, and provide viewing of the finished picture all in one self-contained unit.

Integrated circuit (IC): A miniaturized composite of many circuits on a plastic board or chip.

Interchangeable lens: A removable lens. Used on certain cameras to give the photographer the option of varying focal lengths.

ISO speed: The sensitivity of a film as determined by the International Standards Organization. ASA speed, established by the American Standards Association, is comparable.

Kelvin: A temperature measurement used to describe the color of light sources. Daylight film is balanced for a color temperature of about 5500° Kelvin. For good color rendition in pictures taken in light sources of different color temperatures (such as tungsten or fluorescent), filters are required to alter the light. (Flash illumination provides proper color temperature for daylight film.)

Latent image: Invisible image recorded on film through exposure and made visible by a chemical action of a developer.

Latitude: Tolerance of photographic films to variations in exposure.

Lens tissue: Soft, lint-free material used for lens cleaning.

Lighten/darken control: A feature incorporated into most instant cameras allowing for exposure variations in difficult lighting situations. A change toward lighten gives more exposure, a change toward darken gives less exposure.

Light leak: Appears as a fogged area on the photographic print; usually caused by opening the film door while unexposed film remains.

Light meter: An exposure meter that measures the amount of light to determine proper aperture and shutter settings.

Light sensor: A component within a light meter's circuitry.

Low-key image: Image containing mostly dark tones and no light tones at all.

Macrophotography: Extreme closeup photography, usually magnifications from life size to 10× life size.

Microphotography: See "Photomicrography."

Modeling light: Light defining a subject's three-dimensionality through light and shadow, achieving a chiaroscuro effect.

Monochromatic: Consisting of one color or hue.

Montage: An assemblage of images which forms a picture; collage.

Negative: A photographic image in which each tone is represented by the opposite of its original tone (in black-and-white photography) or by its complementary color (in color photography).

Neutral density filter: A gray-colored piece of glass or acetate that blocks light without altering colors. Reduces brightness of a scene and can be used to achieve shallower depth of field.

Opacity: Opaqueness of a material.

Open flash: Manual triggering of a flash during a time exposure, used for multiple

exposures of subjects or for lightwriting effects.

Orthochromatic: Type of black-and-white film emulsion having no sensitivity to red light.

Overexposure: The result of too much light reaching the film emulsion.

Pack film: A type of Polaroid Land film producing peel-apart black-and-white or color pictures, with development occurring outside the camera.

Panchromatic: Type of black-and-white film emulsion sensitive to all colors.

Panning: An action technique for photographing a subject moving across the field of view. It is accomplished by moving the camera at approximately the same rate of speed as the subject is moving. The result is an in-focus subject with a blurred background conveying a sense of motion.

Parallax: A discrepancy between the field of view seen through the viewfinder and that seen through the separate picture-taking lens. A single-lens-reflex camera, which reveals the same image in the viewfinder as that in the lens, does not cause parallax error.

Peel-apart film: A type of Polaroid pack film producing black-and-white or color pictures, in which layers must be peeled apart after processing has been completed.

Photodiode: A photosensitive cell used for light measuring.

Photoelectric cell: A type of light-sensitive unit incorporated into the circuitry of a light meter.

Photoflood: A tungsten lamp with a filament bulb commonly used for artificial illumination.

Photogram: An image produced without a lens by arranging objects on a light-sensitive emulsion and exposing it to a bright light source.

Photomicrography: Attaching a camera to a microscope in order to photograph magnifications of 10× and greater.

pH value: A measurement of acidity or alkalinity of a material.

Pod: The sack of chemicals in an instant film containing the agitator/reagent used in development.

Polarizing screen: Transparent filter that reduces reflections on water, glass, and other shiny surfaces.

Positive: An image on a developed print having the same tonalities as the original scene.

Primary additive colors: The three primaries for forming a color image through light transmission—red, green, and blue.

Rangefinder: Type of focusing aid for measuring the distance between the camera and subject, reliant on aligning two images of the subject.

Ready light: A red or blinking light usually found on electronic strobes or flashguns to indicate that the unit is fully charged and ready for use.

Reagent: An alkali chemical that acts upon dye developers in integral films to initiate development.

Reciprocity law: Principle stating that if the intensity of the illumination multiplied by the duration of the exposure remains constant, then the resulting effect is the same. Thus, a lens opening of f/11 with a shutter speed of 1/125 should yield the same effect as f/8 at 1/250. The law does not apply for very short or very long exposures. Failure of the law in such instances is called reciprocity failure.

Reflector: Bright, sometimes shiny materials in white or silver, used to direct light into dark, shadowy areas; particularly used in studio work.

Reflex camera: Type of camera using a viewing system that directs the image seen by the lens through a series of mirrors onto a glass screen to form the same image on the viewfinder. Basic type: single-lens-reflex.

Reversal process: A development process employed in integral instant films in which unexposed grains of silver halide in three emulsion layers of red, blue, and green are developed by dyes of complementary colors to produce the final image.

Roll film: The earliest type of instant print material, available in rolls. Development took place inside the camera. The camera back was then opened, and the finished print peeled apart from its negative.

Rule of thirds: A compositional principle used for effective framing of scenes. The rule is to divide a picture into thirds horizontally and vertically and place the subject(s) at one of the four intersecting points.

Safelight: A special illumination that does not affect most unexposed photographic materials. Often used in darkroom work.

Selective focusing: A compositional effect used to draw attention to a particular subject within a scene. The technique relies on using a shallow depth of field to isolate the subject.

Selenium cell: A type of photoelectric cell used in a light meter.

Shutter: A camera mechanism controlling the duration of time that light reaches the film, usually expressed in terms of seconds or a fraction of a second.

Silhouette: An outline of a subject produced by photographing the subject against a very bright background.

Silicon photodiode cell: Highly sensitive photocell used for measuring light in camera exposure meters.

Silver halide: A chemical compound of light-sensitive salts in photographic emulsion.

Single-lens-reflex (SLR): Type of camera using a sophisticated viewing system of mirrors and optics to transmit the image seen in the lens to the viewfinder.

Soft-focus: An effect achieved by diffusing the light so that a subject is not sharply delineated. Special filters or light-diffusing fabrics can be used.

Sonar: Ultrasonic echo device used in some Polaroid cameras to send a sound wave from camera to subject and back in order to measure precise distance and accurately set the focus.

Spectrum: Wavelengths visible when white light is split by a prism into colors ranging from red to violet.

Speed: Light sensitivity of a photographic material, usually designated by ASA, DIN or ISO numbers.

Stop: Designation for f-number or aperture setting.

Stopping down: Making the lens opening smaller. When the lighten/darken control is moved to darken, the lens is stopped down to allow less light to reach the film, producing a darker image.

Subtractive colors: Colors produced by subtracting primary additive colors. Primary subtractive colors of cyan, magenta, and yellow are formed by subtracting one of the three primary additive colors of red, green, and blue from white light.

GLOSSARY

Telephoto lens: A special lens having the optical ability to make distant objects appear closer and larger in an image. Also has a tendency to compress space.

Time exposure: Keeping the shutter open for a long period of time, a technique used in low-light situations to permit enough light to reach the film.

Tonal range: Variances in brightness value between parts of an image.

Toning: A process used for changing the natural color of a print using a chemical treatment.

Tripod: A solid, three-legged device used to steady a camera for long exposures.

Tungsten-halogen lamp: An artificial source of illumination most commonly used in indoor studio setups.

Ultraviolet filter: A glass or gel used to hold back ultraviolet rays and help reduce haze.

Underexposure: Insufficient light reaching the film, resulting in an image that is too dark.

View camera: Type of large-format camera with a ground-glass viewing screen on its back for composing the picture.

Viewfinder: Device on a camera used for viewing and focusing the scene.

Wetting agent: Substance commonly used on negatives after the final washing in order to avoid drying spots.

White light: The result of mixing all colors or wavelengths of light.

Zone system: An exposure system developed by Ansel Adams relating tonal values in a scene to exposure readings.

Bibliography

INSTANT TECHNIQUES/ TECHNOLOGY

Adams, Ansel. *Polaroid Land Photography.* New York Graphic Society, 1978.

Dickson, John. *Instant Pictures.* Pelham Books, 1964.

Land, Edwin H., Rogers, Howard G., and Walworth, Vivian K. *One-Step Photography.* Reprinted by Polaroid from *Neblette's Handbook of Photography and Rephotography,* Van Nostrand Reinhold, 1977.

Langford, Michael. *The Instant Picture Camera Handbook.* Alfred A. Knopf, 1980.

Wolbarst, John. *Pictures in a Minute.* American Photographic Book Publishing, 1960.

GENERAL TECHNIQUES

Bailey, Adrian, and Holloway, Adrian. *The Book of Colour Photography.* Ebury Press, 1979.

Busselle, Michael. *Master Photography.* Rand McNally, 1977.

Curl, David H. *Photocommunication, A Guide to Creative Photography.* Macmillan, 1979.

Editors of Eastman Kodak. *The Joy of Photography.* Addison-Wesley, 1979.

Freeman, Michael. *The Manual of Outdoor Photography.* Ziff-Davis, 1981.

Giambarba, Paul. *How to Make Better Polaroid Instant Pictures.* Polaroid, 1971.

Hedgecoe, John. *The Art of Color Photography.* Simon and Schuster, 1978.

Hedgecoe, John. *The Book of Photography.* Alfred A. Knopf, 1976.

Hedgecoe, John. *The Photographer's Handbook.* Alfred A. Knopf, 1979.

Miller, Jan B. *Amphoto Guide to Framing and Display.* Amphoto, 1980.

Norrison, Alex. *Photofinish.* Van Nostrand Reinhold, 1981.

Time-Life Series. *Caring for Photographs.* Time, 1972.

Time-Life Series. *Photographing Nature.* Time, 1971.

ART

Cosindas, Marie. *Color Photographs.* New York Graphic Society, 1978.

Kertész, André. *From My Window.* New York Graphic Society, 1981.

Recent Polaroid Color Photography, One of a Kind. David R. Godine.

SX–70 Art. Lustrum Press, 1979.

MISCELLANEOUS

Meiselas, Susan. *Learn to See.* Polaroid, 1974.

Olshaker, Mark. *The Instant Image.* Stein and Day, 1978.

Polaroid Education Project, Polaroid.

CRITICISMS AND QUOTATIONS

Cohen, J. M., and Cohen, M. J. *The Penguin Dictionary of Modern Quotations.* Penguin, 1971.

Coleman, A. D. *Light Readings.* Oxford University Press, 1979.

Freund, Gisele. *Photography and Society.* David R. Godine, 1980.

Hill, Paul, and Cooper, Thomas. *Dialogue with Photography.* McGraw-Hill, 1979.

LaPlante, Jerry C. *Photographers on Photography.* Sterling Publishing, 1979.

Peter, Laurence J. *Peter's Quotations.* William Morrow, 1977.

Photographers on Photography, edited by Nathan Lyons. Prentice-Hall, 1966.

Seldes, George. *The Great Quotations.* Simon and Schuster, 1971.

Sontag, Susan. *On Photography.* Farrar, Straus and Giroux, 1978.

Zakia, Richard D. *Perception and Photography.* Light Impressions, 1979.

Zakia, Richard D. *Perceptual Quotes for Photographers.* Light Impressions, 1980.

EXHIBITION CATALOGUES AND MAGAZINES

Camera
CloseUp
Exploration of a Medium
The History of Polaroid One-Step Photography, 1979
Modern Photography, assorted columns by Weston Andrews with David L. Miller
Petersen's PhotoGraphic, assorted columns by Joe Novak
Popular Photography, assorted columns and articles by Don Leavitt
Zoom, Polaroid Special, 1980

BOOKLETS

"A Basic Guide—8×10 Polacolor 2 for the Professional Photographer," 1979.
"8×10 Polacolor 2 Film and the Vertical Copy Camera," 1978.
"Photography with Large-Format Cameras," 1977.
"Photomacrography with the MP-4," 1979.
"Polaroid Black-and-White Land Films," 1980.
"Polaroid 8×10," 1980.
"Teaching Tips from Kodak Teachers," 1979.
"The World of SX–70," Polaroid, 1974.

Index